CHINA TRADE PORCELAIN: PATTERNS OF EXCHANGE

CHINA TRADE PORCELAIN: PATTERNS OF EXCHANGE

Additions to the
Helena Woolworth McCann Collection
in The Metropolitan Museum of Art

Clare Le Corbeiller
ASSOCIATE CURATOR OF WESTERN EUROPEAN ARTS

FOREWORD BY
John Goldsmith Phillips
CHAIRMAN EMERITUS, WESTERN EUROPEAN ARTS

THE METROPOLITAN MUSEUM OF ART
Distributed by New York Graphic Society

Color photography by William F. Pons
Black and white photography, unless otherwise specified,
by the Museum's Photography Studio
Designed by Peter Oldenburg
Printed by the Press of A. Colish
Bound by A. Horowitz and Son
Maps by Joseph P. Ascherl

Copyright © 1974 by The Metropolitan Museum of Art

LIBRARY OF CONGRESS CATALOGING IN PUBLICATION DATA
Le Corbeiller, Clare.
 China trade porcelain.
 Includes bibliographical references.
 1. China trade porcelain—Catalogs. 2. McCann, Helena
Woolworth—Art collections. I. Title.

NK4565.5.L43 382'.45'73820951 74-2097
ISBN 0-87099-089-6

FOREWORD

In 1946 half of the vast collection of China trade porcelain formed by Helena Woolworth McCann came to the Metropolitan Museum as a loan from the Winfield Foundation, the family trust created by Mrs. McCann's children in her memory. The other half of the collection was lent to the Museum of Fine Arts in Boston, and special exhibitions of the porcelains were held in both museums.

Since the collection contained numerous services and numbered about 4,000 pieces, mainly eighteenth-century armorial, the Foundation and the two museums eventually agreed that the collection would be of more lasting value to the general public if it could be shared among other institutions. Hence, with the collaboration of the staffs of the Metropolitan and the Boston museums, twenty-six institutions in the United States and one in Canada were given units of the collection varying in quantity, but not in quality.

The three McCann children who had established the Foundation—Mrs. Richard Charlton, Mrs. Joseph V. McMullan, and its president, Frasier W. McCann— together with the late Joseph V. McMullan, then chairman of the Foundation's porcelain committee, felt that, because of the collection's wide distribution, a publication should record it in its entirety. I was chosen to write the book, *China-Trade Porcelain*, which was published in 1956 by the Harvard University Press. This volume, now out of print, dealt with the historical and cultural background of China trade porcelain and its manufacture and decoration. It also included a study of the objects in the McCann collection, and furnished details of the distribution of the porcelain.

The Foundation, which had underwritten the publication costs, ceded to the Metropolitan all receipts from sales of the book. In accordance with the recommendation of the Winfield Trustees, these receipts were added to the unexpended balance of a fund given to the Museum for the installation of the collection and were used to secure pieces that would bring further distinction to the McCann collection. Pieces especially sought after were export porcelains of the sixteenth and seventeenth centuries and the earliest years of the eighteenth. These are rare, but those that exist sharply illumine the course of development of the China trade.

By 1971 additions to the McCann collection as represented in the Metropolitan numbered more than eighty individual items. The additions formed a coherent group, highly significant in its own right. In recognition of this, Frasier W. McCann commissioned a further publication, the work now in your hands.

More than a quarter of a century has elapsed since collaboration commenced between the Foundation and the Metropolitan. On all counts it has proved fruitful, rewarding to both parties, perhaps even a model of what can be accomplished when people of good will and patience agree to work together.

J. G. P.

PREFACE

Because the Museum's original Helena Woolworth McCann Collection of China Trade Porcelain was both large and comprehensive, it has been possible to add to it, very selectively, pieces whose decorations and associations pinpoint some special aspects of the China trade. For this reason, this catalogue has been designed, not so much as a history of China trade porcelain, but as a collection of essays that attempts to explore the particular context of each piece in that history.

It was an honor to be invited by Mr. Phillips to write this sequel to a book that was my introduction to the fascinations of the China trade. For his quiet enthusiasm and steady encouragement I owe him a debt that I hope this volume will at least partly repay. I am also deeply appreciative of the generosity of the Winfield Foundation, whose support has extended over the years to include the production of this catalogue.

Even the most cursory investigation into the background of a piece of China trade porcelain is apt to lead one into diverse and unfamiliar territory. For their kindness in answering my questions and supplying essential information or photographs, I thank W. T. Affolter; American Numismatic Society, New York; J. A. van den Bergen, Nederlandsch Historisch Scheepvaart Museum, Amsterdam; Elizabeth T. Casey, Museum of Art, Rhode Island School of Design; The Cleveland Museum of Art; F. H. Fentener van Vlissingen; Gemeentemuseum, The Hague; Göteborgs Historiska Museum; Groninger Museum voor Stad en Lande; W. de Haan; Henry E. Huntington Library and Art Gallery, San Marino; Miss M.-A. Heukensfeldt Jansen, Curator of Ceramics and Glass, Rijksmuseum, Amsterdam; Soame Jenyns; John D. Kilbourne; J. van Loo; J. Jefferson Miller, Curator of Ceramics History, Smithsonian Institution; U. Mursia & C. Editore and Francesco Stazzi; Musées Royaux d'Art et d'Histoire, Brussels; National Park Service; A. V. B. Norman, Keeper, Arms and Armor, The Wallace Collection, London; Miss Jale Ozbay, Assistant Curator, Topkapu Saray Museum, Istanbul; Parke Bernet Galleries, Inc.; Mrs. R. E. Peers and J. R. Peers; John A. Pope; G. P. Putnam; Rijksmuseum, Amsterdam; Jaap Romijn, Director, Gemeentelijk Museum, Leeuwarden; Sotheby & Co.; Hans Syz; W. A. Thorburn, Curator, Scottish United Services Museum; Charles Vaurie, Curator, Department of Ornithology, American Museum of Natural History; Victoria and Albert Museum, London; T. Volker; Roderick Webster, Adler Planetarium and Astronomical Museum, Chicago; Roderick Whitfield, Assistant Keeper, Department of Oriental Antiquities, The British Museum; and Witt Library.

Much important work on the China trade has recently been published in Swedish, Danish, and Dutch. I am indebted to Marianne Williams, Maria V. Busoni, John Walsh, and Pieter Meyers for their translations from those languages.

I have benefited from the knowledge and perspective—which he has generously shared—that Dr. D. F. Lunsingh Scheurleer has brought to the study of the China trade in Holland. I have also been extremely fortunate in being able, throughout the preparation of this catalogue, to exchange points of view and information with David Sanctuary Howard and Suzanne G. Valenstein, whose specialized knowledge and unfailing willingness to consider my questions has been of the greatest value.

In its final form this catalogue represents the work of many people whose thoroughness and skill cannot be left unnoted: Alison Hubby and Kathryn Simmons, who provided exemplary typescript; Peter Oldenburg, who has produced a design harmonious with his earlier scheme for Mr. Phillips' volume; and the Museum's photographer, William Pons. My deepest and most affectionate thanks are due my husband for entering into my enthusiasm for the subject, for bringing to it new aspects and dimensions, and for his rigorous but sympathetic criticism.

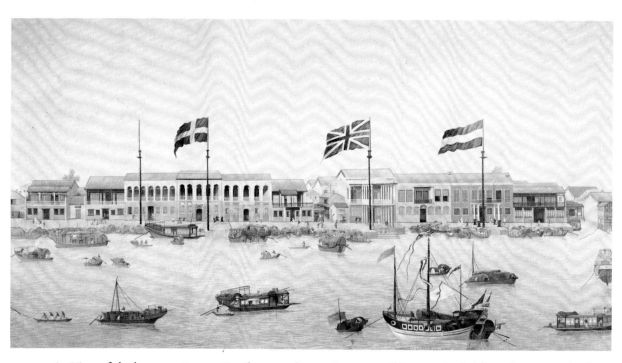

FIGURE 1 View of the hongs at Canton. Detail, watercolor on rice paper. Chinese, end of eighteenth century. Göteborgs Historiska Museum, Göteborg, Sweden

INTRODUCTION

Between the china shops of Canton and London in the eighteenth century lay a trade route that had little to do with porcelain. Spices, religion, and adventure had lured Europeans eastward, and by 1700 spices, silver, coinage, and tea formed the basis of trade—a trade that was to continue for 150 years. Porcelain was incidental to the economic stability of that trade; even when every returning East Indiaman carried as much porcelain "as will floor the Ship fore and aft,"[1] there was a tendency to consider it more a convenience in protecting teas and silks against water damage than a commodity of inherent value.[2] Such, at any rate, was the official view of East India company officers and supercargoes. Privately, however, they imported about a third again as much "chinaware" for themselves as they did on their companies' accounts,[3] and it is to this segment of the trade that most of the export porcelains of biographical and historical interest belong. Shipped merely as kentledge to the retail merchants of England and the Continent were the all-of-a-kind table sets with their noncommittal floral or landscape decoration or genre scenes of Chinese family life. It is in the trade of the East India company officials, the captains, and the supercargoes acting for themselves and their friends at home that we find the personal element that is one of the most beguiling characteristics of the porcelain trade.

The transition from the sporadic acquisition of Chinese porcelain of high quality to the large-scale importation of useful wares manufactured solely for Western taste was a slow one, its progress directly affected by the success or failure of the great sea explorations. By the eighteenth century the sea route between Europe and China around the Cape of Good Hope was a familiar one. Whether from Göteborg, Gravesend, Amsterdam, or Lisbon, ships sailed past the Azores and Cape Verde Islands and down the west coast of Africa. Rounding the Cape, they either sailed directly across the Indian Ocean, through the straits of Sunda, and so up to Macao; or they headed north to the west coast of India and then on to Macao through the straits of Malacca. From Macao, the ships proceeded up the Pearl River, past the Tiger's Mouth, and anchored at Whampoa. Here their cargoes were transferred to waiting junks and ferried the last twelve miles of shallow water to the foreign factories at Canton (Figure 1).

But a sea route was not available to the West until its discovery in 1497 by Vasco da Gama. Up to that time Chinese porcelain had reached Europe only rarely and indirectly. A bottle now in the Dublin Museum,[4] known to have had silver-gilt mounts enameled with the arms of Louis the Great of Hungary (1326–82) and two successive kings of Naples, Charles III (d. 1386) and Ladislas (d. 1414), is presumed to have been a present from the last Yüan emperor to Louis, whose hospitality would have been invoked in the overland route taken by the emperor's ambassador to the Avignon pope in 1338. Such a trip was of course long and difficult, and it was not often made. More often used was the seaway to India, where the Chinese carried their goods to be transshipped by the Egyptians up the Red Sea and so to Venice or Genoa: it was in Calicut that da Gama found the silks, spices, and porcelains he brought back to Lisbon in 1498. Encouraged by his navigational success and the lure of the spice trade, Manoel I (1469–95–1521) sponsored a series of expeditions that quickly established Portuguese hegemony in Asian waters. By 1501 there were factories at Cochin and Calcutta, followed by others at Colombo (1505) and Goa (1509). But the goal of the Portuguese was to capture the market for cloves and nutmegs centered at Malacca, a city whose importance was further enhanced by its being, after about 1500, the westernmost point of Chinese shipping. Portugal took

the city in 1511, and the stage was thus set for the trade breakthrough that came with the sending of a Portuguese embassy to Peking in 1517 (catalogue 1).[5] Although this first contact ended in diplomatic failure four years later, the principle of commercial relations between East and West was now established. The extent of the porcelain trade between China and Portugal, however, was limited. Most, and possibly all, the inscribed and/or armorial pieces of the sixteenth century refer to Portuguese government officials and adventurers who were active in the Far East. Everyday blue-and-white wares were sent home in the bulky merchant ships called naós or carracks in such quantities as earned them the designation carrack ware, but the long-range interest of the Portuguese was to lie in intra-Asian traffic.

The marketing of Chinese porcelain on a multinational scale was realized a century after da Gama by the English and Dutch, who, in their usual spirit of symbiotic competition, sponsored several expeditions in the last decade of the sixteenth century. The definitive one was Cornelis Houtman's, sailing from Texel in 1595 with the English captain John Davis in command of one of the two fleets. Successfully rounding the Cape (for the first time since da Gama) they sailed directly across the Indian Ocean, thus avoiding Portuguese interference, and landed at Bantam, at the northwest corner of Java, where they established a factory. Returning to Holland in 1600 with a cargo of pepper, cloves, nutmegs, and 8000 pounds of mace, Davis was met at Middelburg "by two companies of trainbands with music playing and welcomed with joy bells as well."[6] Some of the excitement of that moment and of the ensuing rush of expeditions is conveyed in a news item of November 1600: "We are advised from Holland that some syndicates have already finished the equipment of their ships and will sail off with the first fair wind," while in July 1601 "Amsterdam letters . . . report that the twelve Holland and Zeeland ships sailing to the East Indies have been joined by seven English ships for the same destination."[7] In fact, the expedition of Houtman and Davis led directly to the founding of England's first East India Company (1600) and (1602) the Dutch Vereenigde Oostindische Compagnie (or, more conveniently, the VOC).

The early voyages were in quest of spices, but the capture by the Dutch of two Portuguese carracks in 1602 and 1604 opened a new chapter in the East-West trade: the Catharina, the second of these prizes, carried an esti-mated 100,000 porcelains, and these pieces, sold at auction in Amsterdam in August 1604, attracted purchasers from all over Europe.[8]

The Dutch now began to expand in the Indies. From Bantam they moved east in 1605 to Jacatra, which they wrested from the local ruler in 1619. Renamed Batavia, the city became the VOC's Asian headquarters. From there, the Dutch conducted their trade with China, and from there they gradually ousted the Portuguese from all their Indonesian bases. By 1660, only Macao was left to Portugal.

It has been estimated that between 1604 and 1657 the Dutch imported no fewer than three million pieces of porcelain into Europe,[9] creating a demand that was to be an important consideration in the formation of later East India companies. Before other countries could take advantage of this growing market, however, political rebellion within China brought trade to a halt in 1657. Resistance to the Manchu succession was led by Cheng Ch'êng-kung (1623–62), a picturesque adventurer better known by the Westernized form of his name, Coxinga, who had once been tailor to the Dutch governor of Formosa. For a time his followers held both Canton and Amoy, a focal trading point; in 1657 Coxinga was able to prevent Chinese junks from crossing to Formosa, the last remaining base of East-West trade, and five years later the Dutch were finally expelled from Formosa. The embargo imposed by the Chinese lasted until 1682, but not until 1695 were their junks free to sail again to Batavia.

Meantime, the kilns for the manufacture of porcelain at Ching-te Chen, some 500 miles north of Canton, had been destroyed: rebuilt in 1677, they again became important only after the appointment by K'ang Hsi in 1683 of Ts'ang Ying-hsuan as director of the Imperial factory. Although some porcelains certainly were smuggled through the official trade barrier between 1657 and 1683, the export of Chinese porcelain was at a virtual standstill. The slack was taken up by the Japanese, who produced their first export porcelains for Holland in the 1660 season.[10] But the Japanese trade proved to be erratic, and with the reconstruction of Ching-te Chen and the normalization of commercial relations at the end of the century, the porcelain trade shifted back to China.

At the turn of the century the Dutch found they were no longer in sole command of the East-West trade. Colbert inaugurated his Compagnie des Indes with the send-

ing of the *Amphitrite*, which reached Canton in 1698, and the company financed eleven more voyages before 1713. Although her volume of trade during this period was small, France immediately acquired great influence in China through the diplomacy of her ubiquitous Jesuits. A year after the arrival of the *Amphitrite*, the *Macclesfield*, first ship of a new English firm, the English Company Trading to the East Indies (chartered in 1698), was granted permission to trade at Canton. This attempt to revive England's presence in the Far East was to succeed. Lacking sustained government support, the old London company had been quickly pushed out of Indonesia by the Dutch; Charles I had even gone so far in 1647 as to underwrite a rival association sponsored by Sir William Courteen, a naturalized Dutchman: his fleet—led by Captain John Weddell—reached Canton, and although it returned with a cargo of cloves and silk and fifty-three tubs of porcelain, Weddell's attempt to open the city to regular English trade ended in gunfire. After that, the English were expelled from the mainland until the arrival of the *Macclesfield* in 1699. In the interval they traded at Amoy and Macao and built up their presence in India. By 1709, when the old and new companies were formally merged, the one with its strong position in India[11] and the other with its foothold in China, England was in a position to dominate the Eastern trade as the Dutch had in the preceding century and the Portuguese before that.

The only threat to English supremacy was raised in 1718 by the Ostend Company, which originated in a revived interest in trade in Flanders following the Treaty of Utrecht.[12] In that year a syndicate headed by a wealthy Dutchman was formed, and the company's first voyage to Canton, captained by an Irishman, ended profitably. Protected by Charles VI of the Holy Roman Empire, the company attracted a variety of sailors and merchants, including Jacobites who were safer out of England, disaffected Dutch and English East India Company personnel who hoped to break their governments' monopolies, and adventurers with an eye to a quick profit. Despite proclamations by the Dutch and English governments against their citizens serving in foreign companies and despite a carefully planned campaign of harassment, the Ostend Company was entirely successful, sometimes clearing 100 percent. After nine years, however, Charles VI was persuaded to suspend the company's charter, and in 1731 he revoked it, thus ending the only significant competition to the government companies of England

and Holland. The establishment of Danish and Swedish companies in 1730 and 1731 in no way affected the trade of the existing ones, since their markets did not extend to the Scandinavian countries.[13]

The quantity of porcelain imported into Europe during the eighteenth century is difficult to estimate, since the figures are given variously by the piece, the weight, the cost, or the container.[14] At the opening of the century the role of porcelain was still somewhat equivocal. On the one hand porcelain had long been part of the Dutchman's daily life; on the other, it filled the *Porzellankabinetten* of the Oranienburg and the Charlottenburg palaces, satisfying the German princes by virtue of its high quality and luxury. In England, Queen Mary also had her collection, brought over from her Chinese room at Hunsslardiek and rehoused in the Water Gallery at Hampton Court. It was a collection, in Defoe's opinion, "the like whereof was not then to be seen in England," and to the Queen he attributed "the custom or humour, as I may call it, of furnishing houses with china-ware, which increased to a strange degree afterwards, piling their china upon the tops of cabinets, scrutores, and every chymney-piece, to the tops of ceilings, and even setting up shelves for their china-ware."[15] But here, too, the porcelain served a decorative rather than a utilitarian purpose. The rise of tea drinking in England occasioned some importation of appropriate china—before 1700, for instance, the Earl of Bedford had acquired several sets of Chinese teapots and cups[16]—but there was as yet no general market, and even as late as 1703 and 1704 the supercargoes were grumbling at the amount of porcelain they were required to buy.[17] The Johnson-Lovelace jardiniere of 1692–97[18] and the service made about 1705 for Thomas Pitt while he was governor of Fort St. George, Madras,[19] are the only armorial porcelains known to have been made for the English market in these early years. With the merging of the old and new English companies and the establishment of a factory at Canton by 1715 the market picked up. Already in 1708 a playwright could satirize "Mrs. Furnish at St. James's [who] has order'd lots of Fans, and China, and India Pictures,"[20] and by the following year London could support the china merchant Henry Tombes, from whom the Duke of Bedford acquired both Chinese and Japanese porcelain.[21] In 1717 two ships were commissioned to spend £44,000 on porcelain (about 610,000 pieces),[22] a dramatic increase that is reflected in the substantial number of services dat-

able to this period. The majority of these were made for East India Company servants and government officials (**19, 20, 22**). From about 1720 the English market expanded continuously for over fifty years, bringing an estimated twenty-five to thirty million porcelains into the country.[23] Elsewhere in Europe the trade was nearly as large. In the quarter century between 1722 and 1747 the French imported a little over three million porcelains, and between 1761 and 1775 another two million.[24] The estimated trade to Denmark, whose third and ultimately successful East India Company was founded only in 1730, has been placed at ten million porcelains,[25] and during the period of the Swedish company's third charter alone, 1766–86, eleven million porcelains were imported to Sweden.[26]

Throughout the trade, porcelain was bought chiefly from stock. The Portuguese continued to make their choice from the wares brought down to Macao or displayed at the annual fair at Canton; until 1729, when they obtained a factory at Canton, the Dutch relied on the goods brought by junk to Formosa or Batavia. And even in Canton itself the supercargoes made up their shipments largely from available stock. The trading season, which was determined by the monsoons, was limited to two or three months in the autumn, and if coats of arms or other special designs were wanted for the return trip they could be ready in time only if the porcelains were already in hand. Despite this limitation, the question of ordering special shapes arose as early as 1616 when Jan Pietrsz. Coen wrote the VOC directors from Batavia that "the porcelains are made far inland in China, and . . . the assortments which are sold to us . . . are put out to contract and made afterwards with money paid in advance, for in China assortments like these are not in use."[27] While there may be some question as to the precise meaning of the word "assortments" here, there is no doubt that in a little over ten years of trade the Dutch had succeeded in turning it to Western advantage in terms of the adaptation of the exported porcelains to Western table customs. The point was made unequivocally in 1635 when the VOC furnished, for the first time, wood models of saltcellars, wide-rimmed dinner plates, mustard pots, ewers, and basins;[28] such models are again referred to in VOC records in 1639 and 1643.[29] This use of wood models is curious. The shapes mentioned in the 1635 order are those familiar in silver and pewter, both materials quite as

sturdy as the models substituted for them, and both likely to have been available in the East, as forming part of the ordinary household equipment of VOC personnel and their families. The issue possibly concerned the decoration of the pieces rather than their form: since painted ornament was alien to the original models, the Dutch would have wanted to provide a complete sample to show the Chinese how they should deal with the decoration of these strange shapes. Certainly this is suggested by the order placed in 1644 for porcelains "to be made fine, curious and neatly painted according to the samples from Holland handed over."[30] In another instance, however, three-dimensional models were supplemented by drawn patterns, the Dutch specifying in 1639 that two hundred flowerpots be made with two handles "like the drawing on the paper No. 11" and that small wine jugs be "Ribbed like the drawing on the paper No. 12."[31] From this period onward the use of models was an integral feature of the porcelain trade, examples being chosen not only from metalwork prototypes but from ceramics and glass as well. Two "great Possett Cups of Purselin" included in the 1641 inventory of the Countess of Arundel's household goods[32] may have derived from the English earthenware form of which an example dated as early as 1631 is known.[33] When the Daimyo of Hizen, in 1678, had "again a longing for mutton," he requested that it be served "in a Dutch porcelain [Delft pottery] dish, and with it a Dutch jug or flask with Spanish wine. It was fortunate that we still had available in the lumber warehouse 3–4 sample pieces formerly sent from Holland to have similar ones baked here, and so we could satisfy His Honour's whims."[34] Also included in this traffic in samples and models was Rhenish stoneware for which the Dutch had hoped, but failed, to find a market in Japan.[35] The constant introduction of new models into the porcelain trade—the taperstick, monteith, and Staffordshire-inspired plate (**46**)—is so conspicuous that the comment by John Latimer of Philadelphia, writing from Canton in 1815, that "To have china ware according to pattern as it respects shape it is necessary it should be engaged [at Canton] 12 months before wanted"[36] is quite surprising. Even in 1643, with their long-distance dealings between Batavia and China, the Dutch received porcelains on 29 October for which the models had been provided only five months earlier.[37] But Latimer was writing at a time when porcelain was no longer experi-

mental or scarce, and the American market, to which the China trade was by then reduced, had to be satisfied with a standard, limited repertoire of shapes.

Whatever porcelains were requested by the Europeans were ordered from Chinese merchants who commissioned their manufacture and, until the eighteenth century, their decoration, at Ching-te Chen. A thoroughly industrial town, with hundreds of private kilns in addition to those that produced Imperial porcelains exclusively, it was well known even to armchair travelers through many series of pictures depicting the stages of porcelain manufacture (Figures 2, 3). From the standpoint of communications alone, the apparent ease with which patterns and models were transmitted from Canton to Ching-te Chen, far to the north, and returned as porcelains is remarkable. But it may be remembered that the Chinese had been exporting porcelain to Asia and the Near East from as early as the ninth century, and that the Europeans encountered a well-organized system of transport and communication. Without such a system the so-called Manueline porcelains for the Portuguese market (**1, 2**) could hardly have been produced. Though we have no information concerning Portugal's specific commercial arrangements with the Chinese, it is apparent from the number of pieces dating before the official reopening of Sino-Portuguese trade in 1554[38] that Portugal enjoyed

FIGURE 2 Enamel-painted porcelains being brought to the muffle kilns for firing. Watercolor on paper, Chinese, early nineteenth century, 15⅛ × 19¼ in. Albums depicting the arts and manufactures of China were a popular export item at the turn of the eighteenth century. The Metropolitan Museum of Art, Winfield Foundation Gift Fund, 55.139.1

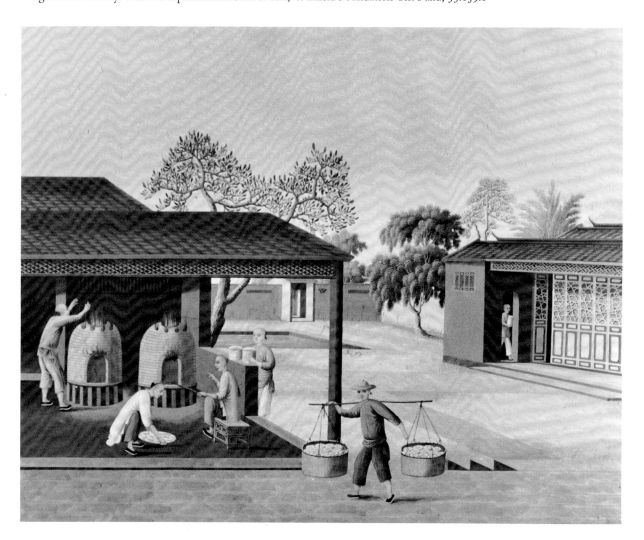

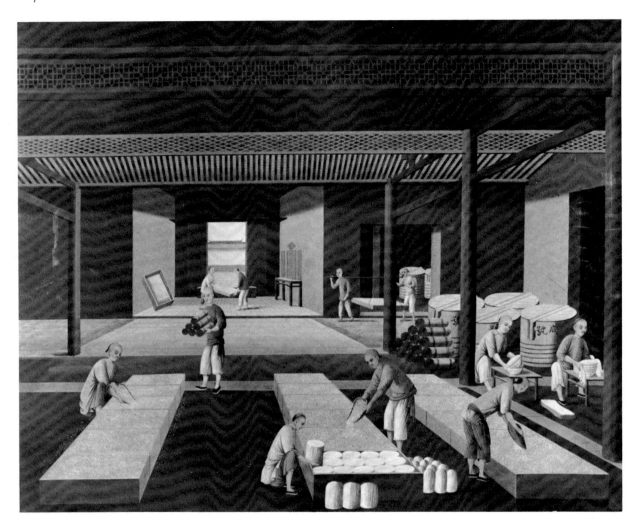

FIGURE 3 Porcelain being packed for shipment to the West. From the same series of illustrations as Figure 2. Watercolor on paper, Chinese, early nineteenth century, 15 × 19⅛ in. The cylindrical containers probably hold stacks of plates which were sometimes protected further by being placed in a handled bamboo carrier. They are being packed in sago, itself a major export in the China trade. The number of chests carried by each ship varied considerably; the *Prince George*, in 1755, carried 120 chests packed with some 74,000 porcelains. The Metropolitan Museum of Art, Winfield Foundation Gift Fund, 55.139.2

an unbroken access to the porcelain market, presumably through merchant-smugglers. In the following century, prior to the collapse of the Ming dynasty, the Dutch placed their orders at Zeelandia with Chinese merchants who shuttled between that Formosan port city and the mainland; subsequently, even after the Dutch acquired their own factory at Canton, the merchants came to Batavia. At Canton itself there were always several porcelain merchants to choose from. As members of a guild, or co-hong, which they formed in 1720, they were in a position to regulate the terms under which the Western-

ers might enter and reside at Canton, although they succeeded or failed as merchants individually. "Your Factory being free for every one to bring in his Goods," wrote a sailor on the *Stretham* in 1704, "you must expect to be visited by the greatest Sharpers in China."[39] Hezekial Pierrepont observed in 1796 that "for Common & Cheap Goods" Synchong was "not so suitable as some Other";[40] Sonyeck was described by Thomas Ward in 1809 as "rather slippery . . . active & industrious get not cyphered China of him," while Exching "does not pack so well, and China ware not generally so good, great breakage."[41]

(This was a difficulty that had plagued the Europeans all along: in placing their order for 1658 the Dutch stipulated "against breakage please add 10 more of each."[42]) In communicating with the Chinese the Europeans were helped by the Jesuits who, by introducing the European languages into China, made it frequently unnecessary to hire interpreters.[43] At the same time, the Jesuits were playing an even more important role in the China trade. Having gained the sympathetic interest of K'ang Hsi, they were in a position to introduce Western taste—by means of paintings, enamels, prints, and even the artists themselves—directly into influential court circles and so to lay a foundation for future technical and iconographic developments. As early as 1687 Jean de Fontaney, the Superior of Louis XIV's first Jesuit mission, wrote home from Peking requesting "peintures en émail" and "des ouvrages d'émail" for presentation to the mandarins;[44] in subsequent years the mandarins themselves purchased enameled objects off the Western ships at Canton and offered them to the emperor.[45] One of the first European painters to visit China, Giovanni Gherardini, arrived in 1698 on the *Amphitrite*, to be followed in later years by Matteo Ripa and Giuseppe Castiglione, both of whom became active at the Imperial court. And in his first letter of 1712, the same year in which the Jesuits presented K'ang Hsi with a collection of engravings,[46] Père d'Entrecolles reported the eagerness of the mandarins to receive from Europe "des desseins nouveaux & curieux" in order to show the emperor "quelque chose de singulier."[47] It may be taken for granted, as has been suggested,[48] that these enamels and prints were used as models by the Chinese and found their way into the repertoire of export porcelain quite as readily by way of the Imperial kilns as by way of East India Company traders. Indeed, the subtle, informal, and personal relationship between the emperor and the Jesuits is implicit in two major aspects of the porcelain trade: the development of painting in grisaille and of the famille rose palette. Père d'Entrecolles reported in 1722, in his second letter, that the Chinese had been experimenting with black-line painting but had so far been unable to discover a medium that did not fade out in firing.[49] The inspiration for such experimentation at this early date must have come from persuasion and engravings provided by the Jesuits. Mastery of the technique was achieved by 1730 when it was included by Hsien Min, then governor of Kiansi province, in his list of decorations used on Imperial porcelains, and it is in the decade immediately following that grisaille subjects are most evident on export porcelains (**29**).

In like manner the Jesuits were influential in the development of famille rose enamel painting, but their role in its application to porcelain was perhaps less direct than has been suggested.[50] It was certainly through them that the Chinese became familiar with late seventeenth-century Limoges enamel bowls, which they copied, and that the Chinese came to depend on European artists for technical expertise. The first of these was Brother Gravereau, whose arrival in China in 1719 was reported by the Jesuit Father de Mailla;[51] ten years later one of K'ang Hsi's sons applied to Fathers Rinaldo and Perroni for "a good enameller as this profession is very much and solely appreciated by the emperor, but such a person is required to be a master in this art, and must know how to properly bake the enamel, something which the Chinese do not know how to do."[52] In none of this, however, are color matters specified, and it must be remembered that rose pink was not in the Limoges palette. Rose pink was a feature of late seventeenth-century enameled watch cases (and watches were the single species of European art constantly in demand in China) and, even more pertinently, of south German tin-glazed earthenware. While one cannot so far demonstrate the use of the latter as models for the porcelain painters, it is possible that these newly colorful wares were introduced into China in the normal course of trade by the Dutch, who had long been trafficking in German pottery, with a view to their being copied in export porcelain. The first, and very tentative, appearances of famille rose coloring on China trade porcelain are on the Lambert service (**20**), which can be dated about 1721, and the Townshend-Harrison services of about 1723.[53] These services are contemporaneous with the experiments in enameling being made under the aegis of the Jesuits, but they may represent an independent development of the technique, specifically for porcelain, at Canton.

It is not certain when enamel painting was transferred to Canton. Apart from the intrusion of Western armorials, the decorative schemes and palettes of export porcelains remained essentially Chinese up to about 1730. Granting that, and the still rather specialized market for the porcelains—the identified armorial services of the period 1710–30 are conspicuously associated with East India Company personnel and political backers—it is probable that most of the early enameled wares were

completed at Ching-te Chen. The first wave of enameled export porcelains coincides with the establishment of the English factory at Canton in 1715, which stimulated a sluggish home market and attracted other East India companies to the city; a gradual shifting of the painting workshops to Canton and the adjacent Honan Island, to keep pace with a steadily increasing demand, may have begun then. It has been argued that the famille rose enameling of the Lambert and Townshend-Harrison services, which examination shows to have been fired after the other colors, must have been done at Ching-te Chen,[54] especially since underglaze blue is incorporated in the Townshend armorial. In that instance, and in others like the Craggs service (19), in which the pattern is carried out in a fully integrated combination of underglaze blue and overglaze enamels, such was undoubtedly the case. But it is observable that in several of the early enameled pieces the armorial and border decorations are independent in both composition and palette. The borders, being traditional in style, may well have been painted in the north as part of stock shipments, while the armorials were added to order in Canton. Such a division is implied in the Dutch provinces series (16), in which the underglaze blue of the rim contrasts sharply with the less controlled blue enamel of the central coat of arms; and in the Elwick service (22), which, judging from the way it is worn, lay in stock for some time before the enameled arms were added to it. The expansion of Canton into the center for the decoration of export porcelains may thus have occurred between about 1715 and 1730, by which time the trade was in full swing.

The influx of East India companies of several nationalities greatly increased the diversity of the porcelain trade. In addition to supplying patterns and models reflective of their own tastes, the supercargoes and sailors encountered those brought from other countries: out of this evolved the full iconographic complexity of the trade in which Canton served as a clearing house not only for an exchange of styles between East and West, but between segments of European culture itself.[55] Thus the well-known fruit basket of Meissen origin, representing two children clambering up a tree trunk, was duplicated for both the Danish and American markets;[56] repetitions of a Höchst pottery tureen are differentiated by Danish and Dutch armorials;[57] while among patterns, for example, the du Paquier-inspired *Laub- und Bandelwerk* border complemented English, Danish, and Iberian coats of arms.[58] However, the precise origins of many Western shapes, patterns, and pictorial subjects are obscured by their having been disseminated in the East by missionaries and merchants, long before the emergence of the porcelain trade at Canton. As early as 1580–83 eight volumes of Flemish engravings of Christian subjects were presented by the Jesuits to the emperor Akbar,[59] and European painting was much in demand at the Mughal court. Writing in 1618 to his employers, the directors of the East India Company, Sir Thomas Roe emphasized that "Pictures of all sortes, if good, [are] in constant request; Some large storie; Diana this yere gave great content."[60] The content was by no means limited to mere admiration: Roe observed that the Indians "imitate euery thing wee bring."[61] Mughal artists overpainted or recomposed Dutch and French landscape and genre scenes,[62] and Roe described in 1616 Jahangir's insistence on borrowing his [Roe's] portrait miniature of his wife so that the emperor's painters could "take copyes . . . and his wiues should weare them."[63] Familiarity with Western iconography increased with the commissions given by Europeans in the East. At Goa, the skill of the local ivory workers was turned to carving Christian statuettes; in Japan, the Jesuits provided models of ritual objects that were copied in metal and lacquer for their churches.[64] Patterns were exchanged beginning early in the seventeenth century. Jahangir himself sent designs for embroidery to be copied in England in 1618;[65] and from England came exemplars for armorials on an Indian lacquer ballot box of 1619, and on a Lahore carpet of 1631.[66] Textiles with European subjects were woven at Macao for the Portuguese,[67] and from 1662 the English East India Company was supplying patterns for Indian chintz.[68] Of three-dimensional models, mention has been made of the role of the Dutch in respect to porcelain, but there were other sources as well. The appearance of the wineglass in eighteenth-century porcelain and Cantonese enamel may ultimately derive from the Venetian glasses that were so acceptable as presents in India a century before. Yet another indication is the complaint of the English japanners, about 1698, that the East India Company merchants were spoiling their market by "sending over our English pattern and Models to India and bringing in such vast Quantities of Indian Lacquer'd Wares."[69] By 1700, then, there was a considerable range of sources on the spot from which to choose, and since most had been supplied precisely for their marketing value they were certain—in

whatever versions they came to hand—to have been as useful to the porcelain manufacturers and decorators as they had been to the makers of Indian chintzes and lacquerware.

Another aspect of the multiplicity of design sources is that demonstrated by the Europeans' habit of copying: copying designs, copying shapes, copying from each other, copying from the East, copying back and forth among materials. Examples in the present catalogue are the taperstick and monteith (**4, 15**); another is the pistol-handled urn popular with the European and American markets at the end of the eighteenth century: the China trade versions are as likely to have been copied from a Swedish pottery model produced at Marieberg in 1775 as from the black basalt prototype advertised by Josiah Wedgwood in 1770.[70] Patterns and borders were similarly treated. The *Laub- und Bandelwerk* border may have been introduced into the China trade by Austrian Jesuits, but it may also have come to Canton via Holland where it was adapted at the Delft factories (Figure 4). Engravings were a particularly fertile source for patternmongers, and in the art of what might be called original recomposition the English were unexcelled (**31**). Some of the pictorial subjects on China trade porcelain, although they may ultimately be traced to prints, must have reached Canton in intermediate forms. Allegorical and mythological subjects after Italian originals comprised the usual decoration of enameled watches that were exported to China in large numbers in the seventeenth and eighteenth centuries; such subjects were also part of the tradition of ceramic decoration, from Italian maiolica of the Renaissance to seventeenth-century faïence of Nevers and Moustiers, and ceramic models certainly figured in the trade. Biblical compositions, too, could have been known as much from textiles, English and Delft pottery, and ecclesiastical plate[71] as from any engravings that might have prompted their use.

A third factor in the traffic in models and designs is the personal one. This tends to elude documentation. Of the books, pictures, and personal possessions that, carried East as part of the paraphernalia of a captain or supercargo, came to figure in the porcelain trade, we have little evidence. But to some such impromptu origin the first Sino-Portuguese porcelains must owe their decoration; and even in the eighteenth century, with the wealth of published engravings and books of heraldry,[72] and a certain standardization of motifs, purchasers occasionally

FIGURE 4 Plate with Laub- und-Bandelwerk-type border. Delft, the Greek A factory, about 1720. Musées Royaux d'Art et d'Histoire, Brussels

turned to more informal resources. "The Arms of Leak Oakover Esqr . . . a Pattern for China plates Pattern to be returned" is perhaps the design for which Arthur Devis, the conversation painter, was paid £1.1s. about 1740,[73] while the blazoning and heraldic style of the Russell arms on a set of six vases ordered about 1753 was apparently copied from the family armorials above the fireplaces in the picture gallery at Woburn Abbey.[74] And if one had no coat of arms but wished, as did the Le Mesurier family of the Channel Islands, to order "a complete set of china with our Coat of Arms," it was a simple enough matter "to finish our Pedigree and send it to London to have our Arms entered at Heralds College so you will perhaps have them before you sail from Spithead."[75]

In measuring these few examples against the total volume of the porcelain trade to Europe in the eighteenth century—at least sixty million pieces—it is at once apparent that they could be multiplied hundreds of times and still only begin to define the whimsicalities, complexities, and harmonies of the China trade.

NOTES

1 Morse, I, p. 178.

2 The usual order of loading was to put porcelain at the bottom, followed by Bohea, then fine teas, with raw silks on top (ibid., V, p. 157). Two Ostend Company ships sailed for home in 1723 with a cargo of tea, quicksilver, and silks "besides China-ware for their Kintlege" (ibid., I, p. 177), and even as late as 1771 porcelain was no more than ballast to the commander of the *British King*, who ordered only as much as he needed to floor his ship (ibid., V, p. 158).

3 Taking the 120 chests (about 108, 400 pieces) on the *Prince George* in 1755 as an average English Company shipment, it can be seen that the private trade could be substantial: one supercargo in 1756 brought back 156 chests of porcelain on his own account; in 1768 the private trade in porcelain on two ships comprised 100 and 120 chests. Comparable quantities are recorded throughout the eighteenth century for the English ships (Morse, I, II, V, passim).

4 *Connoisseur*, April 1956, p. 120.

5 For the events that led up to the opening of Canton, see T'ien-Tsê Chang, *Sino-Portuguese Trade from 1514 to 1644*, Leiden, 1934; and G. F. Hudson, *Europe & China*, London, 1931, chap. 6.

6 V. von Klarwill, ed., *The Fugger News-Letters*, 2nd series, trans. L. S. R. Byrne, New York, 1926, p. 325.

7 Ibid., pp. 328, 333.

8 Volker, *Porcelain*, p. 22. Among the buyers were James I of England and Henri IV of France, the latter acquiring a dinner service "of the very best quality."

9 Ibid., p. 42.

10 Ibid., p. 137.

11 Bombay, which came into English possession in 1661 as part of Catherine of Braganza's dowry, was turned over by the Crown to the East India Company seven years later.

12 For the account of the Ostend Company, Conrad Gill, *Merchants and Mariners of the 18th Century*, London, 1961, pp. 15 ff.

13 Whereas the Danish trade, at least, extended south. Based on contemporary accounts, 77 percent of the porcelain brought into Denmark from 1734 to 1752, and 81 percent from 1753 to 1770, was re-exported, probably to Germany, which was readily accessible on the Baltic and which had no significant East India trade of her own (Bredo L. Grandjean, *Dansk Ostindisk Porcelaen*, Copenhagen, 1965, p. 11).

14 By taking the average weight, 550 grams, of five typical carrack pieces—a large dish, plate, large bowl, small bowl, and cup—Volker arrived at the total weight of 30 lasts or 100,000 porcelains on board the *Catharina* (*Porcelain*, p. 22, n. 8). The 120 chests carried by the *Prince George* in 1755 contained approximately 108,400 pieces; one lot of 26 chests comprised 10,236 single plates, 200 table sets, 4188 half-pint basins and 742 coffee cups (Morse, I, pp. 34–35).

15 Daniel Defoe, *A Tour Through the Whole Island of Great Britain (1724–1726)*, New York, 1962, I, pp. 175, 166.

16 G. S. Thomson, *Life in a Noble Household: 1641–1700*, New York, 1937, p. 170.

17 "The large quantities we have taken . . . had been by force and not choice," wrote the president of the English Council in 1703, and the next year the supercargoes explained apologetically that "The Earthenware [porcelain] was mostly purchased in truck for Cloth, which they found unexpressable difficultys to get quit of at any rates" (Morse, I, pp. 121, 144).

18 Made for Sir Henry Johnson (d. 1719), a shipbuilder, and his wife, Martha Lovelace, some time between their marriage (1692) and her succession five years later to the Barony of Wentworth (James Tudor-Craig, "The Value of a Coat of Arms," *Connoisseur*, June 1959, p. 21).

19 James Tudor-Craig, "The Armorial Services of the Pitt Family," *Connoisseur*, January 1959, p. 246, fig. 2.

20 T. Baker, *The Fine Lady's Airs*, London, 1709, quoted by E. F. Carritt in *A Calendar of British Taste*, London [1949], p. 149.

21 G. S. Thomson, *The Russells in Bloomsbury: 1669–1771*, London, 1940, pp. 335–336. London's first porcelain shop opened in 1609 (B. Sprague Allen, *Tides in English Taste (1619–1800)*, Cambridge, Massachusetts, 1937, I, p. 193), but there seem to have been few others until the following century. Over 100 china merchants were active in London between 1711 and 1774 (A. J. Toppin, "The China Trade and Some London Chinamen," *Transactions of the English Ceramic Circle*, 1935, p. 46).

22 Morse, I, p. 158.

23 R. Picard, J. P. Kerneis, and Y. Bruneau, *Les Compagnies des Indes* [Grenoble], 1966, p. 113.

24 Ibid., p. 132.

25 Ibid., p. 137. Christian IV chartered the first company in 1616, and small quantities of porcelain were imported via India during the century. Although the porcelain trade to Denmark ended in 1823, the third East India Company survived another sixteen years.

26 Stig Roth, *Chinese Porcelain Imported by the Swedish East India Company*, Göteborg, 1965, p. 10.

27 Volker, *Porcelain*, p. 27.

28 Ibid., p. 37.

29 Ibid., pp. 43, 48.

30 Ibid., p. 50.

31 Ibid., p. 43.

32 Lionel Cust, "Notes on the Collections Formed by Thomas Howard, Earl of Arundel and Surrey, K.G.—IV," *The Burlington Magazine*, March 1912, p. 341.

33 Bernard Rackham, *Catalogue of the Glaisher Collection of Pottery & Porcelain in the Fitzwilliam Museum*, Cambridge, 1935, no. 1294, pl. 81b. As Rackham points out, the Oriental decoration was due to importation of Chinese porcelain into England from Holland.

34 Volker, *Porcelain*, p. 165.

35 Ibid., p. 124, n. 12.

36 Mudge, p. 56.

37 Volker, *Porcelain*, pp. 48–49.

38 Three bowls dated 1541 and inscribed with the name of Pero da Faria, governor of Malacca 1539–42; two bottles dated 1552 and inscribed with the name of Jorge Alvares; a bottle dated 1557.

39 Morse, I, p. 105.

40 Mudge, p. 35.

41 Ibid., loc. cit.

42 Volker, *Porcelain*, p. 129.

43 Gill, *Merchants and Mariners*, p. 31.

44 George Loehr, "Missionary-Artists at the Manchu Court," *Transactions of the Oriental Ceramic Society*, 1963, p. 52, n. 2.

45 Ibid., p. 56.

46 Ibid., p. 54.

47 S. W. Bushell, *Description of Chinese Pottery and Porcelain*, Oxford, 1910, p. 204.

48 Loehr, "Missionary-Artists," p. 56.

49 "On a essayé de peindre en noir quelques vases de porcelaine avec l'ancre [sic] la plus fine de la Chine: mais cette tentative n'a eu aucun succès. Quand la porcelaine a été cuite, elle s'est trouvée très-blanche" (Bushell, *Description of Chinese Pottery*, p. 222).

50 The problem has been considered by Sir Harry Garner, "The Origins of Famille Rose," *Transactions of the Oriental Ceramic Society*, 1967–69, pp. 1–16.

51 Margaret Jourdain and R. Soame Jenyns, *Chinese Export Art in the Eighteenth Century*, London, 1950, p. 67.

52 Garner, "Origins of Famille Rose," p. 5.

53 Phillips, pl. 1.

54 Garner, "Origins of Famille Rose," p. 11.

55 Attempting in 1789 to match a porcelain pattern entrusted to him by a Philadelphia friend, Captain John Barry found that the first China merchant he asked "had two or three dozen Plates of the same Kind" (Mudge, p. 36).

56 Grandjean, *Dansk Ostindisk Porcelaen*, fig. 56; Mudge, fig. 42.

57 Scheurleer, *Chine de Commande*, fig. 148 (van Renswoude); Grandjean, *Dansk Ostindisk Porcelaen*, fig. 88 (Moltke and von Buchwaldt).

58 Christie's, 1 April 1968, lot 78 (Saunders), 19 May 1969, lot 77 (unidentified but certainly Spanish or Portuguese), 24 November 1969, lot 63 (Rait or Rhet); Grandjean, *Dansk Ostindisk Porcelaen*, figs. 49, 50 (service made for Queen Maria Juliana).

59 British Museum, *Prince Henry the Navigator and Portuguese Maritime Enterprise*, exhibition catalogue, London, 1960, p. 76.

60 Letter of 14 February in *The Embassy of Sir Thomas Roe to the Court of the Great Mogul: 1615–1619*, ed. William Foster, London, 1894, II, p. 488.

61 Ibid., p. 478.

62 British Museum, *Prince Henry the Navigator*, nos. 137, 138, 141, 142.

63 Diary, 2 September in *Embassy of Sir Thomas Roe*, I, p. 255.

64 Martha Boyer, *Japanese Export Lacquers from the Seventeenth Century in the National Museum of Denmark*, Copenhagen, 1959, pp. 62, 65.

65 *Embassy of Sir Thomas Roe*, II, p. 486.

66 Vilhelm Slomann, "The Indian Period of European Furniture—I," *The Burlington Magazine*, September 1934, pp. 112–126; "The Indian Period of European Furniture—III," November 1934, pp. 201–214.

67 E.g., a set of Sino-Portuguese embroideries of 1600–50 depicting classical subjects, two owned by the Metropolitan Museum of Art (50.97.2 and 51.152).

68 John Irwin and Katharine B. Brett, *Origins of Chintz*, London, 1970, p. 4.

69 Slomann, "Indian Period—I," p. 119.

70 For China trade and Marieberg examples see Phillips, fig. 53 and pl. 74, and Grandjean, *Dansk Ostindisk Porcelaen*, fig. 126. For Wedgwood's version, included in his Shape Book of 1770, see Wolf Mankowitz, *Wedgwood*, London, 1953, fig. 49.

71 For example, a Flemish silver pyx of the late seventeenth or early eighteenth century, in the Victoria and Albert Museum (535-1893), is engraved with a version of the Crucifixion that is essentially the same as that seen on some early blue-and-white export porcelains.

72 It was observed in 1811–12 by an English traveler that the Cantonese engravers of China trade silver had "books of heraldry, which they consult and copy with great exactness," and the enamelers undoubtedly had the same sources available to them (J. D. Kernan, "China Trade Silver," *Connoisseur*, November 1965, p. 198).

73 Arthur Oswald, "Okeover Hall, Staffordshire—II," *Country Life*, 30 January 1964, p. 228. The Okeover-Nicoll service was delivered in two shipments, 1740 and 1743.

74 Thomson, *The Russells in Bloomsbury*, p. 337.

75 Letters from John Le Mesurier, Governor of Alderney, to his son, Captain Frederick Le Mesurier, 16 and 28 December 1779. H. H. P. Le Mesurier, "Notes on the Armorial China of Some of the Guernsey Families," *La Société Guernesiaise*, XII, 1935, pp. 296–297.

I Jug

Portuguese market, probably 1517–21
H. 7⅜ in.
Accession 61.196
Ex. coll. D. M. Hubrecht
Mark on base: the Hsüan tê *nien hao* (four characters)
Arms: five escutcheons in cross, on each as many plates in saltire, all within a bordure charged with seven castles. *Portugal*[1]

Pyriform, on low foot, with flared hexagonal mouth. Of the handle, only the terminal, modeled as a fish tail, survives. Decoration in underglaze blue. On two sides of body, the royal Portuguese arms, painted upside down. Around the narrow lip, a meander.

For comment, see **2**.

NOTE

1 The tinctures, obviously, are not indicated in this blue-and-white version. Properly blazoned, the field is argent, the escutcheons azure, the bordure gules, the castles or.

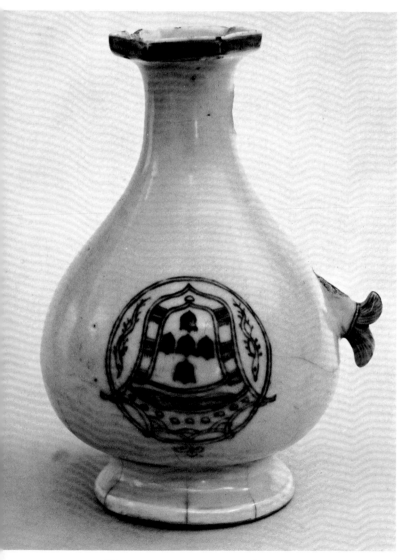

2 Dish

Portuguese market, mid-16th century
D. 20¾ in.
Accession 67.4
Arms: *Portugal*

Decoration in underglaze blue. Center filled with pattern of Buddhist lions with brocade balls amid wave scrolls, encircled by border of alternating trefoils. On the shallow sloping rim, seven medallions, two with the Sacred Monogram within a crown of thorns, one with the royal Portuguese arms, one with an armillary, and three enclosing a bird beside a rock and flowering branch. Rim edged

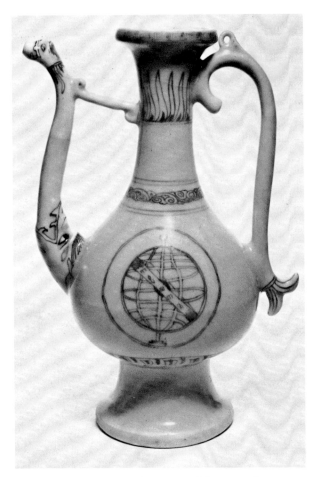

FIGURE 5 Chinese porcelain ewer of the Manueline group, Portuguese market, Hsüan Tê mark (1426–35) but Chêng-Tê period (1506–21). Courtesy Sotheby & Co.

with a lozenge diaper. Exterior, an allover pattern of peonies. Foot rim and base unglazed.

With eight related pieces,¹ **1** and **2** mark the transition from Chinese porcelain made and decorated in an essentially Oriental style to that made for the Western buyer. This transition was effected by the Portuguese. In 1517 Manoel I (1469–95–1521) sent an embassy to Peking. Tomé Pires, his envoy, arrived at Canton in a ship commanded by Fernão Andrade. While Pires was on his northward land journey, Andrade, based on the island of T'un Men, obtained the use of a warehouse on the mainland for the sale or exchange of his merchandise. Taking advantage of this concession, "Fernão Peres sent other men on shore to make their way secretly into various sections of the city and to report what they saw."²

Andrade remained at Canton about a year, returning to Malacca late in 1518. In August of the next year his brother Simão led a second expedition to Canton but by his arrogance disrupted the friendly relations established by Fernão, causing the Chinese to dismiss Tomé Pires and forbid further trade with Portugal. In 1521, with the death of Emperor Chêng Tê, the trade ban was reaffirmed. Two attempts by the Portuguese to break the ban by force failed, and in October 1522 they retreated to Malacca. Although the port of Canton was reopened to Europeans in 1530 it was not until 1554 that the Portuguese were allowed to return, and their trading relations with China did not again become effective until the settlement of Macao three years later.

There is thus an early period of four years, from 1517 to 1521, during which the Portuguese could have, and very probably did, purchase Chinese porcelain.³ Further, it is reasonable to suppose that the initial success of the Sino-Portuguese contact in 1517 would have led to its commemoration in objects of porcelain. The difficulty that now arises is that of determining the relationship of the ten so-called Manueline porcelains to the historical picture and to one another. **1** is closely related in shape to the other, more developed, ewers of the group (Figure 5), and their style accords well with the simplicity and careful painting of the bowl in the Almeida Collection. Three of the pieces—**1**, one of the ewers, and the bowl—are marked to the period of Emperor Hsüan Tê (1426–35), in keeping with the Chinese practice of identifying porcelains with an earlier, classic reign.⁴ **2** and the other two large dishes are of somewhat coarser porcelain than the rest, and are more richly decorated. All ten pieces display one or more symbols of Portugal's presence in China: an armillary, the royal Portuguese arms (painted upside down in all cases), or the Sacred Monogram. The armillary is of especial importance in fixing a chronology for the group.

In keeping with chivalric tradition, Manoel I employed, in addition to the royal arms, a personal device, an armillary (Figure 6).⁵ The device had been chosen for him by his uncle and predecessor on the throne, João II. Inasmuch as it symbolized the extent to which the explorations of Henry the Navigator had brought the non-Christian world under Portuguese authority, João was in effect committing Manoel to continue the program of expansion. The armillary was widely reproduced on Manueline maps and title pages, the ecliptic being in-

scribed either with the initial letters of the names of six of the zodiacal constellations or with the signs of the remaining six (Figure 7). It is in the latter version, the signs being drawn in varying degrees of inaccurate disorder, that the armillary appears on the Manueline porcelains; they may thus be presumed to have been painted to order before Manoel's death, that is, between 1517 and 1521. However, a dated bowl in the Topkapu Saray, Istanbul,[6] puts this in doubt: on the exterior it has the armillary and Portuguese arms; inside the rim is the date 1541 and an inscription associating the bowl with the Portuguese nobleman Pero da Faria (d. 1546), Captain of Malacca from 1537 to 1543. The Topkapu bowl is in turn related to two others, in the Beja and Naples museums, bearing the same inscription and date but entirely different decoration.[7] If we accept the date as 1541—and there seems no reason not to (the numerals, written without understanding, are difficult to read, but the 4 is unmistakable)—it is clear that the use of the armillary did not cease with Manoel's death as has been supposed. Since there was no official trade between the Portuguese and Chinese from 1521 to 1557, the Pero da Faria bowls must

FIGURE 6 Armillary, late fifteenth century. Courtesy U.S. National Park Service

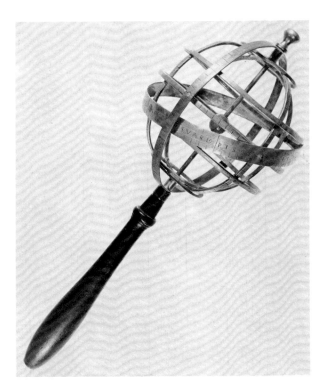

have been among the porcelains acquired through illicit contacts at such northern coastal towns as Ningpo;[8] Manoel's armillary, which could have had no meaning to the Chinese painters, was presumably included at random from their small stock of decorations associated with Portuguese customers. In this context, I suggest that the three large Manueline dishes, which were certainly made at the same time, comprise a group of their own. Of coarse body, not particularly well painted, and showing the Western symbols irregularly (the armillary appears

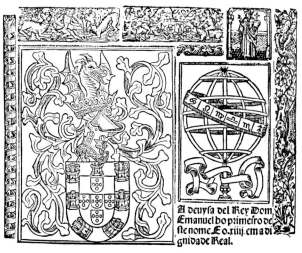

FIGURE 7 Title page of Book I of the *Ordenações d'El-Rei D. Manuel*, Lisbon, 1512, showing arms and armillary of Manoel I of Portugal

only on **2**), they hardly look like suitable pieces for presentation to a king.[9] Stylistically—especially with their recessed, unglazed bases and their exuberant flower scrolls—the dishes seem to correspond more closely to a group of porcelains in the Topkapu Saray described as provincial, with affinities to Ching-te Chen wares. The earliest of this type are thought to date to 1500 or shortly before, and Jenyns speculates that the style may have persisted well into the sixteenth century.[10] It thus seems possible to consider **2** and its companion dishes as relics of an ad hoc Sino-Portuguese trade carried on between Malacca or Goa and Ningpo during the undocumented period 1522–57.

The seven other Manueline porcelains are more difficult to place. They are conspicuously homogeneous, and Jenyns doubts there is much difference in date between the Almeida bowl with its armillary and royal arms and

the 1541 Pero da Faria bowl in Istanbul.[11] On the other hand, both bowls correspond closely in the manner and motifs of their decoration with two other bowls in the Topkapu Saray that bear the Chêng Tê mark and are believed to have been presented in 1521 by the Chinese emperor to Selim I of Persia.[12] Nor is there anything in the decoration of the two ewers and **1** that is inconsonant with the Chêng Tê period.[13] For the time being, it seems legitimate to assume that the Manueline porcelains, excluding the three large dishes, fall within the period of first direct commercial contact between China and the West, beginning in 1517.

NOTES

1 Three dishes (Sotheby & Co., 30 June 1964, lots 43, 44, and 7 February 1967, lot 93); a ewer (Sotheby & Co., 7 February 1967, lot 94) (Figure 5); an almost identical ewer in the José Cortès collection, Lisbon; a bowl (Sotheby & Co., 20 June 1961, lot 25, now in the Almeida collection); two large dishes virtually identical with **2** (Sotheby & Co., 14 November 1967, lot 98, and Princessehof, Leeuwarden).

2 T'ien-Tsê Chang, *Sino-Portuguese Trade from 1514 to 1644*, Leiden, 1934, p. 44.

3 That porcelain was on the minds of the Portuguese from the beginning is clear. Manoel had specifically instructed his viceroys in India, Francisco de Almeida (1505–09) and Affonso de Albuquerque (1509–15), to send Chinese porcelains back to Lisbon (J. M. Braga, *Chinese Landfall, 1513*, Macao, 1955, p. 13). And included in the inventory taken after Manoel's death were "Four articles of white Chinese porcelain contained in woven baskets" (ibid., p. 13, n. 16). The Portuguese Captain of Malacca reported to Manoel that the merchandise carried by the first Chinese junks to trade there included "all kinds of satins and damasks and porcelains" which they sold "in great quantities" (ibid., p. 24). Although Chang (*Sino-Portuguese Trade*, p. 62) emphasizes that no records survive relating to the goods brought or sent home by the first Portuguese in China, he declares that porcelains figured in the shipments.

4 Edgar Bluett, "The Nien Hao and Period Identification," *Transactions of the Oriental Ceramic Society*, 1935–36, pp. 51–63. As noted, **1** is marked with four-character Hsüan Tê *nien hao*, that is, with the characters indicating the reign title and period made. The full six-character mark, which begins with the name of the dynasty, appears on the Almeida bowl.

5 An instrument for determining planetary and geographical positions, the armillary sphere is a representation of the sky that allows spatial relations to be defined either in terms of the ecliptic or in terms of the equator.

6 Soame Jenyns, "The Chinese Porcelains in the Topkapu Saray, Istanbul," *Transactions of the Oriental Ceramic Society*, 1964–66, pp. 61–62, pl. 54b.

7 Luis Keil, "Porcelanas Chinesas do século XVI com inscrições em Português," *Boletim da Academia Nacional de Belas-Artes*, X, 1942, ills. opp. pp. 22, 23.

8 A number of other porcelains dating to this period confirm that the official severance of trade relations had no lasting effect. Bottles inscribed with the name of Jorge Alvares and the date 1552 are in the Walters Art Gallery, the Victoria and Albert Museum, the Caramulu Museum, Portugal, and the Ardebil collection. A ewer with the Peixoto (?) arms, dating about 1542, and a bottle inscribed and dated 1557 are both in the Victoria and Albert.

9 John Pope theorizes ("The Princessehof Museum in Leeuwarden," *Archives of the Chinese Art Society of America*, 1951, p. 37, n. 11) that the royal arms on the large dish in Leeuwarden are flanked by the letters SR (or L), for a later king, Sebastian. He says the letters—of which the second is to be read either as R for Rex or L for Lisbon—are found on coins of Sebastian's reign, and he points out the coincidence of Sebastian's accession and the settlement of Macao in 1557, suggesting that the dishes were made at or shortly after these events when new coins would have been in circulation. This seems overingenious: the painted squiggles hardly differ from those in the other Manueline armorials, and they are surely intended merely to depict either the dragon supporters or the mantling that normally accompanied the shield (Figure 7).

10 Jenyns, "Chinese Porcelains in the Topkapu Saray," p. 60, pls. 52, 53.

11 Ibid., p. 62.

12 Ibid., p. 48, pl. 37.

13 Pope has suggested orally, however, that the hexagonal lip of **1** and the ewers implies a more developed, and thus later, export taste.

3 Jar

English (?) market, 1690–1700
H. 8¹¹⁄₁₆ in.
Accession 1970.218
Mark on base: an artemisia leaf

Decoration in underglaze blue. The Crucifixion on opposite sides separated by scrolled flowering branches that spring from the knoll at the base of each cross. Shoulder encircled by a band of *ju-i* scepter heads, rim by a band of flowers and birds.

The spareness and formality of the floral decoration, together with its stylistic mannerisms, bring to mind the technique of embroidery with its satin stitches, laid and couched threads, spangles, and French knots. All are in evidence here, in the solid and lightly lined flowers and leaves, in the heavier striping of the stems, and in the dotted spirals. Perhaps even a trace of the pattern can be recognized in a leaf (seen at the far lower right in the illustration) left blank within its outline of dots like the holes made by stitches that have worn away. Particularly close, in the choice of motifs and the technique, are pillow and book covers made in England in the mid-seventeenth century, in which the sheen of the white satin ground favored by the embroiderer sets off the pattern much as does the glossy white of the porcelain (Figure 8). Common in Stuart needlework, too, are friezes of conventionalized flowers and birds analogous to that on the neck of **3**. Many of the book covers, despite their cheerful decorativeness, were made for books of prayers or the Bible, and some such source of design may have been at hand in this instance.

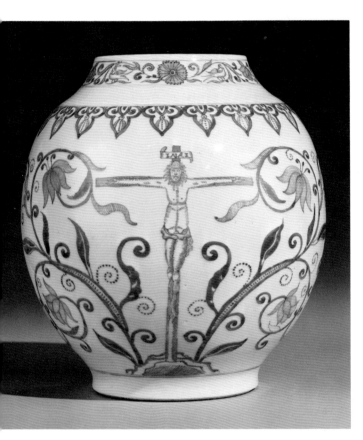

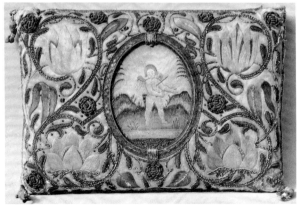

FIGURE 8 Pillow, embroidery on white satin. English, mid-seventeenth century. The Metropolitan Museum of Art, Rogers Fund, 29.23.3

17

4 Taperstick

Dutch or English market, 1690–1700
H. 5¼ in.
Accession 1970.266.3

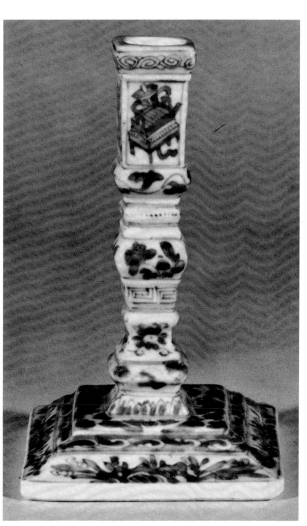

Decoration in underglaze blue. On the socket, emblems from the *po ku* (Hundred Antiques); on the shaft, bands of flowering vines separated by meander, cloud scroll, and lotus-petal borders. On the square, stepped base, flowers, birds, and rockery. The flat underside is unglazed.

As early as 1639 the VOC ordered two hundred large candlesticks to be made "in conformity with the wooden models received from the Directors in Holland," half to be made "according to sample and the other half plain, everything made nicely thin and well-painted according to No. 3 sample."[1] Another order for candlesticks, also based on Dutch models, was placed in 1644,[2] and it was perhaps these China trade exemplars that stimulated the production at the Delft factories by about 1660 of blue and white faïence versions painted in the Chinese style.[3] There was thus by the end of the century a multiplicity of "originals" in wood, Delft earthenware, silver, and presumably brass and pewter as well. With its numerous moldings and curves, **4** would seem to derive from a silver model; stylistic analogies are evident in English examples of the 1690s, when the squared columnar form began to loosen up. This piece can thus have been made directly from an English silver prototype, or indirectly by way of a Delft copy of an English (or possibly Dutch) silver example, or even more indirectly from a wooden model of a Delft copy of a silver original.[4]

NOTES

1 Volker, *Porcelain*, p. 43.

2 Ibid., p. 50.

3 For two cylindrical tapersticks from the De Dissel factory, about 1660: C. H. de Jonge, *Delft Ceramics*, New York, 1970, pl. VII.

4 Another example of the same model but with different decoration is in the Victoria and Albert Museum (550–1897).

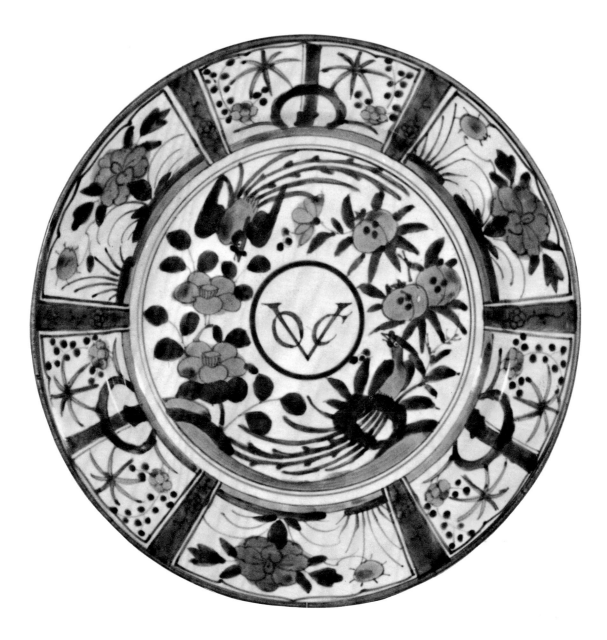

5 Dish

Japanese manufacture for Dutch market, late 17th century
D. 14¼ in.
Accession 68.86

Decoration in dark and medium underglaze blue. In the
center, the monogram VOC (Vereenigde Oostindische
Compagnie) in a ring, surrounded by cranes and flowers.
The wide sloping rim is divided into six panels of two
patterns alternating, one of peony, the other of bamboo
and prunus. Exterior undecorated.

To explain Japan's sudden importance to the porcelain trade in the mid-seventeenth century, some account of the situation in China is necessary. The transition from the Ming to the Manchu dynasty was not peaceful. Effective resistance to the Manchu invasion of the south was organized by Coxinga (p. 2) who, operating from his kingdom of Formosa held Canton and parts of the Fukien coast, blocking direct Dutch access to the mainland. Although the Manchus gained official control of Canton in 1653, civil war continued until K'ang Hsi came to the throne thirty years later.

The effect on the porcelain trade of "this cancerous war"[1] was to bring it to a halt. As long as the Dutch had access to the ports of Formosa and Amoy they could buy porcelain from the Chinese who brought it there, but after 1646 these shipments, affected by the mainland disturbances, were infrequent. They were cut off entirely in 1657 when Coxinga refused to permit Chinese junks to touch on Formosa. The destruction of the kilns at Ching-te Chen sometime between 1673 and 1681 was the final blow to the Ming porcelain trade; not until the accession of K'ang Hsi and the revival of the kilns under Imperial control in 1683 did Chinese porcelain again become available to the West.

Meanwhile, frustrated in its attempt to establish a factory at Canton, and unable to satisfy the demand for Chinese porcelain at home, the VOC turned to Japan. It was in an excellent position to do so, having been granted exclusive trading rights by the Japanese in 1641. In June of that year the Company moved its factory, which it had established in 1609, from Hirado to the artificial island of Deshima off Nagasaki. For the first forty years of Dutch-Japanese relations Hirado and Deshima were simply receiving points for Chinese porcelain. The Japanese had been introduced to it as early as 1583,[2] and, lacking an industry of their own, had since been importing it. In 1650, when porcelain paint was imported by the VOC from China,[3] commercial manufacture of Japanese porcelain began. The industry was centered in the province of Hizen (now the Saga prefecture) (map). The kilns (there are thought to have been 155 operating about 1647) were located between Arita and Nagasaki; fragments decorated en suite with 5 have recently been excavated at the Sarugawa kiln south of Arita.[4] The first export of Japanese porcelain comprised 2200 gallipots, ordered for the VOC's apothecary shop at Batavia in 1653.[5] However, this may have been only a sample order, with the first true commercial export occurring in 1658 when seven junks laden with coarse porcelains sailed for Amoy.[6] Beginning the following year orders and/or shipments for Holland are cited in the Deshima registers annually until 1682.

The development of the Japanese porcelain industry, and of the Dutch market for it, was rapid. Writing of the 1659 season, in which the first substantial lot of export wares was ordered by the VOC, a contemporary observer, A. Montanus declared that

> The Japanese have since a few years taken to the baking of porcelain more seriously than before and so not only the Dutch, but also the Chinese themselves take much Japanese porcelain. . . . Every year the Japanese continuously grow in the art of bettering their porcelain.[7]

And three years later officials in Batavia remarked on the increased demand in Holland for Japanese porcelain, not-

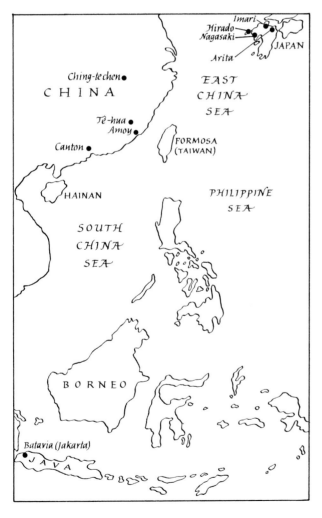

ing "with surprise" that it "was sold so dear in [Amsterdam] and has given extraordinary profits."[8] But with all this enthusiasm the volume of trade remained quite small, fewer than 200,000 pieces reaching Europe between 1659 and 1682 as compared with the three million imported from China between 1604 and 1657. The chief obstacle to the enlargement of the trade was the high prices the Japanese put on their goods, often to the point where the VOC refused to buy.[9] Further difficulties arose from the inability of the Japanese potters to meet Dutch demands regarding style and quality. As with the Chinese, the VOC frequently ordered porcelains to be made from models of European shapes,[10] while their general decoration was to reflect the Dutch satisfaction with Ming prototypes. In 1662 Batavia requested that "the dishes [be] made flat and with such flower-work as the old Chinese porcelain used to have,"[11] and even nine years later the

Dutch were still demanding porcelains "made in the Chinese manner."[12] For the most part this meant the style of blue-and-white ware represented by **5**. With its central medallion and compartment rim, it follows closely the type of Ming carrack ware so much admired in Holland.

The published VOC records do not enable us to single out a particular order that included **5**; dishes and plates comprised a substantial part of each season's trade, and numerous examples of this pattern are known.[13] It may be supposed that quantities of these dishes for the use of the company's overseas staff from Batavia to the Cape were ordered on separate occasions, as there are said to be examples with variant rim patterns.[14] The monogram on **5** is in the form adopted by the VOC on 28 February 1603 and thereafter generally used in place of the company arms.[15]

NOTES

1 Volker, *Porcelain*, p. 55.

2 Ibid., p. 117.

3 Ibid., p. 124.

4 Jenyns, *Japanese Porcelain*, p. 61.

5 Volker, *Porcelain*, p. 125.

6 Ibid., p. 128.

7 Ibid., p. 133.

8 Ibid., p. 145.

9 As the company's profit margin in 1671 was 145 percent, its attitude may seem rapacious. However, it considered a 100 percent profit only reasonable in relation to the uncertainties of the trade (ibid., p. 173).

10 The Amsterdam Chamber of the VOC suggested in 1661 that wood or pottery models be made, and samples were received at Batavia the following year (ibid., pp. 141, 143, 145).

Wood models for porcelain flasks are mentioned again in 1673 (ibid., p. 161), and Delft pottery ones in 1678 (ibid., p. 165).

11 Ibid., p. 143.

12 Ibid., p. 158.

13 Others are in the Victoria and Albert Museum; the Gemeentemuseum, The Hague; the Princessehof, Leeuwarden; the Leiden National Museum of Ethnology. A pair was sold at Sotheby & Co., on 11 April 1961, lot 33; a third was on the art market in 1957. Plates like these are well known in South Africa where they were in general use by VOC personnel stationed in Capetown.

14 Naotsugu Nabeshima et al., *Old Imari*, Tokyo, 1958, p. 210.

15 J. P. Lewis, *Notes and Queries*, 9th series, IX, February 1902, p. 118. For a later use of both the arms and monogram see **43**.

6 Mug

Tê-hua (Fukien province), for English or Continental market, about 1690–1700
H. 4½ in.
Accession 1970.266.2

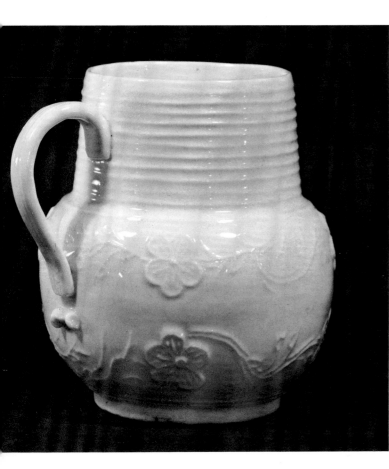

Entirely covered with smooth cream white glaze. Rotund body encircled by two continuous raised flowering vines. Wide cylindrical neck ribbed horizontally. Flat handle terminates in a small scroll.

In shape a replica of a stoneware model made by the London potter John Dwight (?–1703) at Fulham. One version by Dwight, in white stoneware, is fitted with a silver rim dated 1682.[1] On another silver-mounted example, also white, can be seen the same unusual treatment of the handle, its rolled end appearing to be separated from the rest by a narrow space (Figure 9).

Dwight's work was based primarily on the "stoneware vulgarly called Cologne Ware,"[2] which he set out to imitate in 1673. In form and color his pottery recalls examples of sixteenth-century Rhenish, especially Siegburg, stoneware; the idea of using raised masks and figures, as Dwight occasionally did, would also have come from Germany. Quite as well known, however, were the all-white porcelains with raised decoration made at Tê-hua,[3] in Fukien province, and it would be hard to disentangle the influences assimilated in **6**. The stylistic similarities between the Siegburg and Fukien wares, although developed apparently independently, were certainly reinforced by trade relations. The Western merchants discovered the usefulness of this additional source of porcelain during the mid-seventeenth century when the supply from Ching-te Chen began to dry up (p. 2). Thirteen hundred large barrels of porcelain brought to Formosa in 1645 for export were probably of Tê-hua manufacture;[4] if so, over a quarter of a million pieces were dispersed on the Continent by the middle of the century. Reciprocally, the VOC tried for a while to create a market in the Far East for Dutch and German pottery,[5] and a blue-and-white Chinese tankard of German form with silver mounts dated 1642[6] attests to some exchange; while in 1658 the Japanese emperor ordered 120 cups and 60 round small mugs "to be modelled and baked of Cologne or Sijburghse fine earth."[7] By the

FIGURE 9 Salt-glaze stoneware mug with silver rim by John Dwight. English, 1682 (date on rim). Courtesy Trustees of the British Museum, London

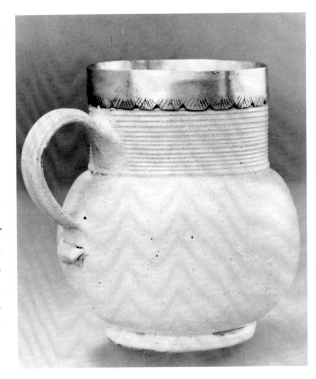

1680s Tê-hua porcelain was well known in Europe, and Dwight would have been able to draw on its traditions directly. Its acceptability in the West was largely due to its unadorned whiteness that allowed of locally added painted decoration. Several examples of this mug are known, variously enriched in Europe with Dutch polychrome painting[8] or Saxon raised gilding (Figure 10). **6** is somewhat atypical in the absence of the band of pointed leaves usually found on the shoulder and/or base of these mugs, and in the style of the bands of plum blossom in thread outline. While rosettes similar to this floral ornament were among the metal stamps used at Fulham for raised work,[9] these are more Fukienese in character.

NOTES

1 Mavis Bimson, "John Dwight," *Transactions of the English Ceramic Circle*, 1961, pl. 122b.

2 Ibid., p. 99.

3 As, for example, a fifteenth-century jar with a raised band of leaves and flowers, P. J. Donnelly, *Blanc de Chine*, New York, 1969, pl. 2B.

4 A similar vessel dating to the Hsüan-tê period (1426–35), China Institute in America, *Ming Porcelains*, exhibition catalogue, New York, 1970, no. 11. There called a tankard, the shape is likened to Islamic prototypes that reached China early in the fifteenth century.

5 Volker, *Porcelain*, p. 124.

6 Soame Jenyns, *Later Chinese Porcelain*, New York, 1965, p. 18.

7 Volker, *Porcelain*, p. 129.

8 Victoria and Albert Museum C.336-1921, 219-1923, 1244-1924.

9 Bimson, "John Dwight," pl. 125.

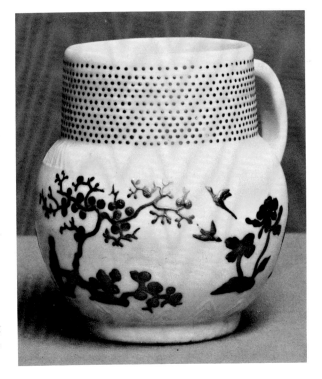

FIGURE 10 Chinese porcelain mug with Saxon raised-gilding decoration. Continental market, early eighteenth century. Victoria and Albert Museum, London

7 Cup and saucer

Probably Dutch market, about 1700
Cup H. 2, saucer D. 3½ in.
Accession 69.63.1, 2
Mark on bases, in underglaze blue: a fretted square

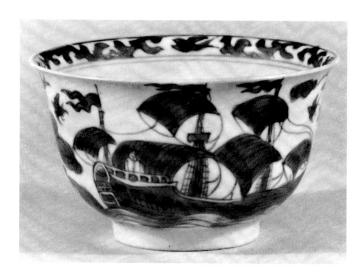

Decoration in underglaze blue. A scene of Odysseus and sirens accompanied (on saucer) by a motto scroll inscribed *Gardes vous de la syrene*. On the exterior of the saucer, in alternation, two of the *pa pao* (Eight Precious Objects), the pearl and the lozenge (*hua*, picture).

The set is closely related to a covered beaker and saucer depicting a scene said to represent Louis IX with his mother, Queen Blanche.[1] In common are the lively style of the painting, the borders, the inscriptions in French, and the mark. The last, designed in imitation of a seal character, appears exclusively on blue-and-white export wares of the early eighteenth century; with all other symbol marks, it was dropped after the death of K'ang Hsi in 1722.

Despite the French inscriptions, these pieces were almost certainly ordered by the VOC.[2] The spelling of "syrene" on **7**, in which the y can easily (and probably should) be read as the old Dutch form ij, is one indication; and the storytelling aspect of the scenes suggests an illustration from one of the hundreds of foreign-language books published in Amsterdam throughout the seventeenth century.

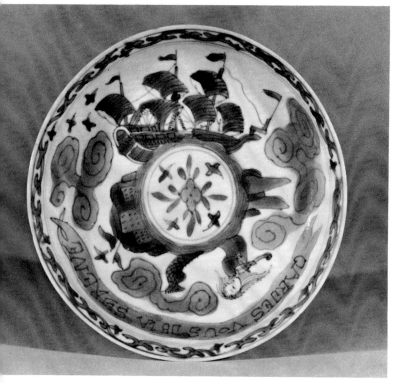

NOTES

1 Scheurleer, *Chine de Commande*, fig. 124. The tradition reported by Beurdeley, p. 153, without evidence.

2 Other Odysseus cup and saucer sets are in the Franks collection at the British Museum, the Percival David Foundation, the Museum De Sypesteyn, Loosdrecht, and the Victoria and Albert Museum. The scene also occurs on a bowl sold at Sotheby & Co., 16 May 1967, lot 143.

8 Dish

FIGURE 11 Chinese blue-and-white porcelain dish, Dutch market. Late seventeenth century. Photograph from Tudor-Craig Archives, The Metropolitan Museum of Art. Whereabouts of dish unknown

Probably Dutch market, 1690–1700

D. 15¼ in.

Accession 1970.266.1

Mark on base: a beribboned conch shell in a double ring

Arms: 1. an eagle displayed; 2. two squirrels (?) confronted; 3. three wheels; 4. three branches chevronwise. Crest: a seated Chinese figure holding a prunus branch.

Decoration in underglaze blue. Center, a pheasant on a rock beneath a peony branch. Surrounding this, a wide band of cloud scrolls interrupted by four conventionalized lotus flowers alternating with three reserves, each enclosing a spray of flowers and leaves, and, at the top, an armorial achievement. On the exterior, at the rim, three flowering branches.

The Chinese character of the decoration is interrupted by the armorial, which occurs with variations on several other dishes of this size. On a version known to Tudor-Craig (Figure 11), the upended wormlike creatures are more recognizable as squirrels, but on two other dishes (a pair) they are said to be two dolphins addorsed.[1] The Chinese figure of the crest is more menacing on the

25

Tudor-Craig dish; he is described as a warrior with a pennant on the pair. Between **8** and Tudor-Craig's example there are also differences in the decorative motifs, the four lotus flowers on **8** being replaced by a shell with a grinning mask below. The latter motif is, of course, a baroque conceit that must have been copied from a Western pattern. What is remarkable, however, is the appearance of spontaneous variation between the two versions, as if it had been left entirely to the Chinese painter to incorporate a skeleton iconography into a scheme of his own.

The arms, apparently fictitious, may represent the pictorially allusive type of heraldry practiced by the Dutch —in what spirit of seriousness it is impossible to tell—in the seventeenth and eighteenth centuries. An example in silver is a tankard made in New York about 1697 by Benjamin Wynkoop, the engraved canting arms of his family depicting one man with a wine barrel, another man with a wineglass.[2] More eccentric are the arms on a China trade plate of about 1740 presumed to have been made for the Dutch market, in which the main charge is a laborer treading grapes, the crest a figure of a wine merchant examining a bunch of grapes:[3] the shield is certainly meant to allude to the owner's profession, if not his name. The shield on **8** and its companion pieces is heraldically more plausible, but, especially with its unorthodox crest, it lies well within the pseudoarmorial tradition.

NOTES

1 Gebouw Haagsche Kunstring, The Hague, 30 November 1908, lot 344. The pair are also described as bearing the mark of the shell and ribbon. Another is in the Mottahedeh collection.

2 Museum of the City of New York, *New York Silversmiths of the Seventeenth Century*, exhibition catalogue, New York, 1963, pl. xv.

3 *Antiques*, April 1935, pp. 150–151.

9 Beaker

Dutch market, 1690–1710
H. 11 ¹¹⁄₁₆ in.
Accession 69.228

Ribbed cylindrical body, slightly flared at rim, tapers to a molded band of lotus petals and rests on a bell-shaped foot. Decoration in underglaze blue: flowers and leaves drawn in line and dot technique. At the top of the foot, a band of spiral scrolls. Inside and outside the rim, a leaf and flower border. Rim is unglazed. Foot, hollowed out, is glazed.

No other beaker of this size seems to be recorded, but a smaller version of late transition date,[1] is, like **9**, reminiscent of the flared cylindrical Chinese vases of the period. However, the ribbing and bell-shaped foot indicate a Western source for the immediate model. Comparable in form are German glass beakers of the seventeenth century, and it is in glass, too, that ribbing is commonly found. But there is no evidence that glassware was ever sent to China or Japan for use as source material. China trade porcelain rummers are mentioned in 1639 in the VOC's records maintained at Batavia,[2] and again in 1644, when they were part of a large order based on "samples from Holland";[3] but that traditionally glass form was by then already known in silver,[4] and the 1644 order was almost certainly dependent on metalwork or the usual wooden models. A more direct comparison can be made between **9** and a group of Delft vases and jars of the period 1690–1710. Characteristic of this group are the ribbing—perhaps inspired by its occurrence in glass—and the use of molded details such as petals in low relief. The working model for **9** may thus have been a Delft adaptation of a glass original.

The style of decoration is unusual; it occurs on relatively few pieces of China trade porcelain and hardly at all in European ceramics. The technique of line shading can be seen on Chinese pieces dating from the sixteenth century, but its combination, as here, with the dotted outlines of the petals results in an effect peculiar to porcelains of the late seventeenth and early eighteenth centuries. It is similar to the decoration on **3**: both recall the embroiderer's repertoire of the French knot and satin and chain stitches. The East-West trade included an active

traffic in textiles, chiefly of printed Indian chintzes for which in 1662 the Europeans began to provide patterns.[5] These were presumably as adaptable as those sent out with orders for porcelain, and it is possible that some were borrowed for use by porcelain painters. While the coincidence of textile and ceramic patterns in this early period cannot yet be documented, Volker notes that the crosshatch technique seen on the smaller beaker of note 1 derives from Dutch *stramien-werk*,[6] a coarse fabric with a double warp and double weft used as a foundation for embroidery.

NOTES

1 Volker, *Porcelain*, fig. 18.

2 Ibid., p. 44. Volker calls the beaker of note 1 a rummer, but I assume that the rummers cited in the Batavia records were of the usual bulbous, thick-stemmed form.

3 Ibid., p. 50.

4 For a Utrecht rummer of 1614/15, complete with simulated prunts on the stem, J. W. Frederiks, *Dutch Silver*, The Hague, 1960, III, no. 46.

5 John Irwin and Katharine B. Brett, *Origins of Chintz*, London, 1970, p. 4.

6 Volker, *Porcelain*, p. 240.

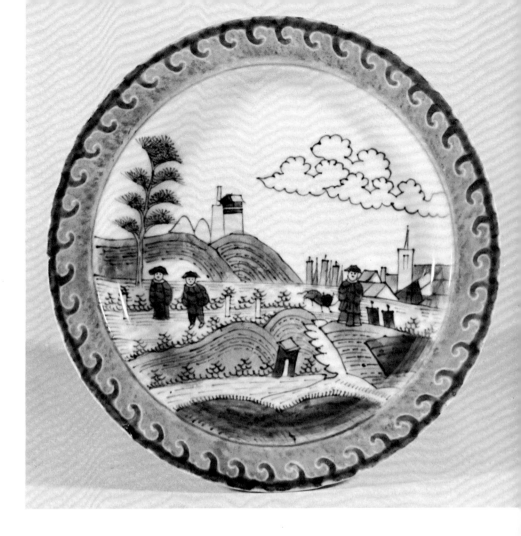

IO Plate

Dutch market, 18th century (?)
D. 7¹³⁄₁₆ in.
Accession 69.3

Decoration in underglaze blue. In center, figures in a landscape with a distant view of a town and ships' masts. The slightly crimped rim is painted with a dark wave-scroll border over a lighter blue ground. On the exterior, three flowering branches. The low foot ring is encircled with a double-line border.

The scene has been thought to represent Deshima,[1] the fan-shaped artificial island in the bay of Nagasaki that served as the VOC's Japanese headquarters from 1641 to 1862. More recently, it has been suggested that it represents a Dutch coastal town, possibly Scheveningen.[2] A plate in Loosdrecht[3] with more detailed and sophisticated painting suggests both a European setting and an engraving as the source.

The several versions of this subject are of interest both for their differences and for the evidence they offer of the repetition of a subject on Chinese and Japanese porcelain at about the same time. Of the three versions, the Chinese is perhaps the latest. In Jenyns' opinion it is based on earlier Arita examples of which one in his own collection[4] differs considerably from the Loosdrecht one in details of landscape and costume.

NOTES

1 Jenyns, *Japanese Porcelain*, pl. 19B.
2 D. F. Lunsingh Scheurleer, "Japans Porselein met blauwe decoraties uit de tweede helft van de zeventiende en de eerste helft van de achttiende eeuw," *Mededelingenblad vrienden van de nederlandse ceramiek*, 1971, p. 20.
3 Ibid., fig. 66.
4 Jenyns, *Japanese Porcelain*, pl. 19A.

II Stem cup

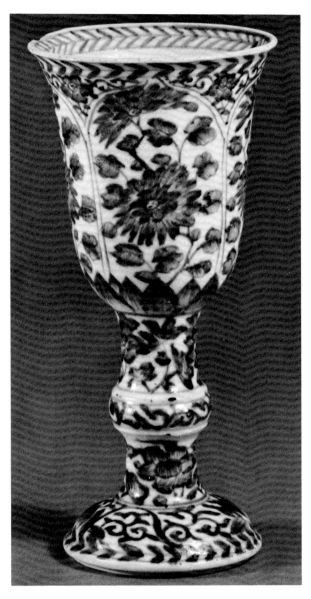

Probably Dutch market, about 1700
H. 5¾ in.
Accession 66.27.1
Mark inside foot, in underglaze blue: a leaf

Bell-shaped bowl, knopped stem, domed foot. Decoration in underglaze blue. Exterior of cup divided into arched panels enclosing flower sprays, with smaller flowers in the spandrels and a band of lotus leaves at the base. Cup's stem also painted with flowers, knop and upper part of foot with scrolling tendrils. Leaf bands in a chevron pattern encircle the lip, inside and outside, and the edge of the foot rim.

In profile, the cup is a slightly simplified version of a type of drinking glass common to Holland and England at the turn of the century. The paneled decoration characterizes a group of late seventeenth-century blue-and-white wares perhaps all made for export; an adaptation of it, including the border pattern, occurs on a Delft vase from the De Dissel factory, marked to the years 1694–97.[1] Examples of this particular shape are rare; Volker illustrates a more usual beakerlike variant with paneled decoration and chevron borders.[2]

NOTES

1 F. W. Hudig, *Delfter Fayence*, Berlin, 1929, fig. 183.
2 Volker, *Porcelain*, fig. 19 (*sc.* 18). For another example also marked with a leaf, Cornelius Osgood, *Blue-and-White Chinese Porcelain*, New York, 1956, pl. 46B.

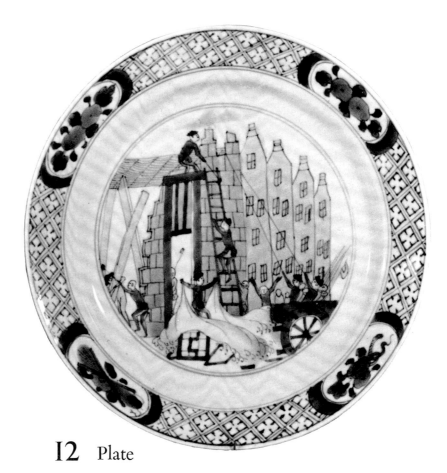

12 Plate

Dutch market, 1690–95
D. 7⅞ in.
Accession 66.27.2
Mark on base: the Ch'eng Hua reign mark (1465–87) in a
double ring

Decoration in underglaze blue. Center: men demolishing
a house. Around the rim, a cell diaper border interrupted
by four reserves, two enclosing flowers, two enclosing
pa pao (Eight Precious Objects) symbols. Exterior, at rim,
a continuous lotus scroll and swastika band.

The scene depicts the climax of rioting in Rotterdam
on the night of 4 October 1690.[1] The trouble had begun
on 28 August when one Cornelis Kosterman had been
intercepted in a plan to smuggle wine into the city hall,
where he was a guard, for a party. In a scuffle, a clerk was
killed. Kosterman was accused of the murder and con-
victed. His execution, on 16 September, set off disturb-
ances by townspeople convinced of his innocence;
attempts by the militia to restore order only aggravated

FIGURE 12 Silver medal by Jan Smeltzing, commemorating
Rotterdam riots of 1690. The American Numismatic Society,
New York
Left, obverse: Demolition of Chief Bailiff Jacob van Nyevelt's
house by townspeople
Right, reverse: Severed head of Cornelis Kosterman resting on
his monument

the popular mood, and on 4 October crowds stormed the house of the city's chief bailiff, Jacob Zuylen van Nyevelt. Breaking down the doors with cannon, they destroyed the interior and then, with ladders and ropes, pulled down the outside walls. The following day, the burgomasters, who had barricaded themselves in the city hall for safety, agreed to appoint a more acceptable official to Nyevelt's position, and the rioting ended.

Celebrated in newspapers, prints, and poems, the Rotterdam riots were also commemorated in a medal by Jan Smeltzing (1656–93) (Figure 12).[2] The obverse of this depicts the demolition of Nyevelt's house; on the reverse, Kosterman's severed head is seen resting on his monument. Both scenes appear on China trade porcelain—Kosterman's head floats rather grimly on the bottom of cups—and one gathers that the medal must have been sent to China while the riots were still news. This appears to be the earliest instance of China trade porcelain reflecting a social context, and from the unusually large number of surviving examples—at least fourteen plates and two sets of cups and saucers are known[3]—we can assume a sizable original order.[4] It is thus clear that well before the end of the seventeenth century a characteristic function

of the porcelain trade—the production in quantity of wares modeled or decorated to suit collective tastes in fashion or politics—had been recognized. The novelty of Western style is evident, however, in the inability of the Chinese painters to cope with Smeltzing's crowded composition and unfamiliar perspective. The several painters who attempted it—their hands are recognizable in differences in draughtsmanship and in the disposition of border details—all failed, in varying degrees of innocent awkwardness. With its clear color and orderly management of the scene, **12** is among the most successful.

The reign mark of the emperor Ch'eng Hua occurs on at least seven of the Rotterdam porcelains; another is recorded as bearing the T'ien Chi (1621–27) reign mark, and the *yü*, or jade symbol, appears on a cup and saucer. This diversity—which underlines the individuality of each version—is characteristic of porcelains made after the edict of 1677, which forbade the use of the K'ang Hsi reign mark. The Chinese habit of appropriating the reign mark of an earlier emperor has already been mentioned (p. 14); it was supplemented at the end of the seventeenth century by the frequent and irregular use of symbol marks.

NOTES

1 My summary of the events is based on G. van Loon, *Histoire métallique des XVII provinces des Pays Bas*, 1736, IV, pp. 18–20. Van Loon drew his version from an account in the *Europische Merkurius*, IV, 1690, pp. 79–90.

2 The history and iconography of the riots are discussed by P. A. van de Kamp, "Een Rotterdams belastingdrama op Chinees porselein," *Antiek*, January 1968, pp. 271–277. See also Suzanne Stocking Mottahedeh, "Numismatic Sources of Chinese Export Porcelain Decorations," *Connoisseur*, October 1969, p. 111.

3 Eight pieces have appeared on the art market in recent

years. Others are in the Princessehof Museum, Leeuwarden; the Gemeentemuseum, The Hague; Museum Boymans-van Beuningen, Rotterdam; the Rijksmuseum, Amsterdam; the British Museum; and Victoria and Albert Museum. One cup and saucer was formerly in the possession of H. E. Keyes (*Antiques*, June 1929, p. 487). The other set is illustrated by van de Kamp, "Een Rotterdams belasting-drama," p. 275.

4 One plate added to the Johanneum in Dresden before 1721, when the Johanneum's collections were inventoried and marked (*Oriental Art*, Summer 1967, p. 70), indicates a more than local interest in this new, reportorial type of export porcelain.

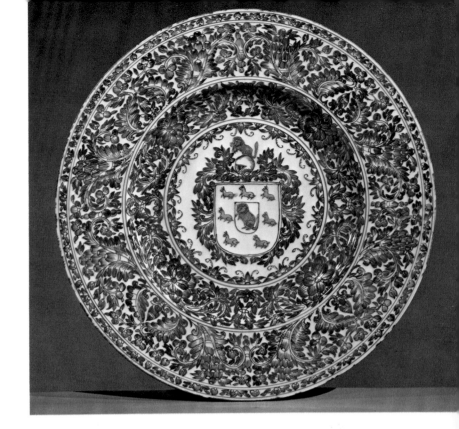

13 Plate

Portuguese market, late 17th or early 18th century
D. 13¹⁵⁄₁₆ in.
Accession 62.83
Arms: a lion, on a bordure seven rabbits. *Coelho*[1]

Decoration in underglaze blue. In center, a coat of arms. Encircling this, bands of scrolled flowering vines. Exterior undecorated. Base unglazed.

The Coelho family, whose arms are rendered variously on this and several smaller plates of the same pattern,[2] were active in the East from the mid-sixteenth century,[3] several members later serving as governors of Macao,[4] where the Portuguese, despite their expulsion from the mainland and their isolation by their maritime rivals, maintained a prosperous and autonomous community. Apart from their paying a small annual rent for the territory, and suffering the presence of a resident hoppo who insured that the Imperial government received its due share of taxes on the foreign trade, the Macaonese were generally ignored by the Manchu emperors, left free to govern themselves and pursue an active trade with Portugal's Indian and South American colonies. The trade in Chinese goods was officially carried on only at Macao, on terms and at prices dictated by the Chinese. However, porcelain and other goods must also have been picked up by Portuguese ships on the Batavia run, and it may be assumed that the Macaonese knew how to circumvent any restrictions through the good offices of other East India companies whose personnel came every winter, as required, to live in their city during the off-season. The Sino-Portuguese trade in porcelain was comparatively small, seventeenth- and eighteenth-century examples being almost entirely commemorative or armorial. Many porcelains must have been ordered for Portuguese residents of Macao rather than for the home market; this plate and its companion pieces may well have been part of such an order.

The border and well decoration of **13** derives from one used at Delft about 1700; see **14** for further comment on this.

NOTES

1 Fully blazoned, with their proper tinctures, the Coelho arms are: Or a lion gules, on a bordure azure seven rabbits argent, spotted sable.

2 Metropolitan Museum (18.65.1, 2) (six rabbits); Sotheby & Co., 3 November 1953, lot 24 (four rabbits).

3 C. R. Boxer, *The Great Ship from Amacon*, Lisbon, 1963, p. 49.

4 C. R. Boxer, *Fidalgos in the Far East: 1550–1770*, The Hague, 1948, p. 274.

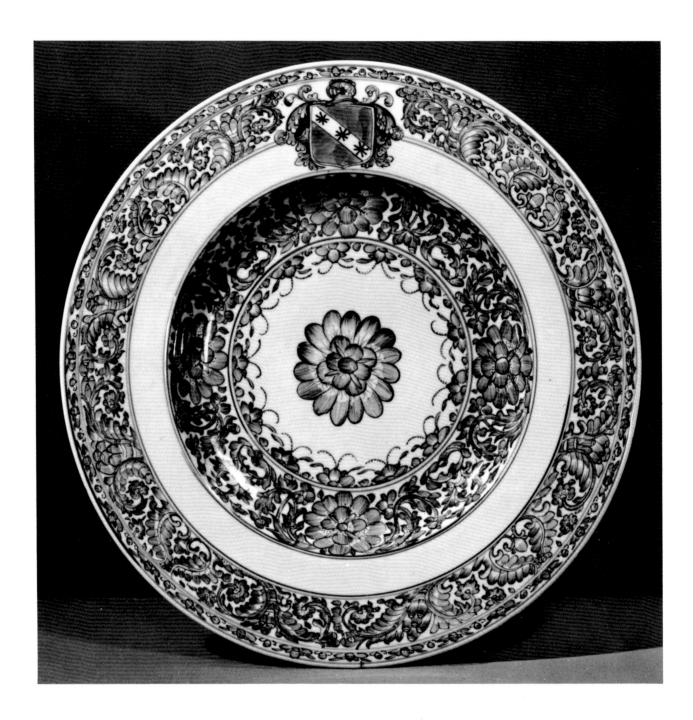

14 Plate

Portuguese market, about 1700
D. 13¾ in.
Accession 62.188
Mark on base, in underglaze blue: a flower within a double ring
Arms: . . . on a bend . . . three eight-pointed stars . . .

Decoration in underglaze blue. In the center, a chrysan-themumlike rosette. Bands of floral and foliate scrolls encircle the well and rim. On the flat rim, a coat of arms. Exterior undecorated.

Given its striking resemblance to **13**, **14** can be assigned to the same market even though its arms do not appear to be those of a native Portuguese family. The shield, varying in its tinctures from one family to another, occurs most often in Italian heraldry. Since it is painted here only in blue and white, it is impossible to make a specific identification, but several Italian families had settled in Portugal by the seventeenth century, and this armorial probably reflects such an emigration.

The decoration of **13** and **14**, with its controlled yet vigorous acanthus and flower scrolls, echoes a Delft style of the turn of the century. Particularly close is the border on a Delft armorial plate of about 1700 (Figure 13), which incorporates at intervals the same clusters of seed pods. The influence of Dutch pottery of the seventeenth and eighteenth centuries on that of the Iberian peninsula was accomplished not only routinely, through normal trading, but exceptionally, through a significant impor-tation of Dutch tiles by the Portuguese and Spanish pri-marily for installation in their churches.[1] Similar, al-though more florid, scrolled leaf ornament can be seen in Dutch tile borders in the churches of Madre de Deus, Lisbon, and of Notre Dame in the coastal hamlet of Nazare, the decoration of both completed between 1707 and 1709.[2] Less sophisticated variants are common to both Portuguese and Spanish—especially Talavera—pottery, on which hatched, rather than solid, shading is also a conspicuous feature.[3]

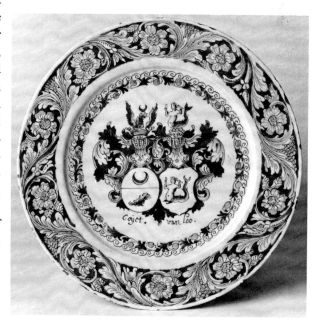

FIGURE 13 Delft armorial plate with border incorporating seedpod clusters. About 1700. Collection J. van Loo, Epse. Photograph courtesy Rijksmuseum voor Volkskunde, Arnhem

NOTES

1 J. M. dos Santos Simões, *Carreaux céramiques hollandais au Portugal et en Espagne*, The Hague, 1959.

2 Ibid., pls. xiia, xva, b.

3 Alice Wilson Frothingham, *Talavera Pottery*, New York, 1944, figs. 67, 107; José Queirós, *Cerâmica Portuguesa*, Lisbon, 1948, I, figs. 33, 34.

15 Monteith

English or Dutch market, about 1715
H. 6¼, D. 12⅝ in.
Accession 60.8
Mark on base: a fungus (*ling chih*) in a double ring

Decoration in underglaze blue with thick honey-brown glaze on rim. Field pattern: chrysanthemum scrolls in reserve. Around the bowl, seven rectangular panels with chamfered corners, painted in reverse, each enclosing a crane, winged tiger, lion, or other creature in a landscape. At top of the foot rim, a narrow cloud scroll. Inside: designs from the Hundred Antiques (*po ku*), a vase and a table with a bowl of fruit, alternate around the rim. On the bottom, a number of emblems within a scroll and leaf border. Underside is white-glazed about halfway down the foot rim; the rest, including the bottom edge, is unglazed.

The monteith, which enjoys an unusually well documented history,[1] is first mentioned as a new invention in England in 1683, and is represented by examples in silver dating from the following year. Early versions are all of the type represented here in porcelain: circular, with an even rim interrupted by plain U-shaped notches. **15** and a matching piece in the Victoria and Albert Museum,[2] are the only recorded blue-and-white examples of the

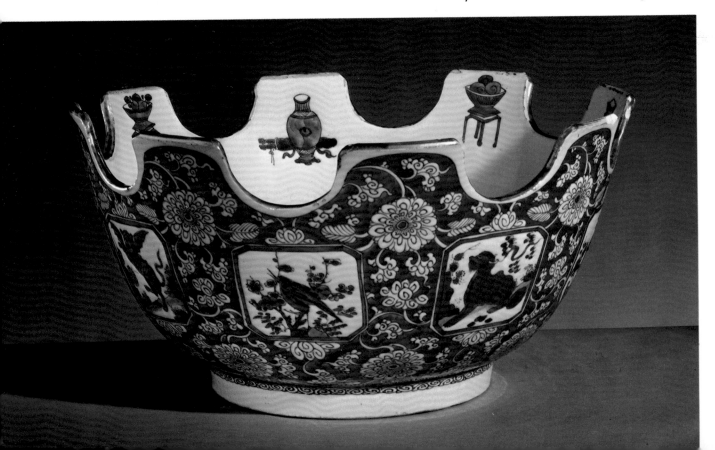

type. Later China trade examples include a famille verte version of approximately the same dimensions,[3] and two much larger oval famille verte ones, on claw and ball feet.[4]

The early type of monteith prevailed in metalwork until about 1694 when the profile of the rim became increasingly curvilinear. As much of the aim of the China trade was to capitalize on fashions, it would seem reasonable to date this export version contemporaneously with its silver prototypes. However, several factors point to a somewhat later dating. In its peculiarly vibrant quality, the blue of 15 accords well with a group of blue-and-white porcelains stylistically ascribed to a period dating from about 1700. To this period also is attributed the use of the fungus and a half dozen other symbolic marks. Their occurrence appears to be related to an Imperial edict of 1677 which forbade the use of K'ang Hsi reign marks on porcelain. But as they are most frequently seen on porcelains of the turn of the century and even later, there is no evident reason to consider their use a direct result of the 1677 edict.[5]

Circumstances of the China trade further suggest that 15 was not made much before 1715. Up to that year English interest in porcelain was negligible, the bulk of

the English trade with China consisting of silks, metals, and tea. Porcelain, mentioned for the first time in a shipment of 1637,[6] does not occur in the records again until 1700.[7] As late as 1703 the English were refusing to buy porcelain, even though the Chinese "very much insisted" on their doing so.[8] Even allowing for records that are missing for the years 1704–11, it is clear from surviving accounts that a demand for China trade porcelain, and a marked increase in the volume of trade, did not occur until after 1715, when the English established their factory permanently at Canton. Some armorial pieces may be dated earlier than this,[9] but given the impersonal nature of the decoration of 15 and its existence in duplicate, it is unlikely that it would have been made before the porcelain trade between China and England was on a regular commercial footing. Its imitation of a much earlier and outdated form is possibly due to its having been copied from a European ceramic version. The earliest of these appear to be the pottery monteiths of the same type as the first English silver examples, made at Delft beginning about 1710.[10] As it was well-established practice for the Dutch to send pottery models to Canton of porcelains they wished to have copied,[11] it may be that the direct inspiration for 15 was Dutch rather than English.

NOTES

1 Jessie McNab, "The Legacy of a Fantastical Scot," The Metropolitan Museum of Art *Bulletin*, February 1961, pp. 172–180.

2 564-1907, marked on base with a lotus flower.

3 Sir John Wormald collection, Sotheby & Co., 14 July 1933, lot 14.

4 Metropolitan Museum (L.2000.93, collection of Mrs. Harry Payne Bingham), and Beurdeley, p. 160, cat. 52.

5 R. L. Hobson, *Chinese Pottery and Porcelain*, London, 1915, II, p. 140; Soame Jenyns, *Later Chinese Porcelain*, New York, 1965, pp. 97–98.

6 Morse, I, p. 26.

7 Ibid., p. 97.

8 Ibid., p. 129.

9 A hexagonal jardinière with the impaled arms of Sir Henry Johnson and his wife, Martha Lovelace, an apparently unique example of seventeenth-century China trade porcelain for the English market, is illustrated in *Connoisseur*, June 1959, p. 21. Married in 1692, Johnson died seven years later, at which time his wife's personal arms would have been altered. The existence of this piece is accounted for by Sir Henry's profession of ship-building, which would most likely have involved him in the

China trade. An exceptionally early table service is that with the arms of Thomas Pitt, Governor of Madras, presumed to have been made before he left India in 1706 or 1708 (Jenyns, *Japanese Porcelain*, p. 43). The armorial services of Somers and Walker are assigned a date of about 1710 by Algernon Tudor-Craig (*Armorial Porcelain of the Eighteenth Century*, London, 1925, p. 11), but neither biographical nor stylistic evidence precludes a later dating for them of about 1715–20.

10 Jessie McNab, "Monteiths: English, American, Continental," *Antiques*, August 1962, p. 159, fig. 11.

11 Models to be made of wood or earthenware were ordered by the Amsterdam Chamber of the Dutch East India Company in 1661 for their Japanese trade. Although a number of China trade porcelains derive ultimately from metalwork forms (monteiths, helmet ewers, candlesticks) there is no evidence from the detailed Dutch records that metal originals were ever sent out as samples. In this instance, however, a metalwork model should not be entirely discounted, as the petition to Parliament of the English japanners (about 1698) observed that their art would, "if Encourag'd, vastly Improve both the Wood and Iron Trade for Cisterns, Mounteths, Punch-Bowls..." (Vilhelm Slomann, "The Indian Period of European Furniture—I," *The Burlington Magazine*, September 1934, p. 119).

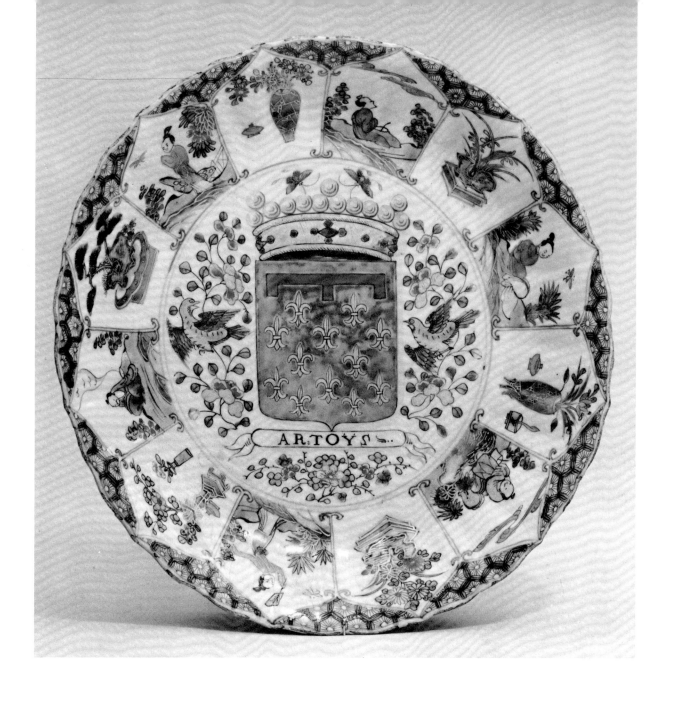

16 Dish

Dutch market, about 1720
D. 12¼ in.
Accession 60.10
Arms: Azure semé of fleurs-de-lis or, a label of three points
 gules. *Artois*

Decoration in underglaze blue, enamel colors of blue,
green, and iron red, with gilt details. In center, coat of

arms surmounted by a count's coronet, encircled by flowering branches, birds, and butterflies. Inscribed on a banderole beneath the shield, the name ARTOYS. The rim, slightly fluted, is divided into twelve petal-shaped reserves enclosing, alternately, a figure in a landscape and a floral display. The spaces above the reserves are filled with diaper pattern. On the exterior, at the rim, two branches with berries, painted in underglaze blue and iron red. Inside the foot rim, pale brown glaze.

This comes from one of four services depicting the arms of the chief towns and provinces of the United Netherlands—including those territories under French or Austrian control—and those of England and France.[1] Artois was French-owned in 1720, having been won from Spain by the treaties of Nijmegen (1698) and Utrecht (1713). A single series of the dishes seems to have comprised twenty-one armorials. No complete sets survive; that represented by **16** is the most complete.[2]

The sets are closely related stylistically, and may all be assigned the same date. The second set is characterized by a flat rim painted with bird and landscape reserves set against a latticed ground; the center is treated in a manner similar to **16**. The coats of arms on the third set are framed by the central arch of a pedimented gateway and are flanked by figures of Chinese ladies in niches; the rim decoration is almost identical to that of the second series. The diapered rims of the fourth set are interrupted by reserves enclosing domestic birds and animals. The arms on several examples are rendered carelessly or inaccurately; on **16** the gold towers that should appear on each point of the label have been omitted. However, since the Chinese painter presumably had a correct model, the absence of towers in this blazoning may be a legitimate variant.

The stylistic dating of the four series coincides with a period of cordiality among Holland, England, and France following the close of the War of the Spanish Succession (1714). Topicality being an essential characteristic of China trade porcelain, it is possible that **16** represents an order commemorating the Triple Alliance formed by those countries in 1717. The nature of the order is odd, though, since apparently it consisted exclusively of plates, dishes, and shaving basins.[3] That the production was both large and popular is indicated by the great number of examples that have been recorded for all three sets; single plates were even duplicated in Delft faïence (Figure 14).

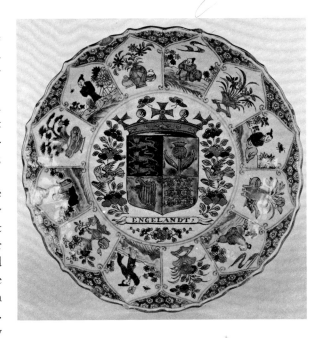

FIGURE 14 Earthenware dish, polychrome. Delft copy of Chinese porcelain, about 1720. Rijksmuseum, Amsterdam

NOTES

1 Amsterdam, Anvers, Artois, Brabant, England ("Engelandt"), Flanders, France ("Frankryk"), Friesland, Gelderland, Groningen, Hainault ("Henegouwe"), Holland, Louvain, Luxemburg, Mechlin, Namur, Overÿsel, Rotterdam, Utrecht, Zeeland, and Zutphen.

2 Although dispersed, with the present whereabouts of most of the set unaccounted for, examples of all but six (Anvers, France, Hainault, Holland, Namur, Zutphen) have been recorded. A dish with the English arms is in the Victoria and Albert Museum.

3 One with the arms of Groningen was acquired by Lady Charlotte Schreiber in 1879 (*Lady Charlotte Schreiber's Journals*, London, 1911, II, p. 205); another, with the French arms, was sold at Sotheby & Co., 19 December 1967, lot 282. Others are in the Mottahedeh collection, New York.

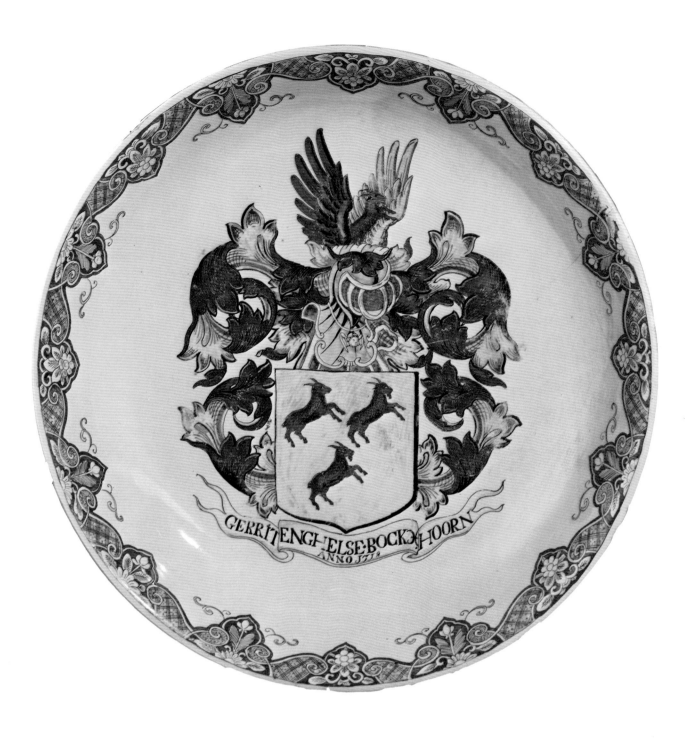

17 Plate

Dutch market, about 1718
D. 14⅛ in.
Accession 66.27.3
Mark on base, in underglaze blue: a lozenge (*hua*, picture, one of the *pa pao*)
Arms: Argent three goats rampant. Crest: a goat issuant gardent.

40

Decoration in enamel colors, chiefly iron red, rust, and dark brown, with gilt details. Rim edged with dark honey brown glaze. In center, a large armorial achievement (shown reversed) with banderole inscribed GERRIT ENGHELSE BOCKXHOORN ANNO 1718. Around the rim, an elaborate border of flower-filled lappets, diapered compartments, and vine scrolls.

Despite the explicitness of the inscription neither the arms nor their owner can be identified. The arms may be presumed to depict bocks and thus fall into the category of canting arms. The surname is written in an awkward manner, making it difficult to determine whether the family is Bock, of Hoorn, or whether the entire surname is Bockxhoorn. The arms do not appear to be recorded for families of either name.[1]

The style and coloring derive from a type of Delft faïence commemorative plate popular from about 1715 to 1725. Examples with only minor differences are dated 1719 and 1727;[2] very similar border decoration occurs on nonarmorial Delft plates as early as 1714.[3] Especially similar to 17 is a Delft plate related to the Nahuys/van Hoecke families and dated 1719 (Figure 15). The faithfulness of 17 to its Dutch prototypes suggests that it was copied from a pottery model.[5]

The reversal of the armorial achievement on 17 may reflect a license common to Germany and Holland in which artistic effect took precedence over heraldic accuracy;[6] alternatively, it may simply have been copied from a printing plaque on which the arms would have been engraved in reverse.

NOTES

1 Branches of the Bock family in Holland and Flanders are recorded, as are the surnames Boxhorn and Boxhoren.

2 J. Helbig, *Faïences hollandaises*, Brussels, n.d., II, fig. 35.

3 Ibid., I, fig. 86.

4 Four other Delft plates relating to the Nahuys/van Hoecke families are known also, attesting to the great popularity of this tradition.

5 The practice of sending ceramic models to be copied in Japan and China is first mentioned in 1661 when the Amsterdam Chamber of the VOC proposed making models of wood or earthenware "of such assortments and flower-work as is thought to make the . . . porcelain best desired and most in demand in this country" (Volker, *Porcelain*, p. 141). That this custom continued throughout the China trade is evident from the number of examples that mirror European ceramic forms and decorative styles. See, for example, 6, 15, 46.

6 On a Delft plate dated 1727 (Frederik Müller & Cie., Amsterdam, 12–18 May 1914, lot 970) the arms of the town of Harderwijk have been reversed while the mantling is correctly positioned. A similar reversal occurs on a China trade dish with unidentified Continental arms, Metropolitan Museum 51.86.312.

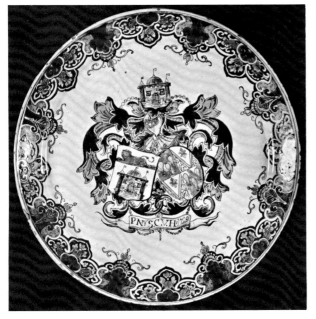

FIGURE 15 Delft plate with armorial of the Nahuys/van Hoecke families. Courtesy of the late Dr. F. H. Fentener van Vlissingen, Utrecht

18 Plate

Dutch market, about 1720
D. 8⅝/₁₆ in.
Accession 60.149.1

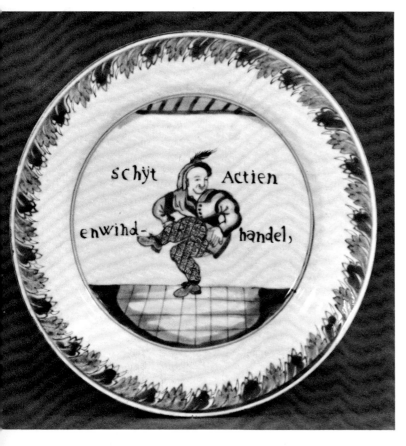

Decoration in underglaze blue overlaid with details in green enamel and gilt. Inscription in black. Rim edged with pale brown glaze. In the center, a dancing harlequin against an architectural setting and inscription *Schÿt Actien en windhandel.* Around the rim, a freely drawn conventionalized leaf border. Exterior undecorated.

One of a set of six plates with harlequin figures and catch phrases satirizing the "bubble" mania that burst in 1720.[1] The references are probably to the South Sea Bubble rather than to the concurrent speculation in John Law's Mississippi company. The disastrous effects of the latter scheme were scarcely felt in Holland, where speculators had sold out at a judicious moment; they were thus quite ready to try their luck again on the English venture. The apparent success of the South Sea Company encouraged hundreds of smaller ones, mostly of an illusory nature, on both sides of the Channel. Among the English ones were companies for the "Fat'ning of Hoggs," the manuring of land, the support of illegitimate children ("We'll keep your Bastards at a small expense"), and the "Furnishing of Funerals to all parts of Great Britain."[2] Similar "windhandel" were invented in Holland, but the primary interest of the Dutch was in the South Sea Company itself, intensive trading in its shares being conducted in Amsterdam at the French coffeehouse on Kalverstraat, while fleets of fishing boats shuttled between England and Holland to bring the latest news of the London market.[3]

By the time it burst in August 1720 the South Sea Bubble had been satirized in books, prints, playing cards, and ceramics.[4] There are, in addition to the set represented by **18**, two variant sets of China trade porcelain, on which the figures are the same but posed without inscriptions in settings and frames of a more Oriental character (Figure 16). Of about the same date as the inscribed set, they may have been intended as oblique allusions to the bubble, or the figures may simply have been recopied for unrelated orders. As if to underline the theatricality of the entire bubble mania, the figure chosen

for the Chinese plates was Harlequin, a familiar figure on Delft earthenware of the period, sometimes in specific reference to the bubble (Figure 17). All the representations presumably derive from still unidentified engravings.

It is perhaps not coincidental that this narrative genre of ceramics recalls the "merryman" plates in English earthenware dating from the late seventeenth century. These sets, although not pictorial, are related in comprising six plates, each inscribed with one line of a six-line rhyme. Whether or not the genre originated in Holland, as has been suggested,[5] it was a popular one there as well as in England and would seem to have influenced the composition of the bubble series.

A considerable market for the bubble plates is indicated by the large number of complete and incomplete sets that have been recorded.[6]

NOTES

1 The other five read
 50 per cent op Delft gewonnen
 De Actiemars op de tang
 Pardie al myn actien kwyt
 Weg Gekke Actionisten
 Wie op Uytrecht of nieuw Amsterdam.

2 Lady Charlotte Schreiber, *Playing Cards*, London, 1892, I, 1.43–46.

3 Charles Wilson, *Anglo-Dutch Commerce & Finance in the Eighteenth Century*, Cambridge, 1966, p. 105.

4 Among the playing cards (Schreiber, pls. 115–118) is a Dutch set of satirical figures entitled *Pasquins Windkaart op de Windnegotie Van't Iaar 1720*. Also published in 1720 was a collection of engravings, *Het Grote Tafereel der dwaasheid* (The Great Picture of Folly) from which Scheurleer (*Chine de Commande*, figs. 350–351) has extracted the source of decoration for a Japanese export bottle; this source may have served the Delft potters as well. The variant China trade sets are discussed and illustrated by D. F. Lunsingh Scheurleer "In China vervaardigde Actie Bordjes," *Antiek*, November 1968, pp. 184–192.

5 Frederic H. Garner, *English Delftware*, London, 1948, p. 14.

6 Several complete sets were on the Dutch art market in the early 1900s, and may be the same as those of more recent provenance. One set was on the New York art market in 1953, another was formerly in the R. H. Gries collection (Parke-Bernet, New York, 10 April 1970, lot 226), a third is in the Mottahedeh collection. One or more plates from this series are in the British Museum and the Victoria and Albert Museum, the Zeeuws Museum, Middelburg, the Rijksmuseum, the Philadelphia Museum of Art, and the Rhode Island School of Design.

FIGURE 16 Chinese porcelain plate with harlequin figure, polychrome, Dutch market. About 1720. Collection C. van Stolk, Rotterdam. Photograph courtesy Rijksmuseum, Amsterdam

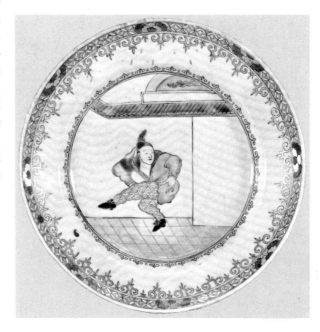

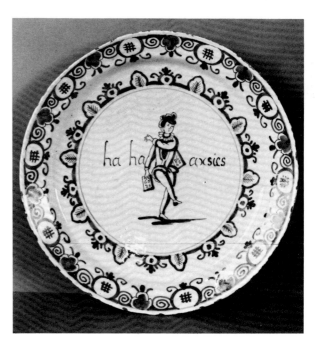

FIGURE 17 Delft earthenware plate. About 1720. Harlequin figure and inscription refer to "Mississippi bubble" mania of 1720. Rijksmuseum, Amsterdam

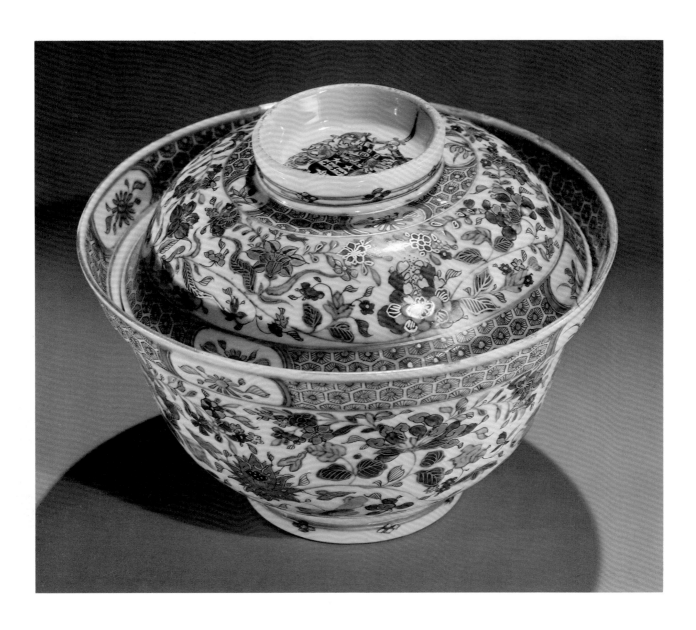

19 Covered bowl

English market, about 1719

H., bowl and cover, 5 in.

Accession 61.102a, b

Ex coll. Clive E. Rouse (Sotheby & Co., 9 May 1961, lot 166)

Bowl marked on base in underglaze blue with character *Ho* within a rectangle. This unrecorded mark is probably the name of the potter or his shop

Arms: Sable on a fess argent between three mullets ermine, three crosses crosslet. Crest: a dexter and a sinister arm, couped above the elbows, armed azure garnished argent, grasping in the gauntles a sword argent, hilt and pommel or. *Craggs*

Decoration in underglaze blue, iron red and bright green enamel, and gilt. Bowl and cover are painted on the outside with a pattern of continuous flower sprays; around the lip of each is a cell-diaper border interrupted at intervals by reserves enclosing a single flower. On the bottom of the bowl the flower sprays are repeated in a medallion in which is a coat of arms. These arms are repeated in the finial of the cover. Inside the cover is a blue-ringed flower spray.

Part of a tea service,[1] **19** represents the full development of the so-called Chinese Imari style. Essentially a floral scheme based on a palette of underglaze blue, iron red, and gilt, it was borrowed from Japanese porcelain shipped from Imari in the late seventeenth century. Its origin was at one time ascribed to the inventiveness of Zacharias Wagenaer, Holland's principal in Japan in 1657 and 1659. But the improbability of such a derivation has been shown,[2] since there was no traffic in polychrome porcelains to Europe until the beginning of the eighteenth century.

Because this type of ware is first alluded to by the VOC [3] only in 1734, it has been surmised that it was not introduced into the China trade until then. However, a number of English armorial services decorated in Imari style can be positively dated well before that year. The Craggs service was made either for James Craggs the Elder or his son. The senior Craggs (b. 1657) began his career as footman to Sarah, Duchess of Marlborough, and rose through her patronage to be Postmaster-General. James the Younger (b. 1686) was enabled by his father's influence to rise rapidly to power. Starting as member of Parliament for the Cornish town of Tregony, he was successively appointed Paymaster of the Spanish troops, resident at the court of Spain, and in 1717, at the age of only thirty-one, Secretary of War. The following year he succeeded Joseph Addison as Secretary of State. He was "equally distinguished for his abilities as a statesman, for his handsome person, his ingratiating manners, and social pleasantry."[4] In addition to his amiable qualities Craggs was engaged with his father, for his own gain, in the promotion of the South Sea Company. When the bubble burst in 1720, discovery of fraudulent management by the directors and promoters, in which the senior Craggs was deeply implicated, led to Parliamentary investigation, but James the Elder died, possibly a suicide, in March 1721, the day before he was to testify.[5] His son had died of smallpox a month before, aged thirty-five; his excellent reputation outweighed his presumed complicity in the South Sea affair, and he was buried in Westminster Abbey.

The coat of arms on **19** was granted to James Craggs Senior in February 1691;[5] the service could have been made either for him or his son. Both men reached the height of wealth and power at about the same time, 1717–20, and both—especially James the Younger—were sensitive on the point of their humble origins.[6] An armorial service such as was being ordered by some of their influential friends[7] would have appealed to either father or son.

NOTES

1 A teapot and stand and a tea caddy were formerly in the F. A. Crisp collection (Puttick and Simpson, London, 8 March 1923, lot 90); a dish was sold in 1919 (Christie's, 4 December, lot 33); another dish is illustrated in color in Algernon Tudor-Craig, *Armorial Porcelain of the Eighteenth Century*, London, 1925, opp. p. 46.

2 Volker, *Japanese Porcelain Trade*, pp. 55–56, n. 59, and p. 72. Trade between Japan and Holland was suspended from 1724 until 1734; on its resumption the Dutch, finding the Japanese merchants to be no more reliable than before, began to consider turning to China exclusively for porcelain, and on 12 November ordered, among other types of ware, "evenly and smoothly coloured work like the Japanese." Volker takes this to refer to Imari ware and observes that if it were not a novelty in 1734 there would have been no need to mention it as a special type.

3 John Heneage Jesse, *Memoirs of the Court of England*, London, 1843, II, p. 412.

4 J. H. Plumb, *Sir Robert Walpole: The Making of a Statesman*, Boston, 1956, p. 347.

5 Thomas Robson, *The British Herald*, Sunderland, 1830, s.v. "Craggs."

6 Jesse, *Memoirs, II*, p. 11.

7 Armorial services were made for Sir John Lambert (d. 1722), a director of the South Sea Company and for Craggs' political acquaintances William Pulteney and Philip Yorke (arms impaling those of his wife, Margaret Cocks, whom he married in 1720).

20 Dish

English market, about 1720

D. 17½ in.

Accession 64.138

Arms: Argent on a mount vert an oak tree proper and in front a running greyhound gules. In dexter chief a baronet's escutcheon. Crest: on a wreath argent and vert three plumes gules azure and gules. Motto: Seguitando si giunge. *Lambert*

Decoration in iron red and gilt, with details in enamel colors of blue, purple, and an unusual lime green. At center, arms, crest, and motto of Lambert. Around the well, in a cell-diaper ground edged with a gadroonlike border, four reserves each containing one of the *pa pao* (Eight Precious Objects). The reserves alternate with chrysanthemums. On the flat octagonal rim, a *ju-i* scepter, flywhisk, fan, and banner, and a repeat of the family crest amid flower sprays. Rim bordered by a narrow raised gilt band and band of gilt foliage. On exterior, at rim, scattered bouquets in iron red.

The arms are those of Sir John Lambert, created a baronet in 1711. One of twenty-eight directors of the South Sea Company, founded the same year, Lambert became wealthy by his unscrupulous handling of the company's affairs. Although he played a lesser role than James Craggs (**19**), he was involved in the selling of fictitious stock, bribing royal mistresses with shares at favorable rates, and juggling the books. His name also occurs in Dutch accounts as agent for speculators in Amsterdam.[1] Lambert tried to cash in on the bubble mania by proposing a company of his own, a whale fishery in Greenland, but this was in July 1720: the South Sea Bubble was about to burst, and his petition was refused. The directors were held responsible for the collapse, and after a public inquiry their estates were confiscated. Of his newly acquired wealth, valued at £72,508, Lambert lost all but £5000. He died in February 1723.[2]

The service to which **20** belongs is typical of the armorial wares made for the English and French markets between about 1720 and 1730. The decoration at this comparatively early stage of the porcelain trade was still essentially Oriental, the European armorials in no way interfering with the traditional K'ang Hsi arrangement of borders and symbols. The Lambert service, which must date before 1723 and was probably ordered at the height of Sir John's financial success, or about 1720, appears to be the earliest of this type. All comparable and datable services fall within the ensuing decade.[3]

Although the decorative style of export porcelains showed little Western influence at this period, the shapes of individual pieces, like the polygonal outline of **20**, were generally copied from contemporary examples in silver; the molding on the rim of **20** offers further confirmation of this point, as does the inclusion in the Lambert service of a tazza, one of the few known to exist in China trade porcelain.[4]

NOTES

1 Charles Wilson, *Anglo-Dutch Commerce & Finance in the Eighteenth Century*, Cambridge, 1966, pp. 206–210.

2 This account of the South Sea Company and Lambert's part in it has been drawn from Adolphe Thiers, *The Mississippi Bubble . . . [and] the South Sea Scheme*, ed. and trans. F. S. Fiske, New York, 1859, pp. 261–332; and Virginia Cowles, *The Great Swindle*, New York, 1960, passim.

3 For example, a service with the arms of Leonora Frederick, that may be dated between the year of her husband's death, 1720, and the accession of the family to a baronetcy three years later, when a new armorial service was ordered. Similar services have the arms of Townshend impaling Harrison (marriage of 1723); of Trevor (d. 1730) impaling Weldon; of George Verney (d. 1728); and of Louis d'Albert d'Ailly (1676–1744) and his wife after he became Duc de Chaulnes in 1711 (Christie's, 19 May 1969, lot 122).

4 The only other one so far recorded was sold by Sotheby & Co., 4 November 1969, lot 159. The Lambert tazza was lot 394 at Sotheby & Co., on 19 December 1967. Other pieces include a circular dish in the Franks Bequest at the British Museum; one slightly smaller octagonal dish sold in 1923 from the Crisp collection, and another formerly in the Gries collection (Parke-Bernet, 6 October 1970, lot 354); two plates (Christie's, 17 October 1966, lot 3, and Sotheby & Co., 7 June 1967, lot 246); an octagonal platter from the Gries collection (lot 355); and a pair of soup plates (Sotheby & Co., 5 April 1966, lot 331).

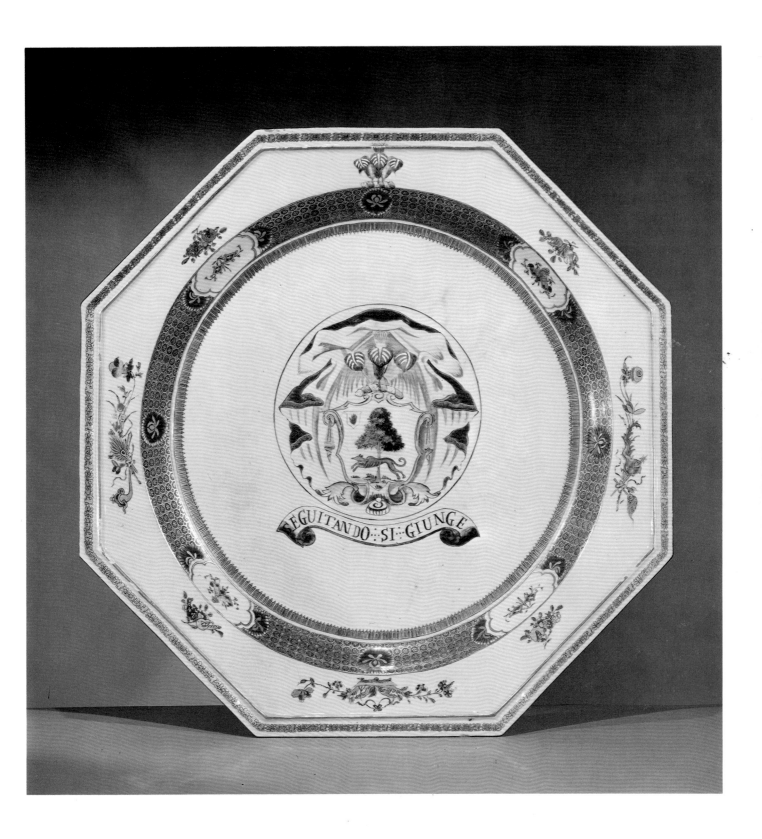

SEGUITANDO·SI·GIUNGE

2I Plate

English market, about 1720

D. 12¼ in.

Accession 66.27.4

Mark on base, in underglaze blue: *ling chih* (sacred fungus) in a double circle

Arms: Argent a fess indented gules, in chief three leopards' heads sable. Crest: on a wreath argent and gules a leopard's head erased sable gorged with a marquis' coronet[1] or. *Pulteney*

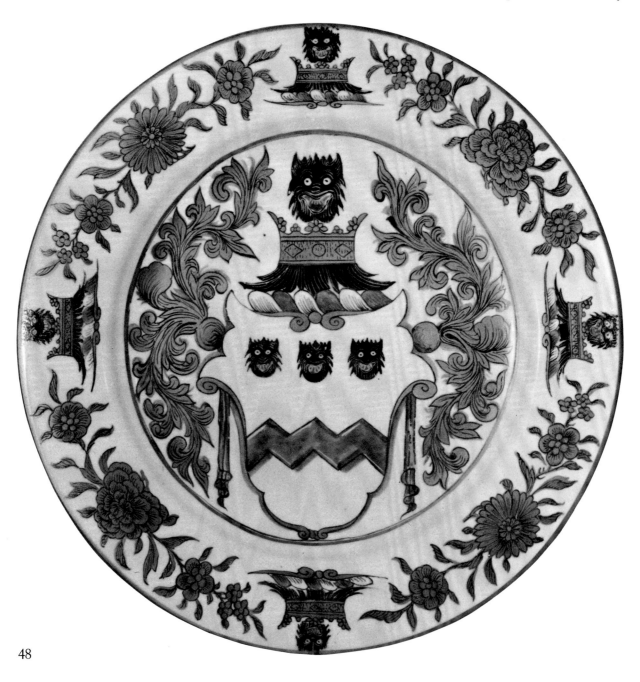

48

Decoration chiefly in iron red and gilt, details in black. In the center, the coat of arms of Pulteney framed in an elaborate scrolled mantling. Four chrysanthemum and peony sprays on the rim are interrupted by repetitions of the crest. Exterior undecorated.

The arms are probably those of William Pulteney (1684–1764).[2] Like his contemporary the younger James Craggs (**19**) Pulteney was a member of George I's government, serving briefly as Secretary of War (1714–17). In the following reign he led the opposition to Sir Robert Walpole and, after declining to serve as Prime Minister, was created first Earl of Bath in 1742.

Stylistically the service is particularly close to one with the arms of Thomas Pitt, Baron Londonderry, and his wife, Frances Ridgway.[3] Since Pitt was created a baron in 1719 and was raised to an earldom in 1726, that service can be securely dated; by extension, the Pulteney service can be assigned to the same period. Pulteney having married a Miss Gumley in 1714, it could be expected that for an armorial service he would include his wife's arms impaled with his own, since—at least as far as the English market was concerned—China trade porcelain was the favored medium for heraldic display. But if some families recorded heraldic change in numerous services,[4] others apparently preferred to use a single coat of arms that would not become outmoded.

The fungus mark was one of several symbols used during the K'ang Hsi period in place of the reign mark, which was forbidden on all but Imperial porcelains after 1677. Rare on China trade porcelains, the *ling chih* also appears on the Pitt-Ridgway service.

NOTES

1 The coronet should be a ducal one of five strawberry leaves, but what seems to have been drawn here—presumably through oversimplification—is the coronet of a French marquis on which the leaves are alternated with three small balls or "pearls."

2 Other pieces from the service are a large dish, formerly in the Crisp collection (Puttick and Simpson, London, 8 March 1923, lot 263), and two others sold from the Quennell collection (Sotheby & Co., 22 June 1933, lot 125).

3 Frederick Arthur Crisp, *Armorial China*, privately printed [London], 1907, p. 47.

4 Sir William Yonge and the Earl of Rochford, each of whom is represented by a service made before and after his marriage. A service with the arms of Sir Hugh Inglis and his first wife was replaced after her death by another impaling the arms of his second wife. Three generations of the Pitt family are identifiable in China trade porcelain: Thomas Pitt (1653–1726), his son (Pitt, Ridgway in pretence), and his grandson, the Earl of Chatham (Pitt impaling Grenville).

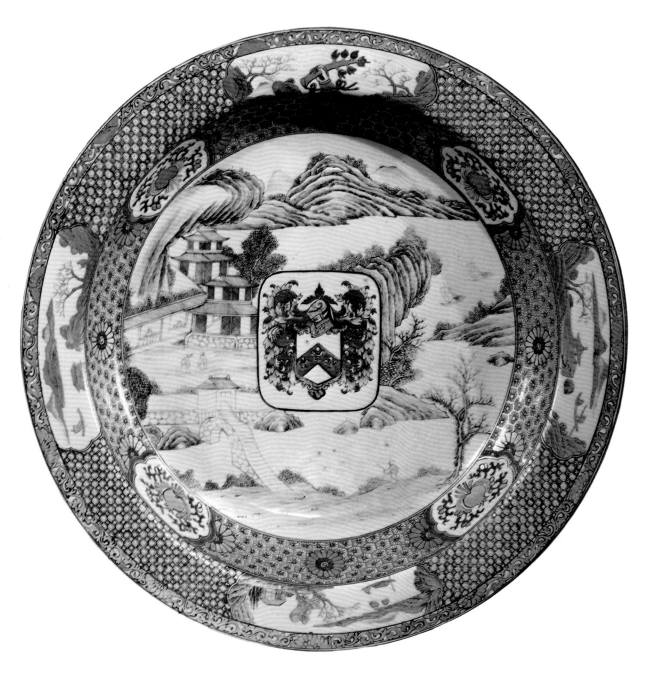

22 Dish

English market, 1725-30

D. 15¼ in.

Accession 67.237

Arms: Argent on a chevron azure three fleurs-de-lis or. Crest: an arm in armor or, tied round with a scarf azure holding in the hand proper a staff raguly of the first, the raguled parts erased of the second. *Elwick*

Decoration in grisaille, enamel colors, and gilt. Center, an Oriental landscape in grisaille, a coat of arms superimposed in a black-edged reserve. Around the well, four reserves, each enclosing a pomegranate and stylized vines in gold, dark blue, and turquoise, set against a background of a cell diaper and chrysanthemums in iron red and gilt. On the rim, a black and gold brocade border interrupted by four cartouches of landscape and river scenes in gold, the cartouche at the top including an armorial crest. Outer band, gold vines and chrysanthemums. Exterior undecorated.

The somewhat jarring placement of the armorial in the delicately drawn landscape emphasizes the uneasy transition from Chinese to Western taste in the decoration of export porcelains. In the early years of the trade, Oriental motifs and the blue-and-white palette were dominant, and occasional European innovations were readily absorbed; by the late eighteenth century Chinese style is scarcely apparent in much of the export ware. It was during the reign of Yung Chêng (1722–35) that important stylistic changes began to take effect, due in almost equal measure to technical improvements and to the Westerners' rapidly increasing command of the porcelain trade.

Considerable advances were made in the use of enamel colors, largely through the development of an opaque white tin enamel that could be intermixed to produce a type and range of colors hitherto unavailable. Among those introduced in the Yung Chêng period were mauve, opaque ("European") yellow (**25**), the bright turquoise and dark blue used on **22** and, most consequentially, the famille rose that was to alter the complexion of Chinese porcelains in the succeeding reign. Also new in the Yung Chêng period was the use of black for figure and landscape drawing (with attempts at approximating Western perspective) and for secondary decoration in combination with gilding, the latter defined in the Imperial list of about 1730 as "European black gold pieces. A novelty."[1]

At this comparatively early stage of their involvement in the China trade the English made few demands on the porcelain painters, generally contenting themselves with half-completed stock items like **22** that could be personalized by the simple addition of a coat of arms.[2] A saucer similar to **22**, but with its central reserve—clearly intended for an armorial—unfilled, is known.[3] That **22** lay in stock for a period before Elwick's arms were painted in is clear from its pattern of scratches: under high magnification these are seen to run *through* the paint of the landscape and *under* that of the armorial.

The arms on **22**, which was probably part of a dinner service,[4] are those of John Elwick (d. 1730), a director of the English East India Company. J. Elwick, probably his son, was mentioned in 1734 as supercargo on the ship *Harrison* bound for Canton; three years later, the year of his death, he was Chief of Council of the *Sussex* and *Winchester* at Canton.[5]

NOTES

1 P'u Lan, *Ching-tê-chên t'ao-lu; or The Potteries of China*, ed. and trans. Geoffrey R. Sayer, London, 1951, p. 25. Representational ink painting, introduced by the Jesuits, is described in the same list (p. 24) as "New style landscape, figure subjects, flower and plant, fur and feather, reproducing the light and dark strokes of the ink-brush."

2 For another example, Townshend-Harrison service (Phillips, pl. 1) with its polychrome armorial added to underglaze blue decoration. The practice of using ready-made wares continued for some time, as is apparent from three platters of about 1760 with identical representations of a chateau by a road and shipping scenes, finished with armorials of the Cooke, Hol-

burne, and Monro families (Phillips, pls. 35, 36; *Apollo*, April 1952, p. 115).

3 G. C. Williamson, *The Book of Famille Rose*, London, 1927, pl. xxxvii.

4 Of this service, a dish of the same size is in the Ashmolean Museum, Oxford; two soup plates and a dish were formerly in the Crisp collection (Frederick Arthur Crisp, *Armorial China*, privately printed [London], 1907, p. 20, where the arms are transcribed as those of Ellick). Small dessert plates have also been seen in recent years on the art market.

5 Morse, I, pp. 220, 257.

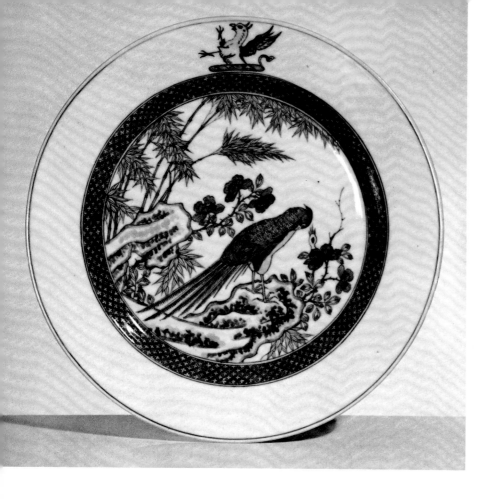

23 Two plates

English market, 1731
Ds. 9¾ and 9¹⁵⁄₁₆ in.
Accession 1970.219.1, 2
Crest: a demi-griffin segreant [argent]. *Peers*

FIGURE 18 Invoice for a service of China trade porcelain made for Charles Peers, dated Canton, 10 December 1731. The British Museum, London. Photograph courtesy Peers family

Decoration in underglaze blue. In center, within a cell-diaper border, a pheasant on a rock amid flowers and bamboos. On the rim, a crest. On exterior, two flower sprays.

On 19 November 1731 these plates, packed in two chests of "China Ware Blue & white painted with a Crest," were put aboard the *Canton Merchant*, a country ship—that is, a ship carrying goods only between China and India—which sailed for Madras on the 24th. The porcelain was consigned to one Nicholas Morris, a Madras merchant, to be forwarded by him to Charles Peers (1703–81) of Chiselhampton, Oxfordshire. It was one of two lots of Chinese porcelain ordered by Peers. The other, painted in famille rose with the full coat of arms of the family, was sent on the *Harrison* directly to London, leaving Canton on 8 January 1732 and arriving late in July.[1] Separate shipments were one form of insurance against the risks of damage or loss en route.

From the invoices (Figure 18), it is apparent that neither order comprised what we would call a dinner service. Although the Marquis de Dangeau had reported as early as 1704 on "new services of china and glass"[2] prepared for a reception at Marly, the idea of complete matched sets of tableware—including candlesticks, vases, tureens, coffeepots, casters, and the numerous jars and bowls for spices and flavorings—was still new in 1735 when the first extensive Meissen services were produced.[3] The Peers sets were both somewhat lopsided in choice and quantity of items and must have been intended to supplement silver and glass table equipment. The blue-and-white set, comprising 100 plates, 6 "soop dishes" (serving dishes), 60 "soop plates" (for eating), 4 sets of bowls, and 12 salts, or about 250 pieces, cost 40 taels, or about £13. The famille rose set amounted to about 450 pieces: 56 dishes in five sizes, 200 plates, 12 soup dishes in two sizes, 100 soup plates, 12 sauceboats, 12 salts, 2 tea sets, 6 quart mugs, 6 pint mugs, 4 pairs of ewers and basins, and 2 sets of 5 bowls each. The cost ("errors excepted") was 228 taels, or about £76. Most of the Peers porcelain still belongs to the family, but examples of it are in the British Museum and the Royal Scottish Museum.

NOTES

1 Details from notes by Commander R. Williamson in R. E. Peers, *The Peers Family China* (booklet, privately printed), n.d.

2 Philippe de Courcillon, Marquis de Dangeau, *Memoirs of the Court of France from the Year 1684 to the Year 1720*, trans. John Davenport, London, 1825, II, p. 95.

3 These were for Count von Hennicke (completed 1735) and Count Sulkowsky (1735–37). Not surprisingly, the design of some of the individual pieces was strongly influenced by metalwork examples, for example a Sulkowsky tureen modeled after a silver one by the Augsburg goldsmith Johann Ludwig Biller. Similar indebtedness is apparent in the early China trade services, notably in the tazza of the Lambert service (**20**, note 4) and the helmet ewers and candlesticks of the Chandos-Willoughby service, both services dating about 1720. The variety of shapes incorporated into these and other table sets of the same period, such as the so-called Fouquet and Pompadour services, had largely disappeared from China trade porcelain by about 1750. Thereafter, the usual order was limited to plates, cups, and dishes in a wide range of sizes.

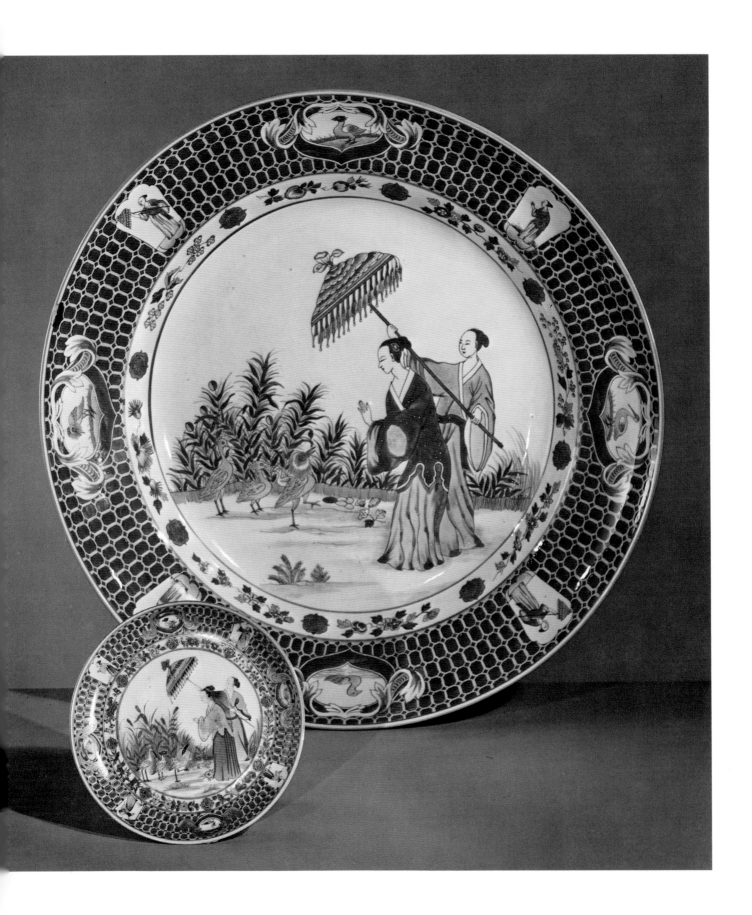

24 Two dishes

Dutch market, about 1736
Ds. 19½ and 6¹¹⁄₁₆ in.
Accession 60.150.1; 68.153

Decoration in underglaze blue (larger dish); underglaze blue, iron red enamel, and gilt (smaller dish). In center, within a floral border, a lady and her attendant standing at a river's edge with three water birds. A cell-diaper

pattern around the rim is interrupted by eight reserves in each of which a figure from the central scene is repeated. Exterior: seven kinds of insects in underglaze blue.

These pieces are among the few China trade porcelains made to designs commissioned by an East India company. Known as the Parasol pattern, this subject is found on a variety of pieces comprising a table service.[1] The authorship of the design has long been ascribed to the Dutch topographical artist Cornelis Pronk (or Pronck) (1691-1759). In the first published account of Pronk and his association with the Dutch East India Company, J. de Hullu wrote that in 1734, upon the failure of the Delft potters to produce satisfactory porcelain models of the wares to be ordered from China, the Delft chamber of

the company engaged Pronk to submit drawings that would serve instead.[2] On 31 August 1734 Cornelis Pronk, painter and drawing-master residing at Amsterdam, agreed

> to make and order all designs and models to our satisfaction, of all such porcelains as will be ordered from time to time in the Indies, with their colors properly put in, blue as well as gilt and other colors, and in various fashions; that he shall have to be occupied at this during the whole of the year, and for this enjoy a sum of 1200 florins.[3]

What were presumably drawings by Pronk, whose name is the only one to occur in the accounts of this transaction, arrived in the East Indies in 1736. The records of the company at Batavia disclose on 9 June that it was sending from there to Japan

> out of drawn samples recently received out of Holland for China, one set for blue-and-white and one for coloured porcelain with the order . . . to have three sets made of each.[4]

The patterns are nowhere itemized or described, but the size of the company's commission is suggested in a request, dated 10 February 1737, for the porcelains to be made from the Dutch patterns. Half of each kind was to be made in "red" and half in "blue." Ordered were 1279 dishes of various sizes, 6 salt cellars, 12 fish bowls, 6 beer mugs, 12 coolers of which 6 were to be from samples 2B and F, and 18 sets of pots to be made from samples 2B, 7, 7D, and 8E.[5] Also required were 432 nine-inch plates, the size of most of the Parasol plates; while no sample number is mentioned in connection with this order, one may be deduced from the fact that on 23 August 1736 the Hizen merchants were permitted "to take away the red and the blue-and-white sample of the table plates to see whether they would be able or not to obtain the right colour."[6]

We come now to the Parasol pattern itself. An unsigned drawing (Figure 19) shows this pattern on a plate and saltcellar. This drawing, and another of a design known as the Visit of the Doctors to the Emperor (Figure 20) have long been attributed to Pronk solely on

the basis of his known connection with the Dutch East India Company.[7] In view of the coincidence of the hiring of Pronk, of the receipt of drawings at Batavia, and of the particular mention of drawings for plates, it is probable that the Parasol and Doctor designs are indeed by Pronk.[8] The Rijksmuseum drawings, however, need not be, for included in Pronk's agreement with the company was the stipulation that "every piece or model which shall be chosen to be sent to The Indies will have to be copied six times," and that Pronk would be reimbursed by the company for the cost of the copyists.[9] The possibility thus remains that a drawing of the Parasol pattern positively attributable to Pronk has existed and that the surviving sketch is the work of a copyist.[10]

The need for six copies of a single pattern is demonstrated by the surviving Parasol plates and the Batavia records. The memorandum of 23 August 1736 quoted above indicated the pattern was to be tried out in both Chinese and Japanese porcelain; and for each, drawings would have been made in alternative color schemes: polychrome and blue-and-white. Among these there was certainly a variant drawing of the pattern since the Japanese plates differ considerably, and consistently, from the Chinese (while, excepting for the floral border that appears with minor variations, the Chinese renditions

are faithful to the Rijksmuseum drawing). In the Japanese version (Figure 21) the position of the attendant in the main scene and the border reserves has been altered, as have the frames of the larger reserves. In addition, the plain loose garment of the Chinese lady has been transformed into the stylish robe of a geisha.

The VOC would naturally have wanted its designs copied quickly into porcelain to determine whether its experiment in hiring Pronk was justified. The Chinese pieces, which are en suite—that is, all but two blue-and-white plates that appear to have been made later in the century—may therefore be dated about 1736. A few, the most carefully executed, of the Japanese plates probably also date from about that year and were perhaps test pieces. From 1736 to 1747 the company tried repeatedly to order from Arita porcelains made from the 1736 patterns, but as it refused to pay what it considered the exorbitant prices demanded by the Hizen merchants, none of the porcelain was officially manufactured.[11] Volker suggests that the existence of the Japanese plates may be accounted for by their having been ordered privately by the Dutch staff at Deshima after it became clear that the design was not going to be used by the company.[12]

The experiment by the VOC in commissioning porce-

FIGURE 19 Design for the Parasol pattern attributed to Cornelis Pronk. About 1734, 19/1 × 16.2 cm. Rijksmuseum, Amsterdam

FIGURE 20 Design of the Visit of the Doctors to the Emperor pattern attributed to Cornelis Pronk. About 1734. Rijksmuseum, Amsterdam

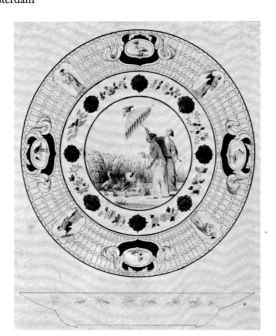

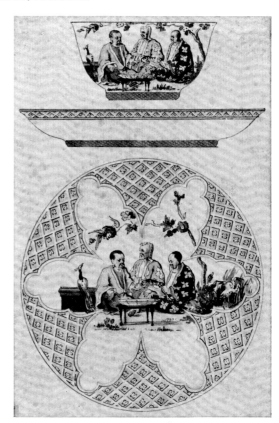

lain patterns appears not to have been pursued. All the remaining porcelains in this category of designed wares are stylistically contemporary with the Parasol pattern and can be assigned to the same period. There is no evidence from existing porcelains of later date or from accounts of the company of the further use of such designs; Pronk's subsequent relations with the company are apparently unrecorded. The relative failure of the venture may be attributed in part to the easy availability, and comparative cheapness, of engravings whose popularity and topicality assured a wider market for China trade porcelain than an individually commissioned design could normally command. But at the same time, Pronk's design obviously enjoyed a certain reputation, since it turned up in European porcelain some decades later on a plate made in Venice at the Cozzi factory (Figure 22).

NOTES

1 In the same color scheme as **24** are nine-inch plates in the Groninger Museum voor Stad en Lande and the Soame Jenyns collection; a tureen and candlestick, Palazzo Venezia, Rome; and a lighthouse coffeepot, Rijksmuseum. In the Gemeentemuseum, The Hague, is a nine-inch plate painted in rose, light blue, and light green, and a small famille rose dish is in the Mottahedeh collection. Two blue-and-white plates, with the scene altered and simplified, are in the Groningen Museum and the Museum Flehite, Amersfoort. A substantial portion of a service—including plates in several sizes, a sauceboat, covered butter dish and tureens—appeared recently on the New York art market.

2 J. de Hullu, "De Porceleinhandel der Oost-Indische Compagnie en Cornelis Pronk als haar Teekenaar," *Oud-Holland*, 1915, p. 52.

3 Ibid., pp. 61–62; translated by Volker, *Japanese Porcelain Trade*, p. 78.

4 Volker, *Japanese Porcelain Trade*, p. 57.

5 Ibid., pp. 58–59.

6 Ibid., p. 58.

7 J. P. Goidsenhoven also attributes to Pronk, but without evidence, a scene of a mandarin on a pair of vases formerly in the Wannieck collection, Paris (*La Céramique Chinoise*, Brussels, 1954 p. 193 pl. CII). For another design attributed to Pronk, see **25**.

8 Jenyns observes that even if the drawings are not by Pronk they are clearly the work of a Dutch artist inasmuch as two of his birds, the ruff and spoonbill, are native to Holland (*Japanese Porcelain*, 1965, p. 72).

9 De Hullu, "Porceleinhandel," p. 62; translated by Volker, *Japanese Porcelain Trade*, p. 78.

10 Volker is satisfied with the attribution of the Rijksmuseum drawing to Pronk himself, on the evidence of its similarity in style and color scheme to his genre watercolors (ibid., p. 80, n. 2).

11 Ibid., pp. 58 ff.

12 Ibid., p. 81.

FIGURE 21 Japanese porcelain plate in Parasol pattern. About 1740. Princessehof, Leeuwarden

FIGURE 22 Venetian porcelain plate in Parasol pattern. Cozzi factory, about 1765. Private collection. Photograph courtesy U. Mursia & C. Editore

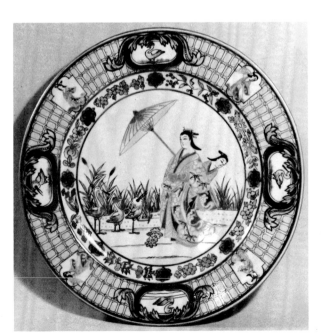

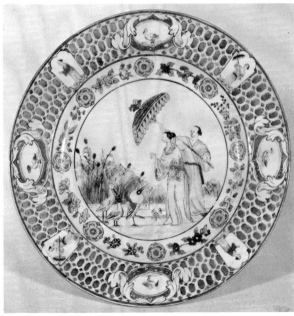

25 Part of a tea service

Design attributed to Cornelis Pronk (1691–1759)

Probably Dutch market, 1735–40

Dish D. 8, caddy H. 5⅜ in.

Accession 61.64. 1–8

Ex coll. (except caddy) Louis Huth; A. E. Cumberbatch, W. Martin-Hurst

Exhibited: Dorchester Hotel, London, Loan Exhibition of works of art in aid of the East London Hospital for Children, 1931 (no catalogue); Seventh Regiment Armory, New York, Seventh Annual East Side Winter Antiques Show, 1961 (cat. p. 33)

Circular dish, two tea bowls and saucers, creamer, caddy, and hexagonal teapot stand. Decoration in enamel colors. On each piece, a trellis diaper in black on yellow, with superimposed panache of seven plumes in violet and black, the turned-over ends of the plumes reserved in white. Tasseled lappets in violet and black border each piece except the caddy; on this a simple scalloped border substitutes on neck and cover. A band of scrollwork in relief encircles base of caddy.

The deliberate character of the decoration and coloring suggests a European design source. Both the spray of plumes—in its more conventional form a palmette—and the tasseled lappets are fundamental elements in the repertoire of baroque ornament; both are conspicuous in the decorative schemes of Jean Bérain, Daniel Marot, and their followers. Featured in designs for gardens, bed hangings, architectural interiors, and metalwork, these motifs were also borrowed by the porcelain painters of Vienna where, during the directorship of Claud du Paquier (1719–44) they were treated with similar boldness and formal balance. Analagous to the lappet borders are those on an olio pot (Figure 23) and on vases and vessels of about 1735.[1] At the same period both the palmette and the trellis diaper—the latter usually in richer variants—were also prominent in du Paquier decorative schemes; although the palmette was never rendered with the naturalism seen here, the two types are clearly derived from Marot's prototypes.

Another link with the du Paquier factory can be seen in the color scheme of **25**. Although it has been said that the unusual shade of violet here may have resulted from an accidentally high temperature in firing, deepening

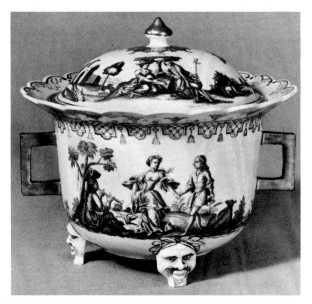

FIGURE 23 Porcelain olio pot. Viennese (du Paquier period), 1725–35. The Hans Syz Collection, The Smithsonian Institution, Washington

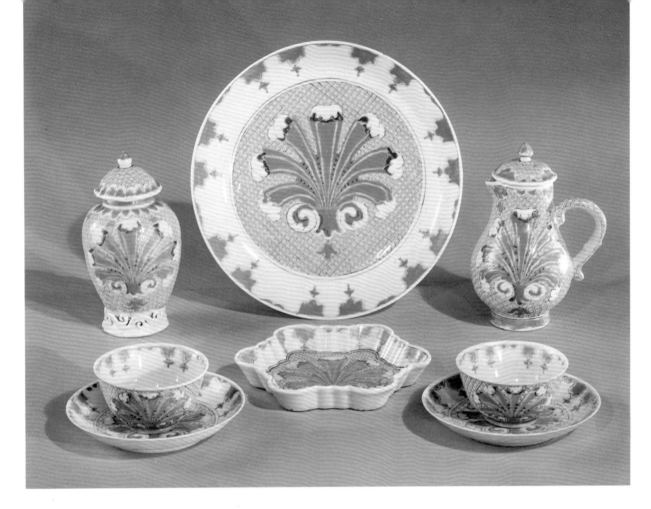

what would otherwise have turned out rose,[2] the striking contrast between the purple and yellow—far more dramatic than a rose and yellow combination—must have been intentional. And this is in character with the astringent color schemes of the du Paquier style. Mauve and violet provide the characteristic tonality of Viennese porcelain of the late 1720s and 30s, and although the thick yellow on this service was not in the Viennese palette it would have been known in Europe from its wide use on Yung Chêng porcelains.

This stylistic reference to du Paquier does not necessarily imply a direct Viennese source for the decoration of **25**. In this instance the design seems to be due more to an outsider's familiarity with that style than to work by a factory artist. Certain mannerisms associate this service with a China trade plate in the Victoria and Albert Museum (Figure 24). Common to both are the distinctively simplified trellis background, the spray of plumes, and the formality of the composition. The subject of the Victoria and Albert plate, an Oriental family group in a Western topiary garden setting, presents the same somewhat unresolved mixture of chinoiserie and baroque formality that characterizes Cornelis Pronk's Parasol pattern

FIGURE 24 Chinese porcelain plate with scene of Oriental family group in European garden setting, probably Dutch market. About 1735-40. Victoria and Albert Museum, London

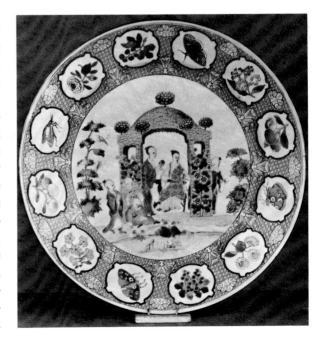

(24) and another subject attributed to him known as the Visit of the Doctors to the Emperor (Figure 20). Further comparisons between the Parasol and the Victoria and Albert plate may be made in regard to the general composition, which in each case consists of a central narrative subject, involving Chinese figures in a European setting, framed by a diaper border interrupted by cartouches of unusual shapes. Also comparable is the treatment of the insects on the border of the Victoria and Albert plate and those that parade around the outside rim of the Parasol plate (24). Working backward from Pronk's undoubted authorship of the Parasol pattern to the Victoria and Albert garden plate and this service, with their marked stylistic affinities, I think it reasonable to attribute the designs of the latter two also to Pronk.

Examples painted like 25 are rare. A teapot and hexagonal stand were recently on the London art market;[3] cups and saucers are in the Victoria and Albert Museum and in several private collections. Pieces of the same pattern in a color scheme of iron red and pale green have been referred to,[4] but no examples are known to me.

NOTES

1 J. F. Hayward, *Viennese Porcelain of the Du Paquier Period*, London, 1952, pls. 19 and 49d.

2 G. C. Williamson, *The Book of Famille Rose*, London, 1927, p. 57.

3 Sotheby & Co., 11 July 1967, lot 154 (saucer dish); Christie's, 13 November 1967, lot 48 (teapot).

4 Albert Jacquemart and Edmond Le Blant, *Histoire artistique, industrielle et commerciale de la porcelaine*, Paris, 1862, p. 104.

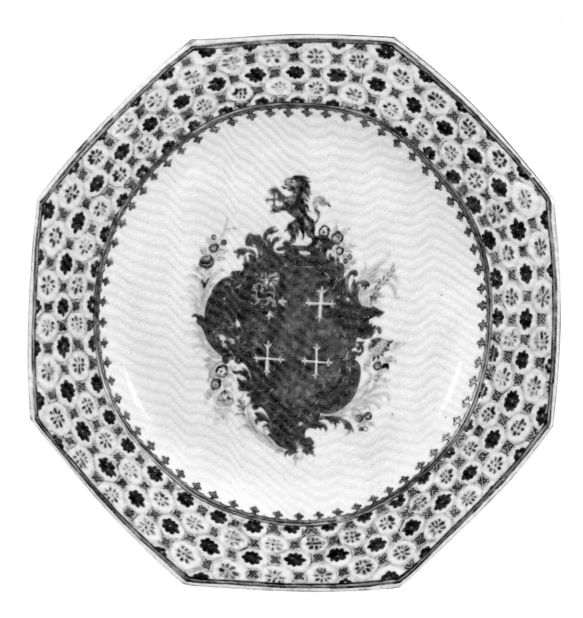

26 Plate

English market, about 1745

D. 8 9/16 in.

Accession 60.150.2

Arms: Gules four crosses patonce argent, on a canton or a lion passant azure langued gules. Crest: a lion rampant sable langued gules holding between the paws a cross patonce or. *Chase*

Decoration in enamel colors of blue, iron red, light turquoise, and pale green, with details in mauve, black, and gilt. Honey brown glaze on rim. In center: an armorial in rococo shield. On octagonal rim: a wide cell-diaper border edged on the inside with spearheads.

61

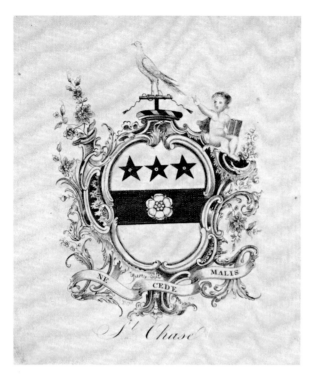

FIGURE 25 Armorial bookplate of Justice Samuel Chase, engraved by W. Boyd. American, about 1805–10

The identification of this service with a particular member of the Chase family poses historical and stylistic problems, since the coat of arms was used by branches of the family in London, Hertfordshire, and Bedfordshire in England, and in New England and Maryland in America. The service itself is variously said to be of English provenance[1] or to have belonged to Justice Samuel Chase of Maryland (1741–1811), a signer of the Declaration of Independence.[2] By exception, the style of the armorial (usually a reliable guide to dating) is equivocal. Clearly copied from an engraving, it displays the essential features—asymmetry, frilled border, natural flower sprays—of the so-called Chippendale bookplate. This style, seen on English silver as early as 1738 and fully developed by the early 1740s, was at its most characteristic in the middle of the century. Although it went out of fashion in England around 1770 it lingered in America into the first decade of the nineteenth century. The style of the armorial is, at any rate, somewhat later than the rest of the piece, which, with its polygonal form and prominent diaper border, is characteristic of Yung Chêng porcelains (1722–35). The arms have recently been identified as those of Sir Richard Chase (d. 1788) of Much

Hadham, Hertfordshire; and the explanation for the disparity of style may be found in a very similar service made about 1735 for Sir Richard's aunt, Hannah Chase, and her husband, William Jephson.[3] Rather than order the latest fashion in China trade porcelain Sir Richard seems to have been content with a slightly out-of-date family pattern.

How the American Samuel Chase came to be associated with the service is unclear. That China trade porcelain of this type should have been made for the American market this early is all but impossible. The participation of America in the China trade before 1784, when the *Empress of China* inaugurated direct commercial relations, was both intermittent and indirect. Although it has been suggested that certain pieces, such as the plates with the arms of Lee of Coton and views of London on the rim, were in the possession of American relatives of the original English purchasers during the colonial period, there is no evidence that armorial porcelain was ordered from America prior to 1784. Justice Chase is known to have possessed an armorial service, but the

FIGURE 26 Chinese porcelain sugar bowl with the Townley arms, from a service possibly made for Samuel Chase, American market. About 1790. The Metropolitan Museum of Art, Bequest of James T. Woodward, 10.149.233

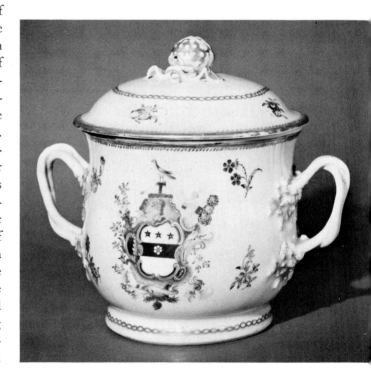

description of it in the inventory after his death ("A dinner service of china, white and gold with coat of arms, appraised at $45"[4]) hardly corresponds to **26**. It corresponds somewhat better to a 248-piece dinner service in the American Wing of the Metropolitan Museum painted with an entirely different coat of arms. American heraldry has always been something of a hit-or-miss affair, very little attention being paid to its genealogical restrictions. His bookplate (Figure 25) shows that Judge Samuel Chase not only did not use the arms registered for his family name but adopted those of his uncle's wife, a Miss Townley.[5] The Chippendale armorial of

the American Wing's service would seem to have been painted from an earlier version of this bookplate, to judge from the slightly different treatment of the flowers and the absence of a motto. Although the Townley-Chase service has been dated as early as 1750–60 on the basis of the armorial,[6] we have seen that its style lasted well beyond that time in America, and such pieces as the covered cups with intertwined handles and grape cluster terminals (Figure 26) indicate a later dating of perhaps 1785–90, which would be consonant with the Sino-American trade and with Samuel Chase's own life.

NOTES

1 Christie's, 22 January 1925, lot 25, identified as those of Chase of Chesham; Sotheby & Co., 25 May 1954, lot 171, identified as Chase of Much Hadham.

2 Algernon Tudor-Craig, "Chinese Armorial Porcelain," *Antiques*, August 1928, pp. 126–127; Wilmington Society of the Fine Arts, *Chinese Export Porcelain and Enamels*, exhibition catalogue, Wilmington, 1957, no. 220.

3 I am grateful to David Howard for making the genealogical connection between the two services and for settling the origin of the present one.

4 Unpublished notes in the Maryland Historical Society kindly communicated by John D. Kilbourne.

5 Richard Chase married Margaret Townley in London in 1714 and emigrated to Maryland about 1736. This service has traditionally been said to have belonged to their son Jeremiah (d. 1828), but extensive research into the possessions of the Chases of Maryland has not shown that he ever owned armorial China trade porcelain. Again this information is from John D. Kilbourne. The motto on Samuel Chase's bookplate is thought to refer to his impeachment and acquittal of 1804–05, which would date this example of his bookplate about 1805–10. The engraver, W. Boyd, is recorded as working about this time.

6 Mudge, p. 105.

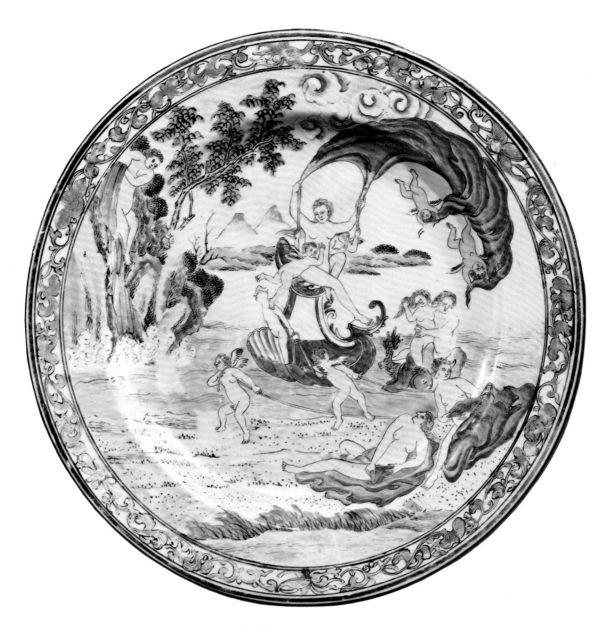

27 Plate

Continental market, 1730–40
D. 8^{15}/$_{16}$ in.
Accession 62.12

Decoration in grisaille and enamel colors of rose, blue, yellow, and shades of green. In center, a scene representing Water, after Francesco Albani (1578–1669). Around the rim, a narrow border of scrolled leaves and flowers in grisaille, filled in with gold. Edge of rim painted dark brown. Exterior undecorated.

Albani painted a set of four mythological scenes representing the elements for the Borghese Palace. Because of their popularity he later painted three variant series, the best known of these being the one for Cardinal Maurice of Savoy in 1635, now in the Turin Museum.[1] The four paintings were engraved by several artists, among them Antoine Herisset (1685–1769) (Figure 27). Albani's scene has been simplified on **27**, with the omission of several figures.

The popularity and widespread repetition of mythological subjects at different periods by engravings makes it difficult to pinpoint a market or date for China trade porcelain of this type.[2] Differences in renderings and secondary decorations make it clear that these porcelains were executed for different customers at different dates. The dating for **27** is suggested, rather, by its border pattern; borders with only minor differences are found on porcelains that, on other evidence, may be assigned to 1730–40.[3]

A complete series of China trade plates of Albani's Elements was formerly in the Martin-Hurst collection;[4] a version of Fire is in the Musée Guimet, of Earth in the S. Stodel collection.[5] All are painted in famille rose, and all have the border ornament of **27**.

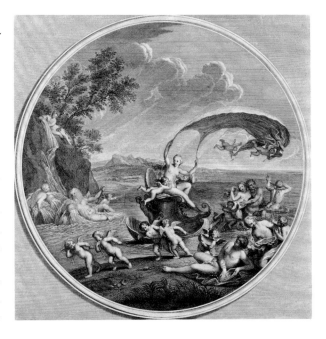

FIGURE 27 *L'eau*, engraving by Antoine Herisset (1685–1769), after one of four paintings depicting the elements by Francesco Albani. The Metropolitan Museum of Art, Harris Brisbane Dick Fund, 53.600.4161

NOTES

1 Ulrich Thieme and Felix Becker, eds., *Allgemeines Lexikon der Bildenden Künstler von der Antike bis zur Gegenwart*, Leipzig, 1907–50, s.v. "Albani."

2 See the several grisaille and polychrome versions of Les pèlerins de l'Isle de Cythère (Phillips, pl. 55) and variant renderings of several biblical subjects.

3 For example, two armorial plates in the Metropolitan Museum, one with arms said to be those of Eldred Lancelot Lee (d. 1734) (58.126), the other with the arms of Harries (51.86.321).

4 G. C. Williamson, *The Book of Famille Rose*, London, 1927, pl. XXXIX.

5 Beurdeley, no. 129; Scheurleer, *Chine de Commande*, fig. 223.

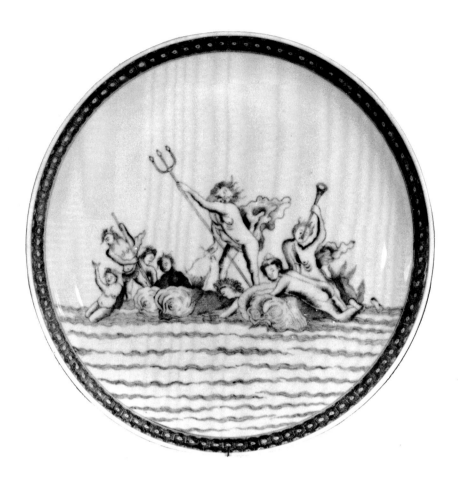

28 Plate

Continental market, about 1730
D. 8 in.
Accession 66.27.5

Decoration in underglaze blue. Neptune astride dolphins, accompanied by tritons and nymphs. At rim, a narrow cell diaper.

The scene is copied from the left half of a composition by Abraham Bloemaert (1564–1651) (Figure 28). It originated in his drawing book, a collection of several hundred figure and landscape studies, genre, mythological, and religious subjects intended to be—and, indeed, extensively—used as a copy book for artists. (Another composition from it often found on China trade porcelain shows a boy fishing by a river bank.)[1]

Larger dishes painted with the same subject in blue and in black[2] include a border decoration of flower sprays very like those on the back of the Peers plates of 1731 (**23**).

FIGURE 28 Detail of illustration from Abraham Bloemaert's drawing book, engraved by his son, Frederick (1610–about 1669). The Metropolitan Museum of Art, The Elisha Whittelsey Collection, 49.95.497 (136)

NOTES

1 Clare Le Corbeiller, *China Trade Porcelain*, China House, New York, 1973, cat. 26.

2 Ibid., cat. 24.

66

29 Plate

European market, 1730–40
D. 8¾ in.
Accession 65.50

Decoration in black and gold. In center, the Nativity. Around the gilt-edged rim, a border of cartouches, strapwork, and flowers.

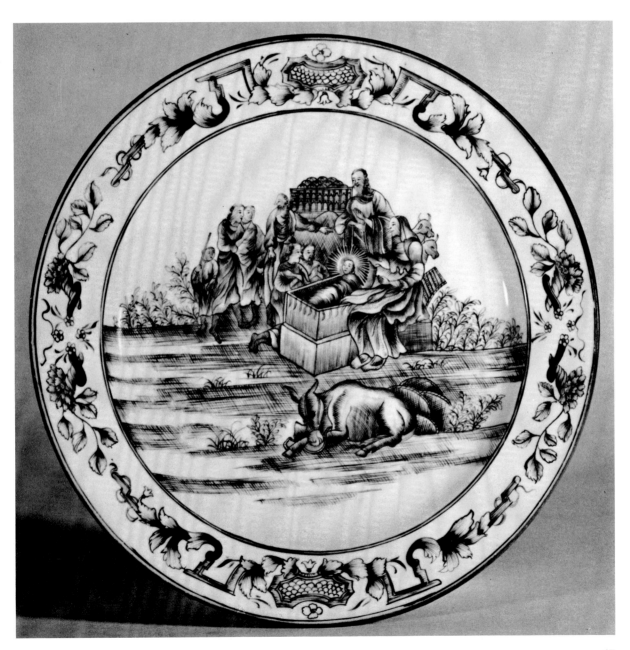

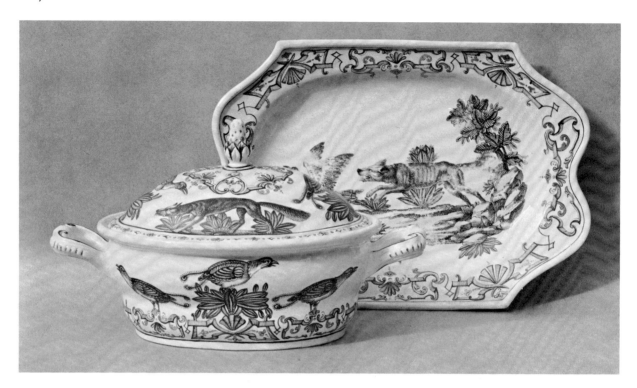

FIGURE 29 Porcelain tureen and tray from the Jagd service. Viennese (du Paquier period), about 1730–40. The Metropolitan Museum of Art, Gift of R. Thornton Wilson, 1950, in memory of Florence Ellsworth Wilson, 50.211.13a, b

In 1722 Père d'Entrecolles reported that the Chinese were experimenting with painting in black, so far unsuccessfully (Introduction, note 49). Black, or schwarzlot, decoration, was also then just being developed in Europe, and in fact the German *Hausmaler* was putting it primarily on Chinese porcelain imported in the white, rather than on wares from the newly established Meissen factory. It must have been these hybrids that were sent back to Canton for imitation at the time of Père d'Entrecolles's letter, but the perfection of the technique and its translation into commercial export porcelain came only later, under the direct influence of the du Paquier period (1719–44).

Unique to the du Paquier factory was the *Laub- und Bandelwerk* border, based on two series of engravings by Paul Decker (d. 1713). Continually modified and varied, its essential elements were strapwork, palmettes, trelliswork cartouches, and foliate scrolls combined into a rhythmical pattern of baroque formality. The scale-filled cartouches of **29** have been called an inveterate feature of

the last years of the du Paquier period.[1] While the variant on this plate is not known to me from an exact Viennese model, it is in its general style and in the particular manner in which the strapwork has been filled in with shaded and hatched lines markedly similar to painting attributed to Jakob Helchis on pieces for the Jagd service of about 1730–40 (Figure 29). Other China trade versions of the *Laub- und Bandelwerk* border, such as the more usual one with the addition of a peacock and with panels of quilting rather than trellis- or scalework (Figure 30), are farther removed from their Viennese factory prototypes, and are perhaps derived from *Hausmaler* variants.

A further correspondence between **29** and the Jagd service is apparent in the rendering of the pictorial subject in careful imitation of an engraving. It was under du Paquier's directorship that this use of schwarzlot—admirably suited to the purpose—was fully developed, being executed with a characteristic density of blackness that was softened by later artists, both in Europe and China, to a more delicate grisaille (see **31**). The Nativity scene is not known to occur on du Paquier porcelain; other biblical subjects only rarely. Two du Paquier plaques in the Metropolitan Museum depict the Flight into Egypt (Figure 31) and the Holy Family with the Infant St. John. Although painted in colors, they are affinite

to **29** in their subject and in their obvious faithfulness to engraved compositions.

The character of the pseudoengraved biblical porcelains is quite different from those painted on China trade porcelain in blue or colors with scenes from the Old and New Testaments. However, all have from time to time been loosely designated "Jesuit ware." And, indeed, the Jesuit missionaries were not uninterested in porcelain, having sent home nineteen cases "for their own account" on the *Amphitrite* in 1703.[2] Attributable to a specifically religious or sectarian market are several pieces ranging in date from the mid-seventeenth century to about 1740: a vase with the Sacred Monogram and the Flight into Egypt; a bottle with the Franciscans' insignia;[3] a square bottle with the Ascension and instruments of the Passion;[4] a famille verte vessel in the Lisbon Museu de Arte Antiga painted with the Sacred Monogram; a Yung Chêng tea caddy with a portrait of Saint Ignatius Loyola; and a Ch'ien Lung enameled bowl depicting the Crucifixion with the Passion instruments.[5] But the painted biblical porcelains with their various (not to say, secular) border patterns originated elsewhere. Père d'Entrecolles, in his first letter of 1712, mentioned seeing a plate painted with a scene of Christ on the Cross between the Virgin and Saint John, adding that "this kind of porcelain was

FIGURE 30 Chinese porcelain bowl and cover with black-painted decoration, Continental market. 1730–40. The Metropolitan Museum of Art, The Helena Woolworth McCann Collection, Gift of the Winfield Foundation, 51.86.17

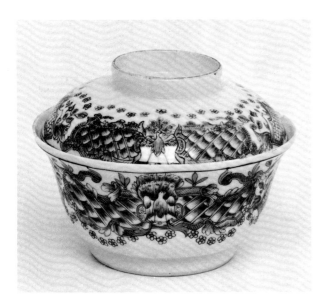

FIGURE 31 Porcelain plaque with scene of the Flight into Egypt, polychrome. Viennese (du Paquier period), about 1730. The Metropolitan Museum of Art, Gift of R. Thornton Wilson, 1951, in memory of Florence Ellsworth Wilson, 51.1.1

shipped sometimes to Japan, but this kind of commerce came to an end sixteen or seventeen years ago"[6] (that is, about 1695). A blue-and-white bowl in the British Museum[7] appears to correspond to the scene Père d'Entrecolles was referring to, but its inspiration—however adaptable to Jesuit purposes—would seem to have been Protestant. It is certainly related to an English (probably Lambeth) delftware plate in the Ashmolean Museum dated 1698:[8] the composition is in all essential respects identical and would have been borrowed, together with its *ju-i* and scroll borders, from a Dutch original. So, too, a China trade plate showing the Baptism of Christ (Figure 32) echoes—even to its incongruous border of putti—Delft biblical plates of the latter half of the seventeenth century (Figure 33). What has been called carelessness or naïveté on the part of the Chinese painters is in fact the literal rendering of the impromptu style of the Dutch models. Although the subjects can perhaps all be traced to engravings,[9] it is clear from peculiarities of style that the painted China trade biblical porcelains were copies from painted examples of Protestant Dutch or English pottery, while the much more carefully black-drawn scenes, with their du Paquier borders, were copies either from engravings or from Viennese porcelain prototypes and were quite possibly meant originally to cater to a specifically Jesuit market.

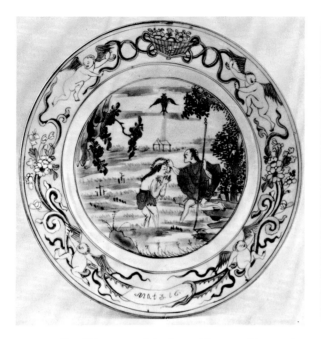

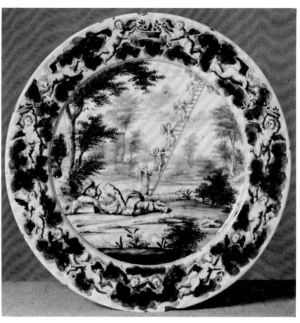

FIGURE 32 Chinese porcelain plate, with scene of the Baptism of Christ painted in iron red, probably Dutch market. About 1720. Museum of Fine Arts, Boston

FIGURE 33 Earthenware plate depicting Jacob's Dream. Delft, De Roos factory, 1675–80. Victoria and Albert Museum, London

NOTES

1 J. F. Hayward, *Viennese Porcelain of the Du Paquier Period*, London, 1952, p. 102.

2 Gregor Norman-Wilcox, "Jesuit China: A Misnomer in China Trade Porcelains," *Los Angeles County Museum of Art Bulletin*, XVI, 4, 1964, p. 19.

3 Beurdeley, cat. 235 and fig. 98.

4 Ibid., fig. 97.

5 Ibid., cats. 231 and 233.

6 Letter of 1 September 1712 (S. W. Bushell, *Description of Chinese Pottery and Porcelain*, Oxford, 1910, p. 207).

7 Margaret Jourdain and R. Soame Jenyns, *Chinese Export Art in the Eighteenth Century*, London, 1967, fig. 86.

8 Anthony Ray, *English Delftware Pottery*, London, 1968, pl. 18.

9 Illustrations such as those by Mathieu Merian père (1595–1651) in *Figures de la Bible*, Amsterdam [n.d.], or in the *Icones biblicae*, Strasbourg, 1625. On the other hand, Arthur Lane observes that the biblical subjects appearing on Delft tiles "often seem to be the naïve conceptions" of the painters themselves (Victoria and Albert Museum, *Guide to the Collection of Tiles*, London, 1939, p. 51).

30 Pair of plates

Scottish market, 1735–45

Ds. 15¼ and 15 in.

Accession 62.187.1, 2

Arms: Azure a chevron between three boars' heads erased or. *French*

Principal decoration, in gold and black, in the manner of an engraving, a luxuriant basket of flowers. The rims gilded. On each base, a coat of arms in enamel colors.

The compositions were adapted from a set of floral subjects designed and engraved by Jean Baptiste Monnoyer (1634-99) and published about 1670 under the title *Livres de Plusieurs Paniers de Fleurs*. Parts of two of Monnoyer's engravings (Figures 34, 35) have been reversed and joined, with some minor alterations and additions, to produce the basket on plate 1. The left half of a third engraving (Figure 36) corresponds to the right half of the basket on plate 2; the remainder of the composition, thoroughly in character but not included in the *Livres de Plusieurs Paniers*, must have been borrowed from another of Monnoyer's engraved designs. Since Monnoyer emigrated to England in 1679, and because the arms are those of a Scottish family, the artist responsible for the recompositions was presumably English, and may have been John Smith (about 1652–1742), whose prodigious output included at least two mezzotints of Monnoyer's flower vases.

Only three armorial services are known with arms painted on the bases of plates.[1] Another pair of dishes with the French arms (Figures 37, 38) is painted with comparable skill and refinement with scenes after Eustache le Sueur (1617–55) and armorials identical with those on **30**. The two pairs of dishes, perhaps part of a single order, denote an aspect of the China trade quite different from the reportorial one of, say, the Rotterdam riot plates (**12**). Unmatched, so far as is known, in size, quality, and subject, they indicate a very personal taste on the part of their original owner. The arms are traditionally identified with Robert French (1704–58), last laird of Frenchland, Berwickshire. Nothing appears to be known about him today beyond the facts that he accumulated great wealth in trade after 1730 when the Frenchlands estate was sold,[2] and that he left no sons. The armorials on **30** are in keeping with the heraldic style of the early 1730s:[3] the set may therefore reflect Robert French's restored prosperity shortly after 1730.

NOTES

1 The other two, according to information supplied by David Howard, are the services of Walpole impaling Cavendish, datable to 1748–56, and of Fisher, about 1752–56.

2 Again, information supplied by David Howard. The arms can easily be misread as griffins' heads, with what appear to be pointed beaks and forked tongues. They are, however, the typical Scottish boars' heads, erased "close," that is, behind the ears. Mr. Howard possesses a plate with the same arms made about 1775 for a member of another branch of the family.

3 See, for example, a plate with the arms of Eldred Lancelot Lee, d. 1734 (Phillips, fig. 7).

73

FIGURES 34, 35, 36
Three engravings by Jean
Baptiste de Monnoyer
from *Livres de Plusieurs
Paniers de Fleurs.* About
1670. The Metropolitan
Museum of Art, Rogers
Fund, 20.61.2 (33-5)

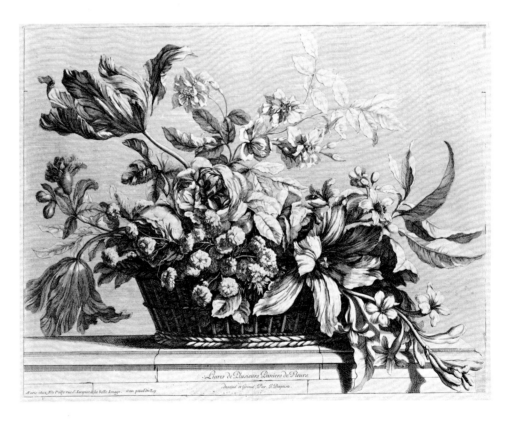

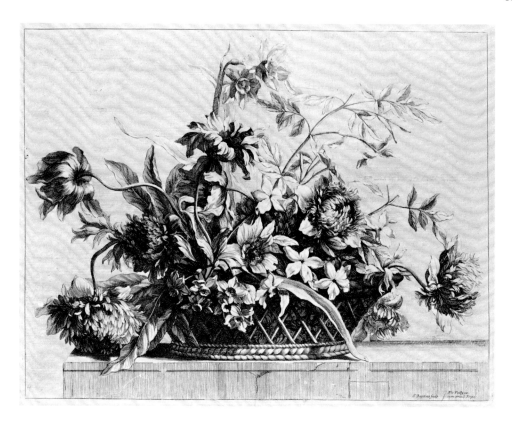

FIGURES 37, 38 Two Chinese porcelain plates with French arms and scenes painted after Eustache le Sueur, Scottish market. 1735–54. British Museum, London

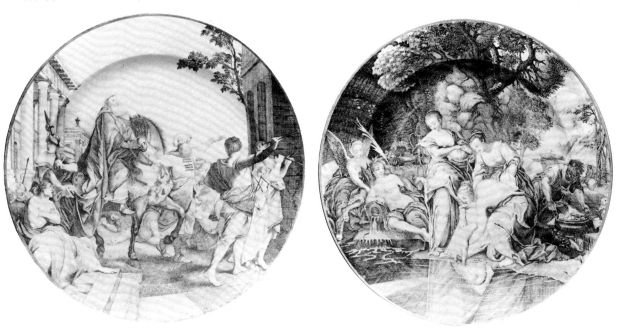

31 Pair of plates

English market, about 1740
Ds. 11 in.
Accession 60.78.1, 2

Decoration in grisaille. Plate 1: eagles with prey and vultures. Plate 2: tropical birds in a riverscape. Rims: a narrow gilt band with a double-line border in iron red. Exteriors undecorated.

Six similarly painted plates are known,[1] and the set of eight, probably complete, seems to be another specialized order like **30**. The avian subjects, different on all the plates, are executed with uncommon sensitivity and care.

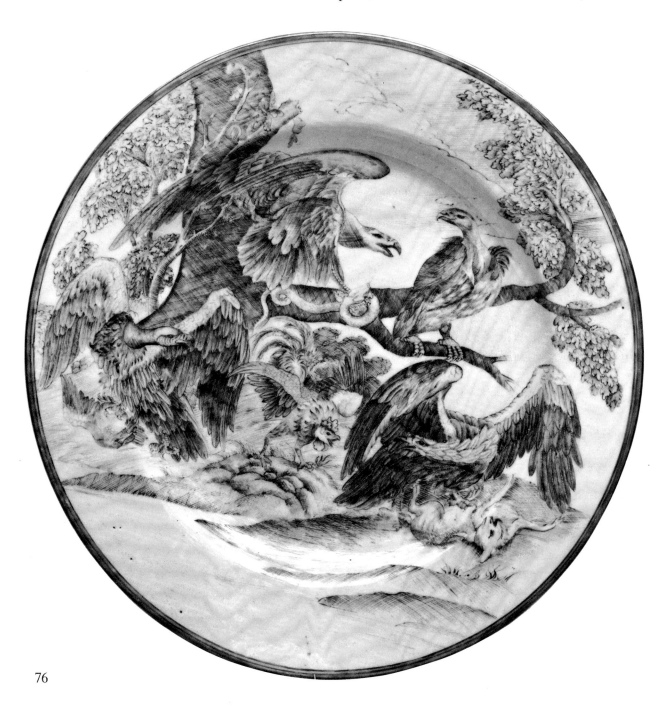

They appear to derive ultimately from drawings by Francis Barlow (about 1626–1702). Thoroughly original in his domestic, hunting, and barnyard scenes, Barlow was less so in his specimen studies of birds, in which he borrowed freely from Dutch and French exemplars. It has been suggested[2] that he spent some years during the Commonwealth in Holland, where he would naturally have been exposed to the style of Hondecoeter and his school. And in Antwerp at the same time (about 1650),

Pieter Boel (1622–74) was engaged in similar work that Barlow may have known at first hand. The eagle and vulture on the tree limb on plate 1 repeat a composition by Boel as engraved by Gérard Scotin (Figure 39); but the eagle with the serpent also appears, in reverse, in an engraving by Francis Place (1647–1728) (Figure 40), the drawing for which is attributed to Barlow. This casual plagiarism was standard practice in the seventeenth and eighteenth centuries, but Barlow at least absorbed his

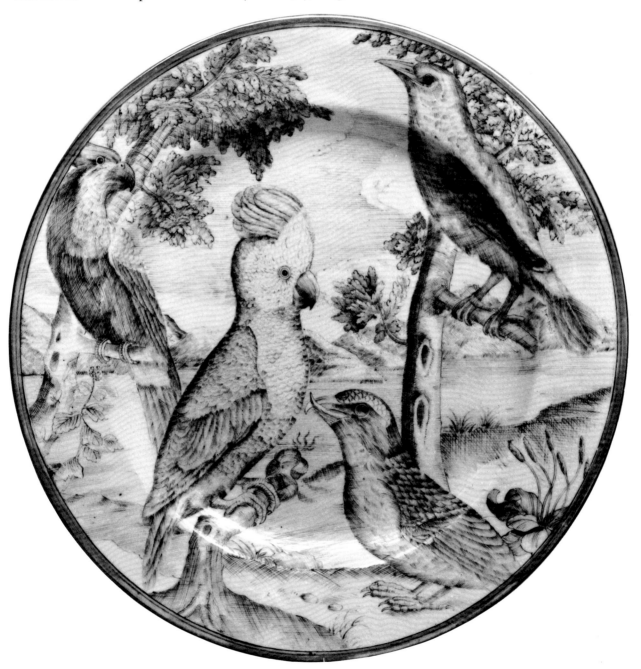

FIGURE 39 Anonymous engraving of eagles and vulture after a composition by Pieter Boel (1622–74). French, early eighteenth century. The Metropolitan Museum of Art, The Elisha Whittelsey Collection, 51.501.1215

gleanings into new compositions. Supplementing his version of Boel's eagle and serpent on plate 1 are the figures of the cock and birds in the foreground; the eagle on the right is anticipated by a drawing that establishes the position of the prey (Figure 41). Whether the composition of this drawing was original to Barlow or was his adaptation of other work is undetermined. Similarly, Barlow's drawing of peacocks, ostrich, and cassowary (Figure 42), found on another of these plates in a version by a contemporary follower (Figure 43), combines exotic and domestic elements in a compilation of Dutch material with Barlow's own work.

FIGURE 40 Engraving of eagle with a serpent by Francis Place (1647–1728) after a drawing attributed to Francis Barlow (about 1626–1702). The Metropolitan Museum of Art, Harris Brisbane Dick Fund, 17.3.2821

The sources for the decoration of plate 2 are equally indirect. The cockatoo and parrot appear in reverse in an engraving by Nicolas Robert (1614–85) (Figure 44). one of twenty-four comprising his *Receüil d'Oyseaux les plus Rares tirez de la menagerie Royalle du Parc de Versailles*, published in 1676. Elements from several of Robert's engravings reappear, reversed in new juxtapositions, in this set of eight plates, sometimes in combination with Barlow's eagles. The recomposition was Barlow's doing; the transformation of his drawings into the highly finished engravings copied by the Chinese was largely, if not entirely, the work of Francis Place. Place's engraving provided the model for a barnyard scene on one plate;[3] the swooping eagle in the center of another is seen as the focus of a quite different composition by Barlow engraved by Place;[4] Place's reworking of Boel's eagle and serpent has been noted, while the description of his "cock in fighting attitude between an eagle and a vulture tearing their prey"[5] seems to correspond to the foreground scene

FIGURE 41 An Eagle and a Hare by Francis Barlow (about 1626–1702). Drawing with pen, brown ink, and gray wash on brown paper, 14.4 × 18.18 cm. Courtauld Institute of Art, London

FIGURE 42 Drawing of peacocks, ostrich, and cassowary after Francis Barlow (about 1626–1702). Henry E. Huntington Library and Art Gallery, San Marino

FIGURE 43 Chinese porcelain plate with scene of peacocks, ostrich, and cassowary copied from an engraving based on a drawing after Francis Barlow, English market. About 1740. Zeeuws Museum, Middelburg

FIGURE 44 Engraving of a cockatoo and parrot by Nicolas Robert from *Reciieil d'Oyseaux les plus Rares tirez de la menagerie Royalle du Parc de Versailles*, 1676. The Metropolitan Museum of Art, The Elisha Whittelsey Collection, 56.644.21

of plate 1. Engravings by Place that would confirm the transition between Nicolas Robert and the Chinese versions of his work have not been discovered, but they may possibly figure in a letter from Pierce Tempest, the publisher, to Place on 9 January 1685/6 in which he reports that "*Barlow* is now beginning with some of the large designes of *birds* I will have a Plate ready August you come up."[6] Other engravers of Barlow's work, in addition to the artist himself, were Wenceslaus Hollar (1607–77) and Jan Griffier I (1645–1718). Griffier is said to have provided the intermediate stage between Barlow's drawing of ostriches and the Chinese version.[7]

NOTES

1 Five are in the Bal collection at the Zeeuws Museum, Middelburg; one in the Mottahedeh collection, New York.

2 Guy Paget, "England's First Sporting Artist: Francis Barlow," *Apollo*, January 1945, p. 10; Philip Hofer, "Francis Barlow's Aesop," *Harvard Library Bulletin*, II, 1948, p. 286.

3 Scheurleer, *Chine de Commande*, figs. 298, 299.

4 An example of the engraving is in the Print Department at the Metropolitan Museum (17.3.2837).

5 H. M. Hake, "Some Contemporary Records Relating to Francis Place," *The Walpole Society*, X, 1921–22, p. 53.

6 Ibid., p. 65. The key to the Boel-Robert-Barlow-Place relationships may be in the unexplored collection of engravings by Place after Barlow in the British Museum.

7 Scheurleer, *Chine de Commande*, p. 155.

32 Covered tureen and pair of plates

German market, 1745–55

Tureen H. 7⁹⁄₁₆, L. 12½ in.; plates D. 9 in.

Accession tureen 64.53a, b; plates 1970.96.1, 2

Arms: Grand quarterly of nine; I. Jülich, Magdeburg, Mecklenburg, Cassuben; II. Brandenburg, Geldern, Stettin, Pomerania; III. Cleves, Berg, Wenden, Crossen; IV. Kammin, Halberstadt, Ruppin, Meurs; V. Jägerndorf, Nürnberg, Mecklenburg-Schwerin, Ratzeburg; VI. Mindne, Wenden, Hohenzollern, Marck; VII. Regenstein, Tecklenburg and Linden impaled, Lauenberg, Rostock; VIII. Ravensberg, Hohenstein, Leerdam, Ravenstein; IX. Schwerin, Buren, Stargard, Breda. En surtout, top to bottom: 1. scepter of the Holy Roman Empire (borne by the Elector of Brandenburg); 2. Prussia; 3. Orange-Neuchâtel; 4. Motto: Gott mit uns. The shield is encircled by the collar and badge of the Order of the Black Eagle. *Frederick II, King of Prussia* (1712–40–86)

Decoration in enamel colors and gilt. Tureen oblong with canted corners. Centered on each long side, the complete armorial achievement of the Hohenzollerns. The Prussian eagle is repeated on the cover, painted at each end; modeled as the finial, it faces the wrong way heraldically.[1] Narrow bands of a T-motif drawn in black

on a gilt ground border the rims of the tureen and cover. The handles of the tureen are hares' heads. The same armorial achievement appears on the plates. Their undulating rims are painted in gilt with a wide border of lacework in the Meissen style, interrupted at the top by the eagle crest. Exterior of the plates undecorated.

Little China trade porcelain was made for the German market. Although much of Europe's enthusiasm for Chinese porcelain in the late seventeenth century had been generated by the collection of German princes,[2] those collections were rarely extended in the eighteenth to include export ware. For one reason, direct contact between the separate German states and China was minimal: the ships of one East India company founded by the Elector of Brandenburg in 1684 failed to reach China, and a second company, established by Frederick the

Great in 1751, was brought to an end by the Seven Years' War (1756–63).[3] Another, more fundamental, reason was the successful manufacture of hard-paste porcelain at home, first at Meissen, subsequently throughout Germany. This curtailed the desire to import it from China. Only a handful of armorial services[4] seem to have been made for the German market, and all, perhaps significantly, are associated with princely families: Hohenzollern, Anhalt, Schleswig-Holstein, Mecklenburg-Schwerin.[5]

Two rather romantic accounts attach to **32**. According to one, the ship carrying the service from Canton ran aground on the East Frisian island of Borkum before it could reach Emden, the Prussian East India Company's home port. The ship was refloated, but the damaged service—thought to have been ordered by the company for presentation to the king—was stored at Emden and

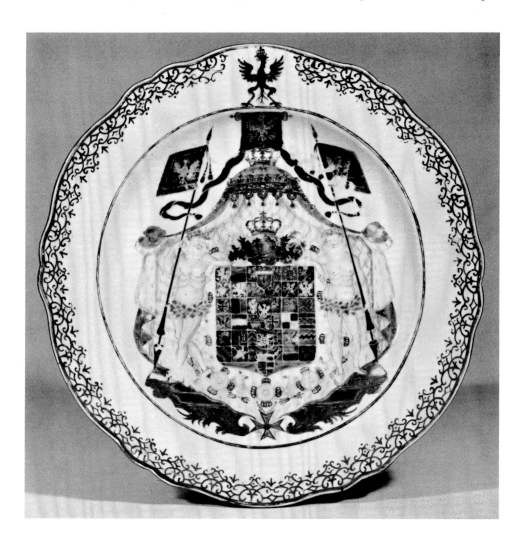

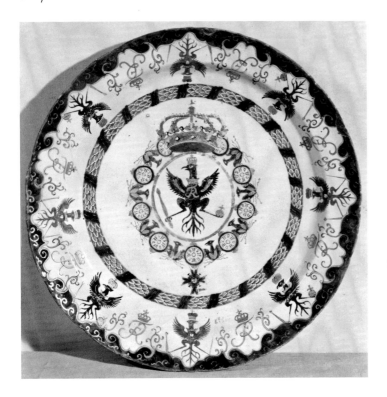

FIGURE 45 Delft armorial plate with monogram and Order of the Black Eagle, from a table service made for Frederick I. Early eighteenth century. Musées Royaux d'Art et d'Histoire, Brussels

sold there in 1757 when the company was disbanded.[6] The other story asserts that the service was ordered by the town of Leer (a few miles south of Emden) as a gift to Frederick following the victorious close of the Seven Years' War. He refused it, the story goes, because he had no money left with which to make a reciprocal gesture, and the service was divided up among the townspeople.[7]

The first tradition is the more plausible. Stylistically and heraldically all the German services are compatible with a date somewhat before rather than after the Seven Years' War;[8] further, two Prussian ships were in Canton during the 1753/4 season and another in 1756,[9] and it would have been natural for their return cargo to include armorial porcelains for the king and others of the nobility.

It is just as possible, however, that the Dutch VOC was instrumental in procuring the Hohenzollern and other German-market porcelains. A long-standing rapport between Prussia and Holland is reflected, ceramically speaking, in a Delft table service made early in the century for Frederick I (d. 1713), decorated with the same monogram and order of the Black Eagle that appears on 32 (Figure 45). And somewhat later it would certainly have been the Dutch who—following the marriage of their Stadholder William V to Frederick William II's sister Wilhelmina—ordered a China trade service with the accosted arms of Orange and Prussia.[10] A further connection is seen in the border of the tureen. An unusual one for China trade porcelain, it apparently occurs on only one other service, bearing the arms of the Dutch family Famars.[11] Despite its air of neoclassicism, evocative of Josiah Wedgwood's border designs of the 1770s, it is clearly contemporary with the Famars arms, which are painted in the typical heraldic style of 1755–60, a dating entirely compatible with the German service. The plates would seem to be a little earlier. The lacework borders, copied from Meissen versions of about 1725–40, are rarely found on export porcelains after 1750; and the timeliness of the decoration—especially of a sort that Frederick could have acquired more readily than by way of China—would normally have figured in the choosing of the pattern. A possibility that the plates were copied altogether from Meissen originals must be discounted. Although Frederick is known to have patronized the Saxon factory as early as 1744,[12] there is no evidence of any armorial porcelain being ordered by or for him, and even his later commissions of tablewares—too late to reflect the style of 32—were impersonally decorative.[13] Widely used as a frame for pictorial subjects, this particular border and its variations were stock patterns, readily available for any order.

NOTES

1 Broken, it has been repaired along the lines of damage. On another tureen from the service the eagle faces straight ahead.

2 The earliest was the Electress Louise Henriette's porcelain cabinet at Oranienburg (1652–67), redesigned from 1688 to 1695 by Frederick William III. Frederick also developed a porcelain collection at Charlottenburg (1695) for his wife, Sophie Charlotte.

3 Seven Prussian ships are recorded at Canton from 1753 to 1791; two, and perhaps all five, of the German ships in service after 1763 were there on behalf of other companies.

4 Other export porcelains with pictorial subjects or border patterns derived from Meissen prototypes are excluded from this reckoning, since they were presumably not made for the German market. As luxury ware, Meissen porcelain was accessible to English and Continental buyers chiefly through Chinese versions.

5 Pieces from the Hohenzollern service matching this tureen are in the Staatliche Museen, Berlin, and the Huis Doorn, Holland. A tray with the Anhalt arms is in the Metropolitan Museum (51.86.437); pieces from a service with the accosted arms of Anhalt and Schleswig-Holstein are in the McCann collections at the Museum of Fine Arts, Boston, and the Metropolitan Museum. A platter with the Mecklenburg-Schwerin arms was sold at Sotheby & Co., 18 June 1968, lot 131.

6 Johannes Gutschmidt, "Das Chinesische Tafelservice mit dem groszen Königlich Preuszischen Staatswappen," *Zeitschrift des Vereins für die Geschichte Berlins*, 52, 1935, as summarized by A. Westers, "Een wapenschotel van chine de commande," *Bulletin Museum Boymans-van Beuningen*, X, 1959, pp. 39–41.

A good shipwreck story is hard to put down, and this one is reinforced by the Princess Hermine, second wife of Emperor Wilhelm III, in her memoirs *An Empress in Exile: My Days in Doorn*, New York, 1928. She describes pieces from this service in the smoking room of the castle as having been ordered for Frederick the Great, wrecked in the North Sea, and accidentally discovered and salvaged about 1910.

7 In private correspondence.

8 The Anhalt-Zerbst/Schleswig-Holstein service is presumed to have been made for Christian Augustus and Johanna Elizabeth, parents of the future Catherine the Great, on his succession in 1746. The Anhalt-Dessau service, which incorporates the monogram L in the arms, must have been made during the short rule, 1747–51, of Leopold II. The arms on the Mecklenburg-Schwerin tray would seem to be those of Christian Lewis II (d. 1756). The heraldry of the Hohenzollern services is noncommittal, being the standard *grossewappen* of the Prussian monarchy during Frederick the Great's reign. The only deviation is the substitution of an unidentified shield in place of the arms of East Friesland, which from 1732 customarily occupied the lowest of the four superimposed shields.

9 Morse, I, p. 291; ibid., V, p. 46.

10 Staatliche Museen, Berlin.

11 Metropolitan Museum, 51.86.366.

12 Ordering, for example, figures of Apollo and the Muses modeled by J. J. Kändler.

13 As examples, a flower-decorated service ordered in 1761 for General von Möllendorff, and snuffboxes for himself.

33 Plate

Dutch market, about 1740
D. 8¹⁵⁄₁₆ in.
Accession 60.9

Decoration in enamel colors and gilt. In the center, framed by gilt scroll and brown lappet borders, Dutch ships in Capetown harbor. The scene is painted chiefly in tones of brown, blue, and green. At rim, a wide gilt lacework border.

The view is from the southwest, somewhat beyond the harbor. The ships in the foreground are said[1] to represent the fleet that established Dutch possession of the territory in 1652. The square fort at the left, or eastern, edge of the city was built by Capetown's founder, the surgeon Jan van Riebeck. Behind rises the flat-topped bulk of Table Mountain, flanked on the northeast by the Devil's Peak and on the west by the two humps of the Lion: the Lion's Head, and, to the right, the Lion's Rump, or Signal Hill.

The site of Capetown had long been known to the Portuguese, and Table Mountain, 3500 feet high, owes its name to Antonio de Saldanha who, in 1503, was the first European to ascend it. The advantages of the site became apparent with the regular commercial voyages of the seventeenth century: The Dutch East India Company was quick to recognize the value of a resting point about midway in the six-month trip between Holland and Canton.

The earliest illustrations of the city, published in 1660 by Jan de Vingboon, show a far less developed site than is depicted here. Extensive building began only in 1671 with the first purchase of land from the Hottentots; further building was spurred by the influx of Huguenot refugees in 1686, at which time the city began to acquire the appearance it retained throughout the Dutch rule.

Table Mountain was an important beacon to the sailors of the several East India companies: they could look forward to a stopover of at least a week in the hospitable harbor to pick up fresh food and water for the last part of their journey. Conceivably, plates like 33 could have been ordered by any of the maritime travelers for whom Table Bay was such a focal point, but this composition is known only with the Dutch flag.[2]

The lacework rim border is copied directly from a pat-

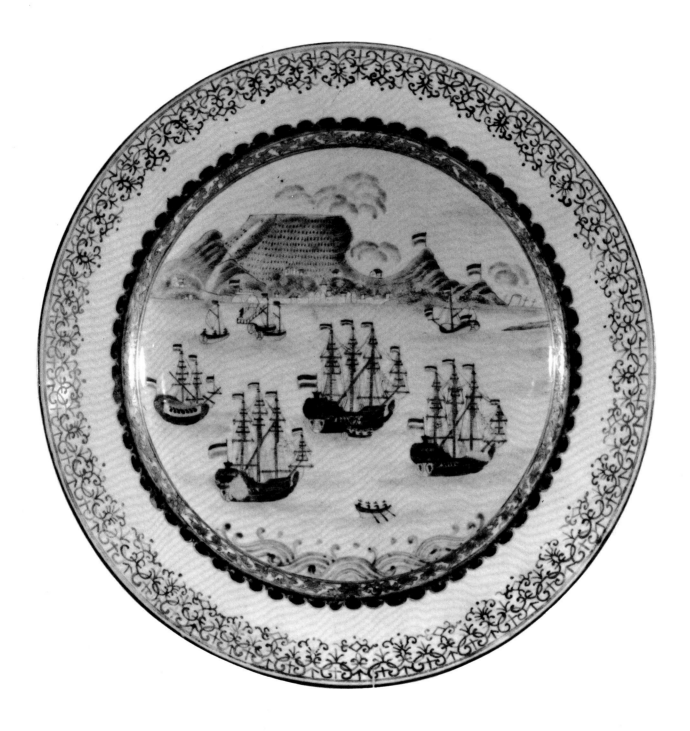

tern much in use at the Meissen factory from about 1725 to 1740. Its appearance on porcelain clearly made for the Dutch market indicates the ready availability of the German porcelain in China at this early date. The unusual brown lappet border also occurs on plates which, copied from a 1740 medal commemorating the capture of Porto Bello, were certainly made at the same time as **33**.

NOTES

1 Frederik Caspar Wieder, *Monumenta Cartographica*, The Hague, 1925, I, pl. 11.

2 Other examples of what was obviously a favorite subject are in the Victoria and Albert Museum, the Rijksmuseum, and the Nederlandsch Historisch Scheepvaart Museum, Amsterdam.

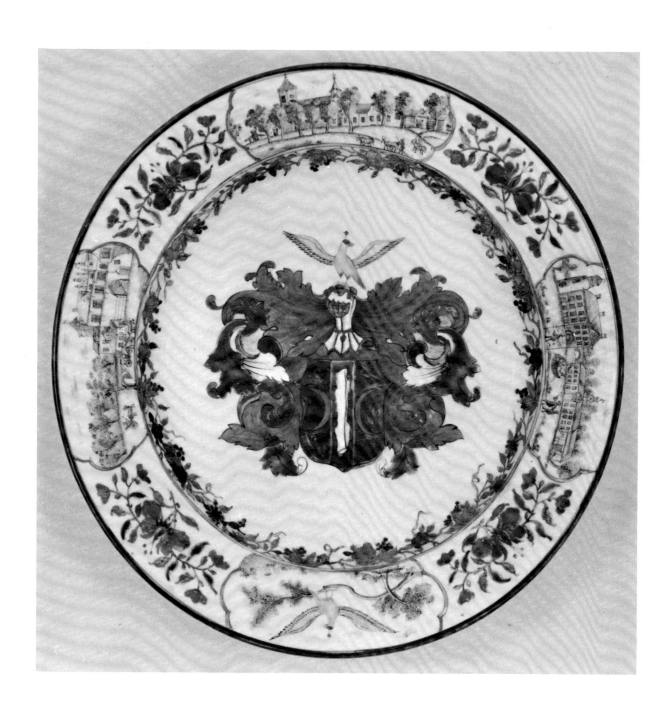

34 Plate

Dutch market, 1735–40
D. 9 in.
Accession 58.155.1
Arms: Or on a pale azure between two crescents addorsed gules
 a tree stump argent. Crest: a falcon rising, hooded gules.[1]
 Valckenier

Decoration in grisaille and gilt, with details in enamel colors of iron red, royal blue, and pink. In the center, a coat of arms within a circle of flowers and leaves. On the rim, separated by flower-sprays, four reserves, three enclosing grisaille town views, the fourth repeating the crest of the arms. Rim edged in black and gold. Exterior undecorated. Narrow foot rim unglazed.

The Valckeniers, prominent in the seventeenth and eighteenth centuries, were active in their home city of Amsterdam as aldermen, treasurers, burgomasters, tax collectors, and church officers;[2] in the East Indies, where a branch of the family was settled by 1670, they were influential as judges and East India Company officials.[3] Long residence in Batavia, the VOC's Asian outpost, gave them a ready access to the China trade, and this doubtless accounts for the number of different porcelains bearing their arms. The earliest of these is a blue-and-white jug formerly in the Cleveland Museum of Art (Figure 46), fitted with a Dutch silver lid datemarked to 1677 or 1701, either year being stylistically compatible with the piece. With its companion jug, similarly mounted and painted with the arms of the Geelvinck family, it was presumably a wedding present. Of later date are the services represented by **34** and a plate with the arms and flower sprays but lacking the town views (Figure 47). The scene on the left rim of **34** is of the New, or King William, Gate at the entrance to Cleves. The buildings appear exactly as they do in one of a series of engraved views of the town published in 1695 (Figure 48), but the foreground of the scene on the plate rim has an additional carriage and no standing figures. At the top of **34** is another typical Dutch view with drawbridge and conventional architecture. The scene at the right is perhaps Batavian, the row of solid European buildings being countered by the pagodalike tower and low pavilion with verandah. An Oriental setting is further denoted by the dinghy on the canal, with the mask that invariably adorned Chinese rowboats.[4] This particular view also occurs by itself, as on cups and saucers in the Cleveland Museum and the Metropolitan (1970.95.1, 2).

In their heraldic style, tentative inclusion of the famille rose palette in the crests, and graceful, naturalistic flower sprays of grisaille and gilt, the two Valckenier services are quite similar to that made for Lee of Coton, which can be dated prior to 1734.[5] It is thus likely that they were made for Adriaan Valckenier (1695–1751), who, resident

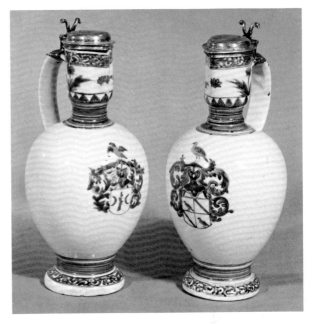

FIGURE 46 Two blue-and-white Japanese porcelain mugs with Dutch silver lids, Dutch market. The Cleveland Museum of Art
Left: Arms of Valckenier
Right: Arms of Geelvinck

FIGURE 47 Chinese porcelain plate with the Valckenier arms. 1740–50. Museum of Fine Arts, Boston, The Helena Woolworth McCann Collection

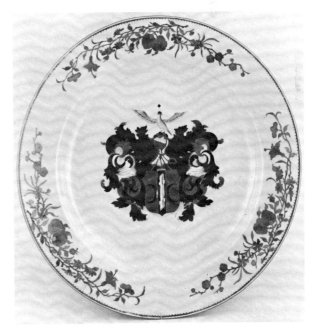

FIGURE 48 View of King William Gate at entrance to Cleves.
Top: Detail of **34** showing town view on left rim
Below: Engraving from *Veues et perspectives de la ville de Cleves*, Amsterdam, 1695. The Metropolitan Museum of Art, Harris Brisbane Dick Fund, 28.3

in Batavia from 1715 as a merchant, rose to the successive posts of VOC bookkeeper, counsel, director-general, and ultimately Governor General of the Dutch East Indies (1737–41). His career was terminated by his acquiescent role in the massacre of some 10,000 Chinese at Batavia in 1740, and he returned home the following year.[6]

A fourth Valckenier service appeared on the art market in 1960:[7] consisting of tea bowls and saucers painted in famille verte enamels, with utensils and flowers in addition to the arms, it would appear to be somewhat earlier than **34**.

NOTES

1 The falcon should be argent; the slight pink color was probably added simply to set off the figure from the white ground.

2 Caspar Commelin, *Beschryvinge van Amsterdam*, Amsterdam, 1693, I.

3 Johan E. Elias, *De Vroedschap van Amsterdam 1578–1795*, Amsterdam, 1963, I, pp. 412, 479–480; ibid., II, pp. 657–658.

4 The same three views that appear on the rim of **34** have been said to depict Doorn, Batavia, and Buitenzorg, while the arms on a plate apparently identical with **34** have been called those of Labouchere.

5 Phillips, fig. 7.

6 M. S. van Rhede van der Kloot, *De Gouverneurs-Generaal en Commissarissen-Generaal van Nederlandsch-Indië: 1610–1888*, The Hague, 1891, pp. 90–91.

7 Sotheby & Co., 15 November, lot 165.

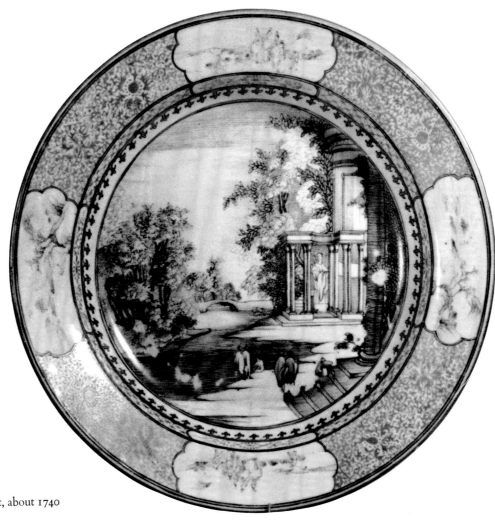

35 Dish

Continental market, about 1740
D. 9 in.
Accession 61.133

Decoration in grisaille and gilt. In the center, figures in a landscape with classical architecture. Scene framed by gilt spearhead and diaper borders, the latter interrupted by four reserves enclosing gilt floral decoration. On the flat rim, a field of gilt flower and leaf scrolls with four reserves, two enclosing a Chinese family group, two a riverscape. Rim edge gilt. Exterior undecorated.

The central scene reflects a taste for architectural views fashionable about 1740 at Meissen, where they were sometimes accompanied by versions of this traditional Yung Chêng border. Similar, but more obviously specific, views occur on a pair of saucers in the Irwin Untermyer collection,[1] and on pieces from the Christie-Miller service,[2] both datable about 1740. For the most part such views were topographical, but it was standard practice to lift features from two or more prints and combine them into new compositions, as in the mixture of reality and fantasy seen here.

Another China trade dish, depicting a city scene,[3] is en suite with 35; these appear to be the only two now known of what was presumably a larger series.

NOTES

1 Yvonne Hackenbroch, *Meissen and other Continental Porcelain, Faience and Enamel in the Irwin Untermyer Collection*, Cambridge, Massachusetts, 1956, fig. 134.
2 Sotheby & Co., 7 July 1970.
3 Christie's, 17 October 1966, lot 37.

36 Dish

Dutch market, 1730–40
D. 15¼ in.
Accession 58.134

Decoration in sepia, grisaille, iron red, and shades of green. Central scene: two East Indiamen in a European harbor. Enclosing the scene is a double border of reversed leaf scrolls in alternate colors of iron red, mauve, and deep blue. Around the well and the edge of the rim is a border painted in aquamarine overpainted with a band of black dots; it is edged on the inside with a gilt spearhead border and on the outside with gilt and black bands. Exterior undecorated.

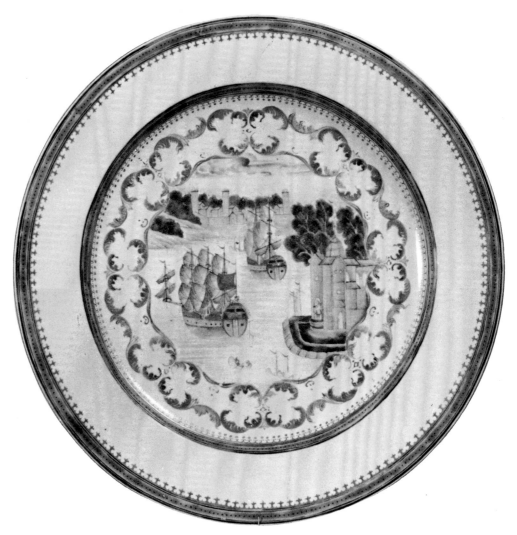

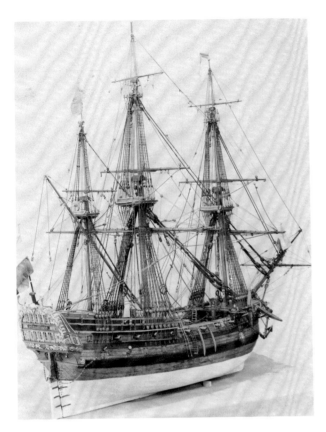

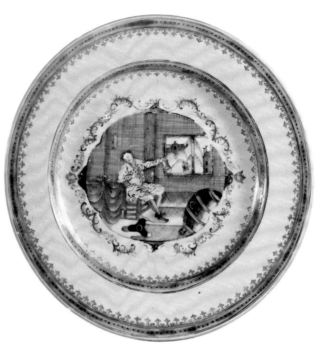

FIGURE 49 Wooden scale model of a three-masted two-decker ship like those used by the VOC about 1730–40. Photograph courtesy Nederlandsch Historisch Scheepvaart Museum, Amsterdam

FIGURE 50 Chinese porcelain plate with Meissen scrollwork border, Continental market. 1730–50. Courtesy Sotheby & Co.

Although considerably simplified, the ships are meant to be the three-masted two-deckers used by the VOC. Generally similar in design to the ships of the English and other Continental companies, they differed chiefly in the sharply undercut stern with its carved scrolling frame and recessed rudder (Figure 49). The ship in the foreground flies what appears to be a red- and gold-striped flag, possibly meant to indicate Enkhuizen, one of the VOC's ports on the Zuider Zee.

The leafy border of the riverscape recalls the elaborate scrolled cartouche frames typical of Meissen porcelain about 1725–30, but the version here is more relaxed, more fully rococo than was usual at Meissen, and must be the result of an intermediate design. Its only known occurrence on China trade porcelain is on the several examples of this plate.[1] Also unusual is the ground color of the dotted borders. Although somewhat muddy, it is related

to the light clear turquoise of late Yung Chêng porcelains, a color also used at Meissen about 1725–35 both (as in China) as an overall ground color and (as in Japanese kakiemon decoration) in detail work. Rare in China trade porcelain, the border of **36** does occur on another plate (Figure 50) with a more lacelike variation of the scrollwork, reinforcing the link with Meissen.

NOTE

1 The one illustrated by W. G. Gulland (*Chinese Porcelain*, London, 1902, I, no. 414) is approximately the same size as **36**; three others (Sotheby & Co., 23 July 1960, lot 144; 2 July 1963, lot 101; 12 December 1970, lot 129) are 9 inches in diameter. A sixth example is in the Victoria and Albert Museum (C.334-1931).

37 Pair of cups and saucers

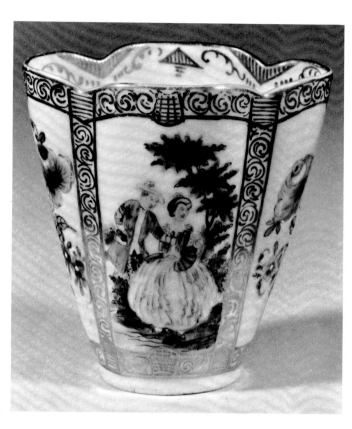

European market, 18th century (?)
Cups H. 3¼, saucers W. 5⅜ in.
Accession 68.50.1–4
Mark on each base, in underglaze blue, monogram AR (Augustus Rex)

Decoration in famille rose and gilt. Four panels on each four-lobed piece are decorated alternately with galanteries on a white ground and bouquets on a yellow one. Bordering the panels and rims, and encircling a small flower spray in the center of each saucer, are broad gilt scrolls. Inside the cups, at the rim, a modified gilt lacework band in Meissen style. The cups rest on low, undecorated foot rings.

The decorative scheme of these pieces has been adapted from a Meissen style popular about 1745–50. The earliest dated example of the type is a service made for the Queen of the Two Sicilies in 1738,[1] on which the flower panels are sea green, a color that was repeated in the majority of later versions. Yellow, although less common, has been recorded on several examples,[2] and is the only other ground color known to have been used. There are significant disparities between the Meissen prototypes and their China trade variants. For example, the gilt border inside the cups is a crudely simplified rendering of the graceful Meissen lacework patterns, and is not really related to its German counterparts, whose intricacies the Chinese were well able to reproduce (33). Further, even allowing for the uncertainty over the use and dating of the AR monogram,[3] it has not been recorded in conjunction with Watteauesque subjects, the Meissen examples all being marked with the regular factory mark of crossed swords. If the Chinese were literally copying a single model, there would be grounds for doubting the plausibility of these cups and saucers. But it is not necessary to suppose that this was the case. Most China trade porcelain represents a compilation of elements—a pictorial fragment from one source, a border pattern from another, the model itself from a third—and the coordination of an AR-marked piece with a "Watteau" one would not have been difficult. It would, moreover, have appealed to a buyer, who could content himself with a "Meissen" set marked with the Elector's monogram at well below the

cost of the real thing. The simplified border and the absence of handles on the cups (the Meissen ones of this type all have at least one, and often two—a characteristic, also, of the later Wolfsohn imitations) suggest adaptation rather than straightforward copying.

Two other cups and saucers en suite are known, one in the Mottahedeh collection, the other, formerly in the Ionides collection, in the Victoria and Albert Museum.

NOTES

1 A cup and saucer from this service is in the Metropolitan (54.103.1, 2).

2 Sotheby & Co., 27 January 1970, lots 120, 121.

3 W. B. Honey, *European Ceramic Art*, London, 1949, I, pp. 414–415; Rainer Rückert (*Meissener Porzellan: 1710–1810*, Munich, 1966, p. 40) dates the mark, as used by the two Electors Augustus II and Augustus III, from about 1723 at least until 1736.

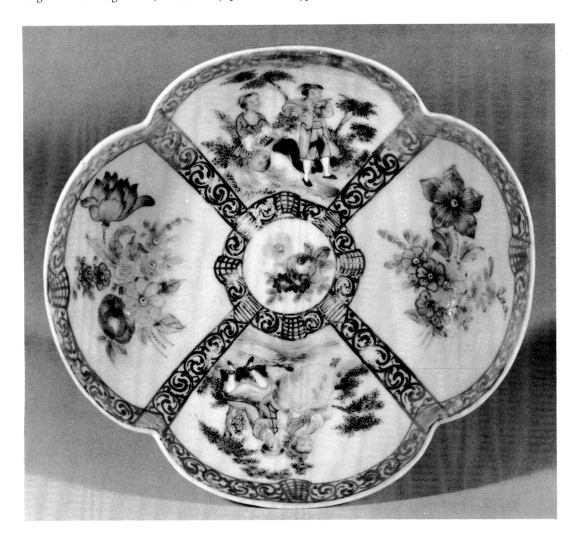

38 Pair of plates

Scottish market, 1745–50
Ds. 9 and 9 1/16 in.
Accession 62.125.1, 2

Decoration in enamel colors and grisaille. In the center, two Highlanders on a grassy mound. On the rim, between black double-line borders, two pairs of reserves in gilt scrolled frames, one enclosing a Chinese landscape, the other a bird on a peony branch. Exterior undecorated.

The subject exemplifies the widespread interest surrounding Highlanders in the 1740s, partly as a result of Jacobite agitation and partly out of fascination with their exotic costume. Numerous engravings of Highlanders circulated throughout Britain and the Continent; seen here are a piper and a private of the first Highland Regiment of the British Army, the 43rd, or Highland, Regiment of Foot.[1] The figures are copied from drawings by George Bickham, engraved and published by the artist in or before 1743. From the carefully distinguished colors and plaids of the uniforms, and the consistency of rendering from one plate to another, it is clear that the Chinese painters worked from colored versions of Bickham's prints. The private's red jacket is the regulation one of 1739; the piper's blue bonnet is the usual Highland headgear both before and after that date. Although the newly

formed Highland Regiment was eventually to be recognized by its uniform in the Black Watch tartan, there was a good deal of informality in the use of plaids until after the 1745 Rising, and the ones shown here could represent either a clan or a company.

In its original version, Bickham's engraving of the piper was identified simply as "A Highland Piper in his Regimentals"; later, versions of it appeared as the frontispiece to *A Short History of the Highland Regiment*, 1743, (Figure 51) and as a single print in which the piper was identified as Alexander Munro, "piper to ye Prince" (Charles Edward).[2] Versions of the private are dated 1743 and 1747;[3] an undated one (Figure 52) is inscribed, in an apparently contemporary hand, "The Scottish Highlander 'Hamilton' who was executed on Tower Hill at the time of the Rebellion 1745." There was certainly some Jacobite sentiment underlying the popularity of these Highlander porcelains, of which an unusually large number survive,[4] but whether Bickham's prints were intended as portraits or simply as illustrations of Highland costume to which political loyalties attached personal identification is uncertain.[5]

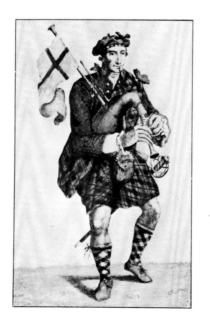 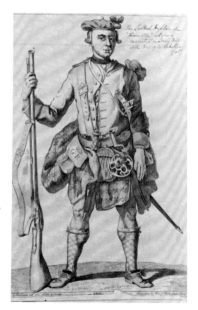

FIGURE 51 A Highland Piper in His Regimentals, engraving by George Bickham. About 1743. Scottish United Services Museum, Edinburgh

FIGURE 52 Engraving of a Highland Regiment piper by George Bickham, frontispiece to *A Short History of the Highland Regiment*, 1743

94

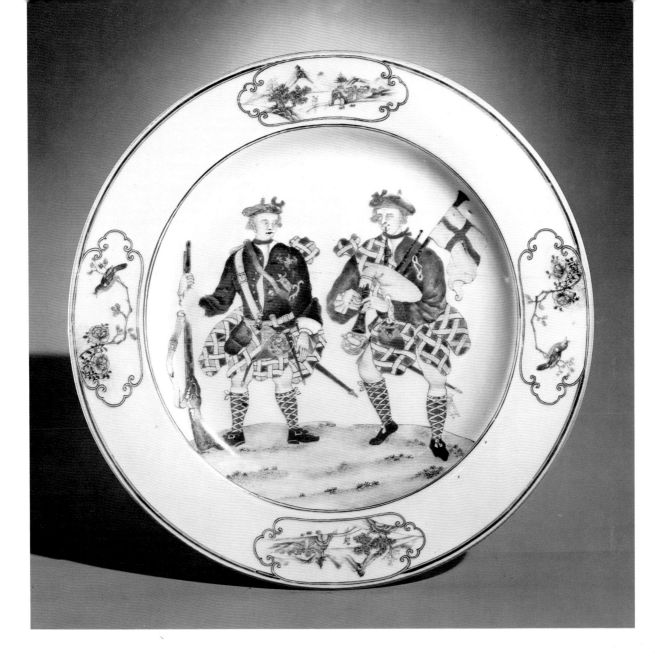

NOTES

1 Better known under the name of the Royal Highland Regiment, or the Black Watch, it was a 1739 amalgamation of the six independent Highland companies raised in 1725, and four newly raised ones.

2 Army Museums Ogilby Trust, *Index to British Military Costume Prints 1500–1914*, London, 1972, no. 427 (1). The version shown in Figure 52 is a hand-colored reproductive print, in reverse.

3 Ibid., no. 427 (2).

4 Single plates are illustrated by J. P. Goidsenhoven, *La Céramique Chinoise*, Brussels, 1954, pl. 118, fig. 286; J. A. Lloyd Hyde, *Oriental Lowestoft*, Newport, England, 1954, pl. xv, no. 52; Beurdeley, pl. xix (Musée Guimet); and Scheurleer, *Chine de Commande*, fig. 196 (Zeeuws Museum, Middelburg). Others are in the Victoria and Albert Museum (C.29-1951, from the Ionides collection) and a private American collection. Additional examples were sold at Sotheby & Co., 4 July 1961, lot 152, 24 November 1950, lot 81; and at Christie's, 28 November 1960, lot 44. Two punch bowls have also been recorded: one on the New York art market in 1951 on which the figures were reversed; the other, acquired by Lady Charlotte Schreiber and sold by Lord Wimborne, included a portrait of the Old Pretender inside.

5 In the opinion of W. A. Thorburn, director of the Scottish United Services Museum, there is no connection between the figure and the legend on his museum's engraving (Figure 51). Even though the provenance of **38** is Brodick Castle, the seat of the Dukes of Hamilton, a direct family relationship is not necessarily implied.

39 Plate

Dutch market, 1740–50
D. 9 in.
Accession 60.80

Decoration in shades of mauve. A view of Canton harbor. On the flat rim, a gilt scroll and shell border, outlined in iron red.

The Pearl River at Canton was studded with small islands on which stood windowless tower-forts, most of them having flags, trees, and canopies on their roofs. Appearing in seventeenth century views of Canton,[1] the forts had presumably been built by the Chinese as protection against outsiders; however, the fort at the center of **39** was said to have been occupied by the Dutch as early as 1655, the year of the Dutch embassy to Peking.[2] By the end of the eighteenth century a few of the forts appear to have been regularly occupied by the European trading companies; they cannot have been used for self-protection, since the Europeans, who enjoyed no civil rights in Canton, were required to deposit all their ammunition on entering the harbor. But they may have provided the answer to another difficulty encountered by the Europeans: how to handle and store their merchandise, since they were required to anchor at Whampoa, twelve miles downriver from their factories. It is likely that they were occasionally granted the privilege of using the forts as warehouses. By about 1780, when descriptions and views of Canton begin to flood the book market, these little towers—"children's castles," as they had been described early in the century—were popularly known as "folly forts," a designation so redolent of the frivolous pavilions of eighteenth-century gardens that one wonders if the irony was intentional.

The delicacy of the painting and the thoroughly Oriental perspective on **39** suggest that the scene was of Chinese composition, done on the spot, rather than copied from some European tourist's view. The border, on the other hand, appears to be a simplified version, commonly found on China trade porcelains of about 1750, of a scroll and shell framework used at Meissen in the preceding decade.

NOTES

1 James Orange, *The Chater Collection*, London, 1924, p. 244.
2 Ibid., p. 148.

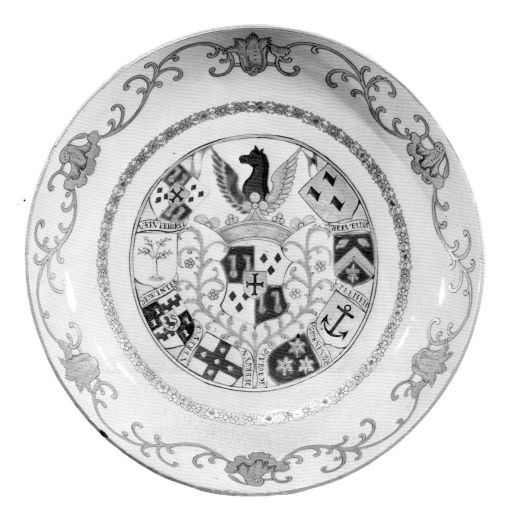

40 Dish

Dutch market, 1735–45
D. 10⅜ in.
Accession 60.149.2

Arms: (in the center) Quarterly, 1 and 4. Azure two keys pale-wise or 2 and 3. Argent three lozenges gules 2 and 1; on an inescutcheon or, a cross ancrée gules. Crest: issuing out of a marquis' coronet a horse's head proper between two wings azure and or. *Van Reverhorst*

(clockwise) I. Or three crampoons sable. *Schrevelius*

II. Azure a chevron between two pinecones chev-ronwise, in base a fleur-de-lis or. *Van Peene*

III. Or an anchor sable. *Van Groenendyck*

IV. Azure three stars or. *De Vroede*

V. Argent on a cross gules five escallops of the first. *De Bruyn*

VI. Quarterly, 1 and 4. Sable two cocks' heads or, combed gules; 2 and 3. Argent a fess bretessed gules; on an inescutcheon or a lion rampant gules. *Vereyck*

VII. Argent a bare tree sable crowned with three birds of the same. *De Winter*

VIII. *Van Reverhorst*

97

Decoration in enamel colors, chiefly royal blue, turquoise, red, and black, with details in gold. In center, a medallion enclosing a coat of arms surrounded by eight smaller ones each identified on a banderole. Framing the medallion, a band of gilt flowers outlined in iron red. At the rim, a wide rococo shell and scroll border. Exterior undecorated.

The service of which this dish is one of many surviving pieces[1] must have been unusually extensive, combining elements of a dinner and a tea set. There was little consistency in the composition of table services, but for the most part China trade services were limited to a fairly standard assortment of plates and dishes, cups, bowls, and serving vessels.[2] A few, however, all dating before 1750, are of particular interest as they follow closely the traditions of the more elaborate silver services. In addition to the usual eating and serving pieces, the Sichterman service[3] of about 1735 included candlesticks, a lighthouse coffeepot, a beaker, a large covered vase, and a ewer. The so-called Pompadour service covers an even wider range, including a wine cooler, covered beaker, écuelle, cruet frame, cream pot, double-lipped sauceboat, and even a

pot de chambre.[4] Apparently unique to the Reverhorst service are the covered sugar bowl with its serpentine handles, the double-lipped sauceboat with cover, and the covered cup with a single handle (Figures 53, 54, and 55). The sauceboat, derived from a silver prototype, was also being produced at Delft in the first quarter of the eighteenth, but I know of no versions that include a cover.[5] The shape of the footed cup is analogous to a standard silver form of mustard pot, but the lack of a finial on the cover is odd.

The Reverhorst coat of arms is thought to refer to Theodorus van Reverhorst (1706–58),[6] who was a member of the VOC's Council of Justice at Batavia, returning home in 1752. The surrounding coats of arms are presumably all of allied families; Schrevelius was the maiden name of Reverhorst's mother, who may have been the daughter of Theodorus Schrevelius, Burgomaster of Leiden, and his wife Elisabeth, née Van Peene.[7] The family ties with the De Bruyns, prominent in Amsterdam in the eighteenth century, are implied in their continued ownership of pieces from this service in the early 1900s,[8] before the large Dutch family collections of China trade porcelain were broken up.

NOTES

1 Plates of different sizes are in the Musée Guimet, Paris (Beurdeley, cat. 174); in the Princessehof, Leeuwarden (Nanne Ottema, *Chineesche Ceramiek Handboek*, 1946, fig. 264); and in the Rijksmuseum, Amsterdam (Scheurleer, *Chine de Commande*, fig. 264). W. Watkins Old (*Indo-European Porcelain*, Hereford, 1882, no. 81) records a platter; Albert Jacquemart and Edmond Le Blant (*Histoire artistique, industrielle et commerciale de la porcelaine*, Paris, 1862, p. 389) refer to a cabaret service of this pattern as having been sold in Paris and dispersed among Paris private collectors. The Metropolitan Museum owns a tea bowl and saucer (48.172.14, 15). Some of the pieces in present-day collections are presumably those that came on the Dutch market from time to time between 1900 and 1910.

2 In 1772 the porcelain for England included 350 table services each consisting of 18 "long dishes" in sizes from 8 to 18 inches, 60 plates, 20 soup plates, and "1 tureen to 2 sets" (Morse, V, p. 168).

3 A large selection of this service, with the arms of a squirrel (occasionally misattributed to Fouquet) was on the American

art market in 1970; other pieces are illustrated by Scheurleer, *Chine de Commande*, figs. 96, 97.

4 Sotheby & Co., 15 October 1968, lot 180; 28 June 1968, lot 216; 10 December 1968, lot 165; 1 July 1969, lot 202; Christie's, 19 May 1969, lots 146, 148, 150, 163; Metropolitan Museum (51.86.96–99, covered bowl, two plates, cruet frame).

5 It is perhaps the cover that leads Scheurleer (*Chine de Commande*, p. 113) to call this a *ragoutterrine*, but in design and size the piece is no different from the sauceboats of the period.

6 Ottema, *Chineesche Ceramiek*, p. 226, no. 1; Scheurleer, *Chine de Commande*, p. 112.

7 Johan E. Elias, *De Vroedschap van Amsterdam 1578–1775*, Amsterdam, 1963, II, p. 990. Although the name is inscribed v: PEENEN on the banderole, the arms of the Flemish family of that name were not the same as those of the van Peenes of Leiden, seen on **40**.

8 Frederik Müller & Cie., Amsterdam, 24–28 April 1906, lot 599.

FIGURES 53, 54, 55 Chinese porcelain sugar bowl, sauceboat, and cup from the van Reverhorst armorial service, which also included **40**. About 1735–45. Private collection. Photographs courtesy R. A. van der Zwan, The Hague

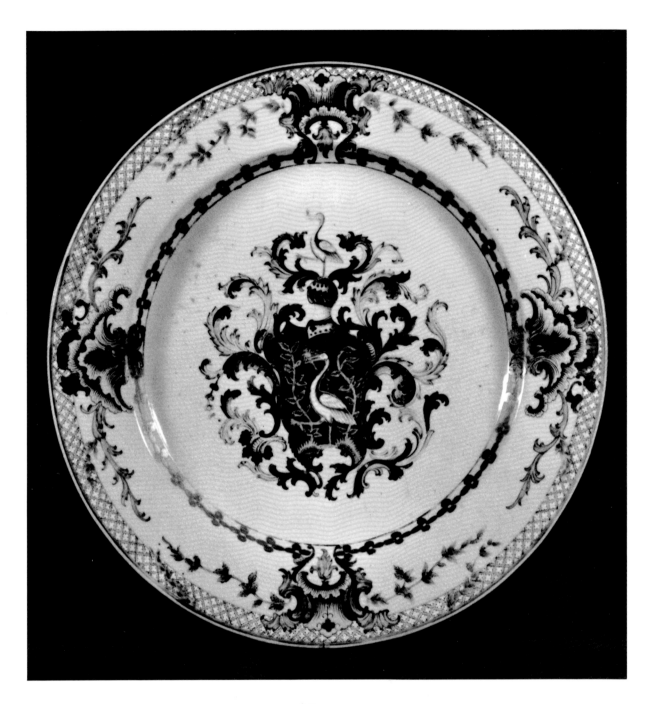

4I Plate

Swedish market, 1745–55

D. 12⅝ in.

Accession 1971.149

Arms: Or, a crane proper holding a cricket in its mouth, on a mound between two branches proper. Crest: a crane of the arms. *Grill*

Decoration in pastel enamel shades of mauve, turquoise, and yellow with details in iron red, black, and gilt. In center, a rococo frame encloses a coat of arms; around the well, a flower chain. On the rim, superimposed on a cell-diaper band, four cartouchelike ornaments trailing scrolls and vines. On rim, dark brown glaze. Exterior undecorated. Shallow foot rim unglazed.

At least one member of the Grill family was active in the Swedish East India Company, founded in 1731. Frederik I awarded the first charter to Henry Koenig & Co., and Koenig and the Scotsmen Hugh and Colen Campbell were among the first directors.[1] Abraham Grill, described as a prominent merchant, was among Swedish citizens interested in this venture.[2] The Campbells, both having served as supercargoes in the English East India Company, brought solid professional experience to the new company; Colen Campbell, in addition, had been active with the Ostenders whose charter had just been revoked by Charles VI. This close sequence perturbed the English and Dutch, who felt that the economic threat formerly posed by the Ostenders had simply been transferred to Göteborg, and, certainly, a number of unemployed Ostenders signed up for service with the new company. The first Swedish ships met considerable harassment from their English and Dutch rivals; in spite of this, their voyages sometimes cleared a hundred percent profit. It was not until 1740 that the competing countries came to terms, following which the Swedish company enjoyed commercial success until 1805 when her last ship was recorded at Canton.[3]

The amount and kind of porcelain carried to Sweden is difficult to estimate because, under the terms of its first charter, the company's books were destroyed every three years.[4] However, during the period of the third charter (1766–86), eleven million pieces are said to have been imported.[5] In 1759 the ships were to bring back "heavy and durable things,"[6] presumably standard blue-and-white ware of the type sunk in the Göteborg in 1745 and salvaged in 1905. That there was also a demand for armorial porcelain is attested by Roth,[7] who mentions services for some 300 families of the Swedish nobility. Six different services are recorded for the Grill family alone.[8] The pattern of this plate was repeated in blue and white; two other services are conventionally painted with flower sprays, while the remaining two, both blue-and-white, are heraldically most unusual, the Grill crane being incorporated allusively into pictorial compositions. The design of two of the Grill services—41 and one of the blue-and-white ones—has been attributed[9] to Christian Precht (1706–79), who provided a sheet of sketches for China trade porcelain in 1738 for his patron, Count Axel Sparre.[10] There are certain stylistic similarities between Precht's drawings and this service, but in the opinion of Precht's biographer there is insufficient evidence to support the attribution.[11]

From the few Swedish armorial services that can be dated with precision there would appear to have been some conservatism in heraldic and decorative styles; while this service is consonant with Precht's work of 1738, the style was still in fashion in the late 1750s.[12]

NOTES

1 Conrad Gill, *Merchants and Mariners of the 18th Century*, London, 1961, p. 101. The present resumé leans heavily on this excellent account of the Swedish company.

2 Stig Roth, *Chinese Porcelain Imported by the Swedish East India Company*, Göteborg, 1965, p. 6.

3 Morse, III, p. 2.

4 Ibid., p. 5.

5 Ibid., p. 10. Porcelain was evidently held so cheap that a surprised traveler in Sweden in 1781 noticed that "broken pieces of china from plates, saucers, bowls, in blue, red and white, pieces which had been unusually beautiful, now lie on all the paths in the garden" (Roth, *Chinese Porcelain*, p. 16).

6 J. A. Lloyd Hyde, *Oriental Lowestoft*, Newport, England, 1954, p. 17.

7 Roth, *Chinese Porcelain*, p. 25.

8 Ibid., figs. 19–24.

9 Bo Lagercrantz, *Slakten Grills vapenporslin*, Stockholm, 1951.

10 Gustaf Munthe, *Konsthantverkaren/Christian Precht*, Stockholm, 1957, fig. 106.

11 Ibid., p. 280.

12 Compare a Rorstrand platter dated 1759, Victoria and Albert Museum (C.21-1960).

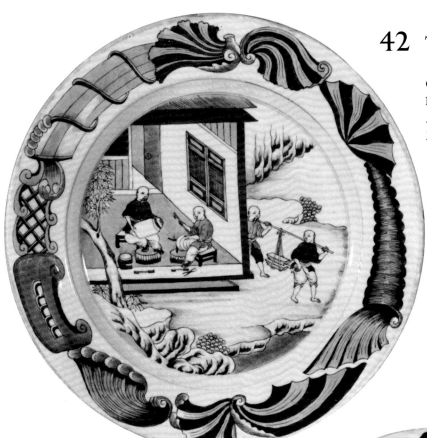

42 Two plates

Continental (probably Dutch) market, 1740–50
Ds. 12⅝, 13¾ in.
Accession 1971.32.1, 2
Marked on base: 13, 21

Decoration in underglaze blue. Scenes of tea cultivation. On the wide rims, a border of shell, cornucopia, and lattice ornament.

Part of a service of which a tureen, sauceboat, and plates of several sizes have been recorded,[1] and of which each piece is numbered. The scenes were presumably copied from one of the many series of Chinese export paintings of trades and manufactures that appealed to the Europeans. Among the "Books of Highly finished Drawings" included in the Van Braam sale of 1799, for example, was just such a volume of forty-eight drawings "shewing the culture and growth of rice, cotton, and tea, and manufacture of silk, and earthen ware."[2] As the numbers painted on the porcelains go at least as high as twenty-two, the original set of drawings must have been unusually detailed.

The exuberant shell and cornucopia border is uncommon in China trade porcelain, its only other appearance, to my knowledge, being a polychrome version on the armorial service for the Snoeck family of Holland.[3] It has also been noted, in a less definite rendition, in blue and white on a Japanese export plate.[4] Its limited use, and its association with the Dutch market, might presuppose a Delft origin of this striking design, but in fact its closest relative is found in the decoration of Rouen faïence, where, in the traditionally named *décor à la corne*, the cornucopia is more readily recognizable, occurring both as a central motif and in borders in combination with the outsized shells (Figure 56).

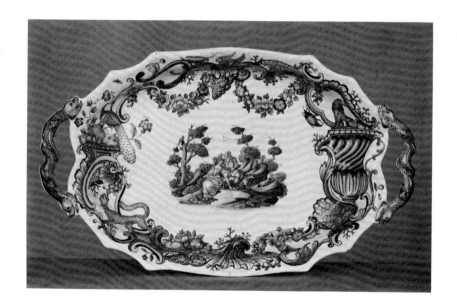

FIGURE 56 Rouen faïence tray with *décor à la corne* and shell decoration. About 1750–1760. Victoria and Albert Museum, London

NOTES

1 Museum Willet-Holthuysen, *De Chinese porseleinkast*, exhibition catalogue, Amsterdam, 1968/69, cat. no. 274 (tureen, dish, and sauceboat in Fries Museum, Leeuwarden). A number of the plates have recently been on the New York art market.

2 A. E. van Braam Houckgeest (1739–1801) is perhaps best known to American readers as the donor of a small China trade service decorated with the initials of Martha Washington and the names of the fifteen states, presented to the First Lady in 1796. A director of the VOC at Canton, van Braam concluded his career in 1794/95 as co-ambassador of the last Dutch embassy to Peking. His collection was sold at Christie's, 15–16 February 1799, and was probably typical—although larger—of those formed by European merchants and sailors, comprising Chinese export oil paintings, collections of natural history, books of descriptive drawings, and great numbers of "curiosities" in ivory, coconut, and bamboo.

3 Phillips, pl. 5.

4 D. F. Lunsingh Scheurleer, "Japans Porselein met blauwe decoraties uit de tweede helft van de zeventiende en de eerste helft van de achttiende eeuw," *Mededelingenblad vrienden van de nederlandse ceramiek*, 1971, p. 20.

43 Cup and two saucers

Dutch market, second half of the 18th century
Cup H. 1⅜, saucer D. 4 in.
Accession 69.109.1–3
Arms: Or a lion rampant crined vert and crowned of the first, holding in the dexter paw a sword argent, pommel and hilt gules, in the sinister paw a bundle of arrows vert banded gules. Supporters: two lions rampant gardant gules crined or crowned of the first. Motto: Concordia res parvae crescunt. *Dutch East India Company*

Decoration in enamel colors, chiefly rose, yellow, and iron red. An armorial achievement, the monogram VOC framed in a scrolled cartouche, and the date 1728. Around the saucer rims and cup rim, a geometric border, black on a rose ground.

These pieces are from a tea service probably made for members of the VOC. It has been suggested that the decoration derives from a coin, perhaps the reverse of a gold "silver rider" minted for the VOC in 1728 at Hoorn and received in Batavia the following year.[1] Since examples of the pattern are to be found in Capetown as well as in European collections,[2] the service was undoubtedly ordered for the use of company officials wherever they were stationed.

The rendering of the decoration varies considerably from one example to the next, suggesting its repetition over a period of years. The palette, especially the slightly muddy opaque yellow, is fully consonant with export porcelains of the Yung Chêng period (1722–35). However, a certain uncharacteristic hastiness in the manner of the painting on these three pieces suggests that they were executed somewhat later.

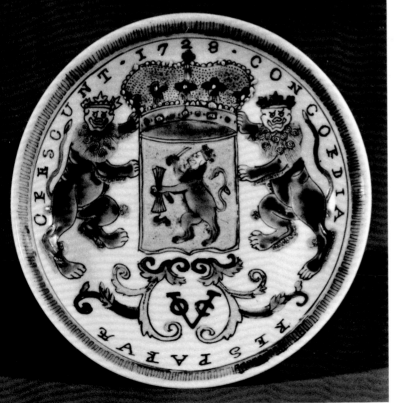

NOTES

1 T. Volker, "Vroeg Chine de Commande," *Bulletin Museum Boymans-van Beuningen*, IX, 3, 1958, pp. 108–109.

2 David Heller, *In Search of V.O.C. Glass*, Cape Town, [1951], pl. 18. Other pieces are in the Rijksmuseum, Amsterdam, the Rotterdam Historisch Museum, and the Victoria and Albert Museum.

44 Plate

English market, 1765–70
D. 9 in.
Accession 65.219

Decoration in grisaille, enamel colors (rose, yellow, blue, green), and gilt. In center, within a narrow gilt border, the main gateway to the Oxford Botanical Garden painted in grisaille. A spearhead border in iron red and gilt encircles the inner edge of the rim. On the rim, small European-inspired flower sprays. Exterior undecorated.

Oxford's Botanical Garden, or Physic Garden as it was known until the end of the eighteenth century, was founded in 1621 by Henry Danvers (1573–1644), later Earl of Danby, who purchased five acres of land "which had formerly served as a burying-place for the Jews" and presented them to the university "for the encouragement of the study of physic and botany."[1] Ten years later, the mason Nicholas Stone (1587–1647) "Agreed with the Right Hon. Lord Earell of Danby for to mak 3 ston gattes in to the phiseck garden Oxford."[2] These were completed in 1632. The design of the principal gate, seen here, was long held to have been the work of Inigo Jones, under whom Stone had served as master mason, but there is no reason to dispute Stone's own account of the assignment, nor any evidence to associate Jones with the project. As depicted on **44**, the gateway presumably appears much as it did originally, with the exception of the statues. In 1694/5 the sculptor John van der Stein (fl. 1678–1700) was paid £26.10s. "for worke done at the Physicke Garden," and the following year he received a further £7.12s "for cutting the Earl of Danby's statue, and for other worke at the Physick Garden."[3] Danby's statue, a half-length, occupies the niche over the arch; the "other worke" was presumably the statues of Charles I and Charles II, standing in the side niches. The gateway is further ornamented with escutcheons bearing the arms of Danvers quartering Nevill, the Royal Stuart arms, and the arms of Oxford University and of St. George. Such heraldic ornament was a characteristic feature of Stone's work and undoubtedly formed part of his original design.

105

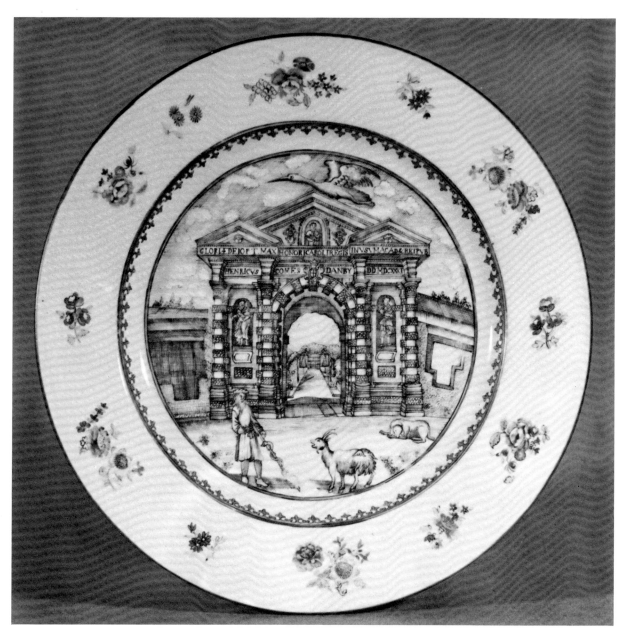

This view of the Danby Gate, the earliest one in its completed form, originally appeared in 1713 as the frontispiece to a poem by Abel Evans entitled *Vertumnus, An Epistle to Mr. Jacob Bobart, Botany Professor to the University of Oxford, and Keeper of the Physick-Garden* (Figure 57). In the foreground stands Bobart (1596–1680), a German botanist who settled in England and was appointed, successively, supervisor (1631) and keeper (1641) of the Physic Garden. According to contemporary account, Bobart was a well-built man who "in his latter dayes delighted to weare a long Beard" and was accompanied on his daily walks by a goat.[4] It would be presumptuous to assert that the iconographical similarity between Bobart and Aesculapius was anything but coincidental, but there is no doubt of the resemblance in both role and appearance. Bobart was keeper of plants collected chiefly for their supposed healing virtues, and his serpent-entwined staff, like that of Aesculapius, emphasizes his role as physician. The goat and dog, too, are shared by both. Less directly related is the stork, traditionally symbolic of filial piety and, by extension, of care for those in need. Not classically associated with Aesculapius, the

stork appears in the late Renaissance in Cesare Ripa's *Iconologia* as an attribute of Aide, represented as a bearded man with a staff. It was perhaps familiarity with Ripa's very popular work that prompted the engraver of the Danby Gate to include the stork.

Although the engraving is unsigned it is conjecturally the work of Michael Burghers (1653?–1727), who came to Oxford from his native Amsterdam in 1672 and was active as an illustrator of the Oxford almanacs. Prior to the publication of *Vertumnus* Burghers had engraved a bird's-eye view of the Physic Garden and a portrait of Bobart after a painting by his employer, David Loggan.[5]

Given the particularity of the subject, one assumes that **44** and matching examples[6] were ordered by, or for, someone directly connected with the Botanic Garden. Among several names recently proposed two are particularly likely.[7] Humphrey Sibthorp (1713–97) was, from 1747 to 1784, Sherardian Professor of Botany at Oxford. He further appears to have had some connection with John Bradby Blake (1745–73), a young naturalist who went to Canton in 1767 as a supercargo of the East India Company, remaining there as a member of the company's administrative council until his death.[8] Blake shipped seeds and plants back to England with a view to their being propagated in England and her colonies;[9] further, a collection of 700 Chinese export paintings of trees, fruits, and flowers, with annotations by Blake, were owned by Sibthorp before 1784.[10] In addition to his botanical researches Blake was interested in Chinese porcelain, sending to Josiah Wedgwood "specimens of the earths, clays, sand, stones, and other materials used in making the true Nankin porcelain."[11] With his combined interests thus documented, it is reasonable to think that the Oxford plates were ordered by Blake, perhaps for presentation to Sibthorp.[12]

NOTES

1 Leslie Stephen and Sidney Lee, eds., *Dictionary of National Biography*, London, 1885–1901, s.v. "Danvers."

2 W. L. Spiers, "The Note-Book and Account Book of Nicholas Stone," *The Walpole Society*, VII, 1918–19, p. 70.

3 B. D. H. Miller, "Oxford in Chinese Export Ware," *Oriental Art*, Summer 1966, p. 99.

4 R. T. Günther, *Oxford Gardens*, Oxford, 1912, pp. 5, 192.

5 Miller, "Oxford," p. 101; Freeman O'Donoghue, *Catalogue of Engraved British Portraits Preserved in the Department of Prints and Drawings in the British Museum*, London, 1908, I, p. 207.

6 Another is in the Rijksmuseum; four were sold at Sotheby & Co., 5 November 1965.

7 Miller, "Oxford," pp. 101 ff. The others mentioned by Miller are Charles Du Bois (1656–1740), Cashier General of the East India Company from 1702 until his death, and an acquaintance of Sibthorp's predecessor John James Dillenius; and Gilbert Slater (1753–93), active in the China trade as a ship owner. Both were well known as botanists and both imported Asian seeds and plants into England. The dates of their lives, however, are not compatible with the evident date of the plates themselves.

8 Morse, V, pp. 130, 144, 149, 165, 176.

9 Stephen and Lee, *Dictionary of National Biography*, s.v. "Blake."

10 Miller, "Oxford," p. 102.

11 Annual Register (1775) as quoted in *Gentleman's Magazine*, XLVI, 1776, p. 350.

12 As all the plates are identical in decoration, they were certainly ordered at one time. Blake is traditionally said to have presented a well-known table service with the arms of Pitt and Grenville to William Pitt in 1773.

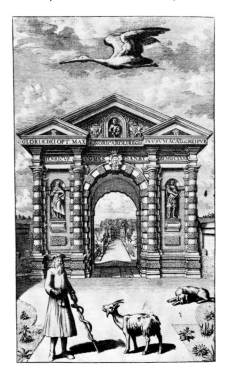

FIGURE 57 Engraving of the Danby gate to the Oxford Botanical Garden, frontispiece to *Vertumnus, An Epistle to Mr. Jacob Bobart, Botany Professor to the University of Oxford, and Keeper of the Physick-Garden*, a poem by Abel Evans, 1713. Courtesy New York Public Library

45 Plate

Dutch market, 1750–60
D. 8 13/16 in.
Accession 64.267

Decoration in grisaille and pastel enamel shades of blue, green, and rose. In center, the Nieuwe Stadsherberg, Amsterdam.[1] On rim, flower sprays in famille rose colors. Rim edged in gilt. Exterior undecorated.

Built in 1662 and demolished in 1872, the Nieuwe Stadsherberg, or public house, stood at the corner of a pier that jutted into the River Y. Although the house was originally a single structure (Figure 58), drawings and engravings of the late eighteenth century[2] depict a line of three buildings as on **45**, with the addition of a flight of steps leading down to the water. The Nieuwe Stadsherberg was a popular subject for tea services, occurring with little variation in technique or incidental decoration.[3] The inclusion in one service of lobed hexagonal dishes and a tea caddy with a scrolled base molding[4] like that on the tea caddy of **25** suggests a date not later than 1760, when both these forms fell into disuse.

NOTES

1 Correctly identified in pre-World War I sale catalogues, when Dutch collections of China trade porcelain, still intact, were part of a continuing local tradition, the scene has in recent years been misidentified as the VOC warehouses in Amsterdam. For the correct attribution and some iconography, D. F. Lunsingh Scheurleer, "De Nieuwe Stadsherberg in het Ij voor Amsterdam op Chinese porselein," *Antiek*, May 1968, pp. 484–486.

2 Ibid., loc cit.

3 A saucer illustrated by Scheurleer (ibid., p. 484) includes a coronet and wreath supported by putti in a style common to the second quarter of the century.

4 W. J. R. Dreesmann, *Verzameling Amsterdam*, The Hague, 1949, II, unnumbered pl. after p. 631.

FIGURE 58 Engraving of the Nieuwe Stadsherberg (public house) on the River Y, Amsterdam, showing the original single structure, from *Beschreibung der Stadt Amsterdam*, Amsterdam, 1664

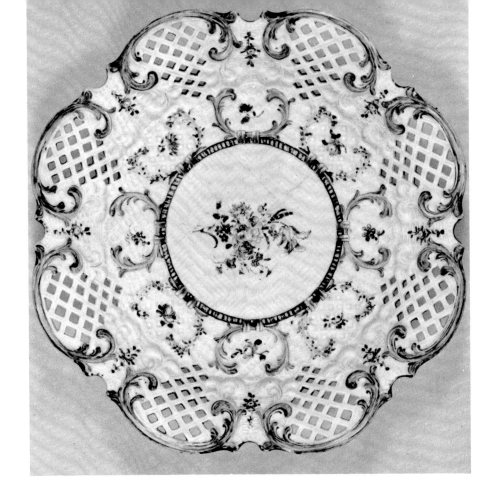

46 Dish

English market, about 1760
D. 10⅜ in.
Accession 58.155.2

Decoration in enamel colors of rose, blue, mauve, green, iron red, and gilt. Ground molded and pierced with trellis and basket work patterns. C-scrolls define the eight-lobed rim and fill the bottom around the center.

The design is copied directly from a salt-glaze stoneware model made in Staffordshire about 1760 (Figure 59), providing evidence that even at this late date, when the mass production of the Staffordshire potteries made their wares easily accessible, porcelains were still carried to Canton for replication. 46 would have been made for an English customer at the time when the Staffordshire model was popular.

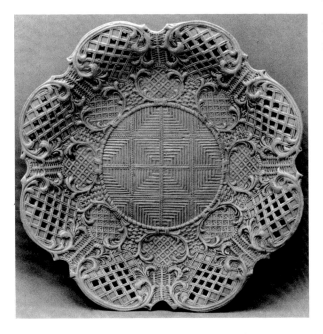

FIGURE 59 Staffordshire salt-glaze stoneware plate. About 1760. The Metropolitan Museum of Art, Gift of Mr. and Mrs. William A. Moore, 23.80.68

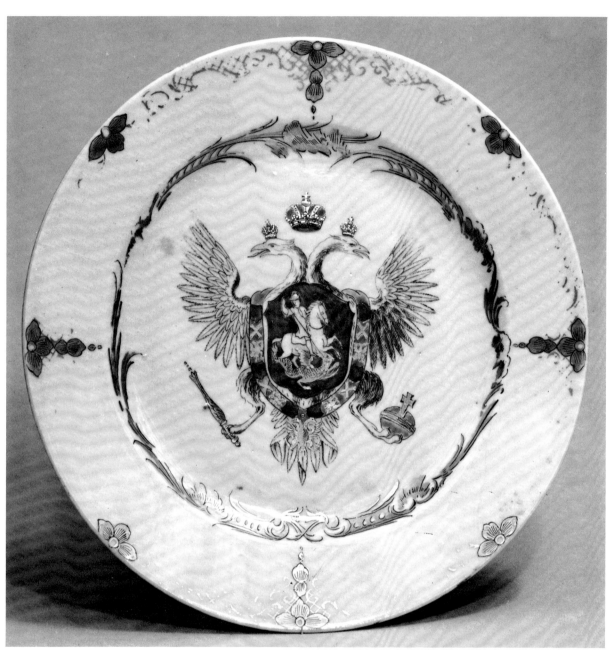

47 Pair of dishes

Russian market, 1770–75

D. 9 ⅟₁₆ in.

Accession 59.90.1, 2

Arms: Gules, the mounted effigy of St. George slaying the dragon, all proper (Moscow), the shield encircled by the collar and badge of the Order of St. Andrew. The whole charged on the breast of the crowned imperial double-headed eagle, the right claw holding the imperial scepter, the left the orb.

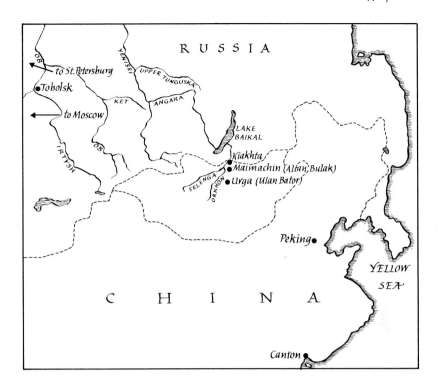

Decoration in enamel colors, red and blue, gilt, details in black. In center, the imperial Russian arms encircled by a sketchy feather and scroll border. At rim, an irregular trellis border interrupted by leaf and petal motifs. On the back of the dish, an inventory letter and number painted in red in which traces of newspaper print are visible. On plate 1: Г. 4/2577; on plate 2: Г. 4/2580.

Unlike the Western European countries that were granted sea access to Canton, Russia was excluded from that city and thus from any direct contact with the porcelain trade. All her commerce with China was carried on via a difficult time-consuming northern land and water route.[1] Until the end of the seventeenth century trade between Russia and China was carried on by private merchants along the Siberian-Mongol border. This was extended in 1692 following the successful embassy to Peking of Isbrandt Ives, a Dutchman in the service of Peter the Great, which resulted in permission for the Russians to send a caravan annually to Peking where goods could be exchanged. According to contemporary writers the transaction was exclusively one of barter.[2] Private merchants continued to trade in border towns as before, but for diplomatic reasons all contact was for-

bidden in 1722. Five years later, a new embassy was sent to Peking, and in a treaty signed in 1728 Russia was permitted to send one caravan every three years to Peking "on condition of its not consisting of more than two hundred persons,"[3] while private merchants were restricted to two northern towns: Zuruchaita, which never developed as a trade center, and Kiakhta. To the latter town, southeast of Lake Baikal (map), Russian merchants[4] came to exchange their goods for those brought by the Chinese to their station, Maimachin, within sight on the Chinese side of the border. In 1755 the imperial monopoly of the caravan trade was abandoned in favor of the private merchants, and Kiakhta became the sole point of contact for Chinese goods. Trade relations were suspended on several occasions by Ch'ien Lung.

Although Russia's opportunities for commissioning porcelain from Canton were limited, export wares nonetheless figured in the Sino-Russian trade, as is clear from old reports. The traveler John Bell, writing in 1720, observed that Urga, a town near Lake Baikal,

is much frequented by merchants from China and Russia and other places.... The Chinese bring hither ingots of gold, damasks, and other silk and cotton stuffs, tea, and some porcelain, which are generally of an inferior quality, and proper for such a market.[5]

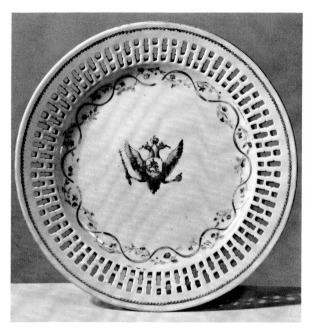

FIGURE 60 Chinese porcelain plate from a tea service, Russian market. About 1780–90. The Metropolitan Museum of Art, Purchase, The Lucile and Robert H. Gries Charity Fund Gift, 1970.220.3

The early date of this report suggests a modest traffic in standard blue-and-white wares. A more sophisticated market had developed by 1780:

> For some years past the Chinese have brought to Kiachta parcels of porcelain, painted with European figures, with copies of several favourite prints and images of the Greek and Roman deities.[6]

Both accounts imply that such porcelains as were directly imported into Russia were selected by the Chinese merchants and accepted or not when they reached the border. In view of this—and admittedly the evidence is thin—it is probable that the service of which **47** formed a part,[7] another table service, and a later tea service (Figure 60)[8] were ordered through a Western company based in Canton. Indeed, this must be assumed, since the tea service, whose stylistic date is about 1780–90, falls within a period of suspended relations between Russia and China.[9] Catherine II's well-known enthusiasm for English taste—encompassing such varied purchases as the entire Walpole collection of paintings, English silver, and goldsmiths' work, and a creamware table service from Josiah Wedgwood—was at its most active in the decade of the 1770s. The sketchy borders on **47** are strongly reminiscent of patterns in use at the Worcester factory about 1770–75. Accordingly, it is both stylistically and historically likely that the dishes were ordered through the agency of an English purchaser.[10] The inventory mark on the back of each dish is that of Gatchina, the summer palace built by Catherine in 1766. It is not known when the service was dispersed.

NOTES

1 William Coxe, *Account of the Russian Discoveries between Asia and America*, London, 1780, pp. 201–246; Charles Gützlaff, *A Sketch of Chinese History*, London, 1834, II, pp. 247 ff.

2 Coxe, *Russian Discoveries*, p. 232; John Bell, *Travels from St. Petersburg* [in 1720], Edinburgh, 1788, I, p. 344.

3 Coxe, *Russian Discoveries*, p. 207.

4 They preferred to leave Moscow and St. Petersburg in the summer, traveling overland to Irbit and thence by sledges to Kiakhta where they arrived in February. The return trip was mostly by water, down the Selenga, Angara, Upper Tunguska, Ket, Ob, and Irtysh rivers to Tobolsk and from there by land back to Moscow and St. Petersburg.

5 Bell, *Travels*, I, p. 344.

6 Coxe, *Russian Discoveries*, p. 239.

7 Only plates are known from this service. Two, formerly in the Ionides collection, are now in the British Museum; others were formerly in the Galitzine collection (*Starye Gody*, May 1911, p. 10, fig. 7) and Blazy collection (Beurdeley, cat. 210).

8 A vegetable dish from the table service is in the Mottahedeh collection, New York. In addition to a number of plates like Figure 60, a cylindrical teapot from that service is in the collection of Mrs. Walker O. Cain (repr. *Antiques*, October 1955, p. 358).

9 In 1791 the hoppo at Canton refused to accept a shipment of skins believed to come from Russia "as the Emperor has been at variance with that Nation for some years past, and no intercourse allowed of" (Morse, II, p. 185).

10 This reflection of English decorative style is also a feature of Catherine's service, the swag borders echoing a pattern current on New Hall porcelain in the 1780s.

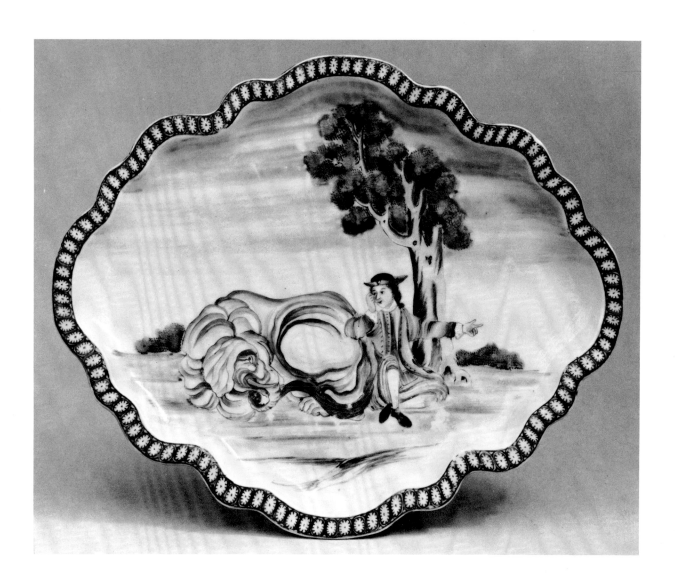

48 Tray

English colonial market, about 1800
L. 9½ in.
Accession 63.162
Ex coll. Mrs. Nellie Ionides, Buxted Park

Of oval shape, with lightly scalloped edge. Decoration in enamel colors. In center, a young man in European costume seated beneath a tree next to a recumbent elephant. At rim, a border of white rosettes reserved on an iron red ground. Exterior undecorated.

FIGURE 61 Chinese porcelain tureen in the shape of an ele-
phant, English market. About 1800. The Metropolitan Mu-
seum of Art, The Helena Woolworth McCann Collection,
Gift of the Winfield Foundation, 51.86.346

Only one other example is recorded of this tray,[1] which
was made to accompany a tureen modeled in the same
position as the painted elephant. One such tureen (Figure
61) matches **48** in size; two more tureens are in the Santo
Silva collection.[2]

The motif of the elephant—not native to China and not
normally part of Chinese iconography—reflects Euro-
pean colonial interests in India. A number of porcelains
depicting, or modeled as, elephants were made for the
Anglo-colonial market during the late eighteenth and
early nineteenth centuries. One is a hot-water plate with
a brightly colored paneled decoration copied from a
Chamberlain's Worcester pattern of the turn of the
century.[3] An echo of the Worcester style is also evident in
the border pattern of **48**, which is a faithful Chinese copy
of Worcester's popular version of the traditional Yung
Chêng cell diaper.

NOTES

1 J. A. Lloyd Hyde and Ricardo R. Espirito Santo Silva,
Chinese Porcelain for the European Market, Lisbon, 1956, pl. VIII.
The scene is reversed but the tray is otherwise identical.

2 Ibid., p. 39.

3 The version in the McCann collection at the Metropolitan
(Phillips, pl. 109) has an inscription in Urdu, but on another
one, recently on the art market, the pseudoarmorial had been
replaced by a monogram in English style and the inscription by
the name "Mallacca."

49 Punch bowl

European market, about 1780
D. 14½ in.
Accession 58.52
Ex coll. W. Martin-Hurst

Decoration in enamel colors and gilt. A continuous view of the foreign factories at Canton. Around the foot, fret and spearhead borders. Around the inside of the rim a border of vases and diapered and scrolled cartouches depends from leaf and fret bands. On the bottom, a flower-filled vase encircled by a leaf band.

The hongs at Canton were groups of Chinese-built wood and brick buildings that served foreign traders as residences, offices, and warehouses. The thirteen hongs together stretched along about a thousand feet of the Pearl River at the southwest edge of the city; each hong

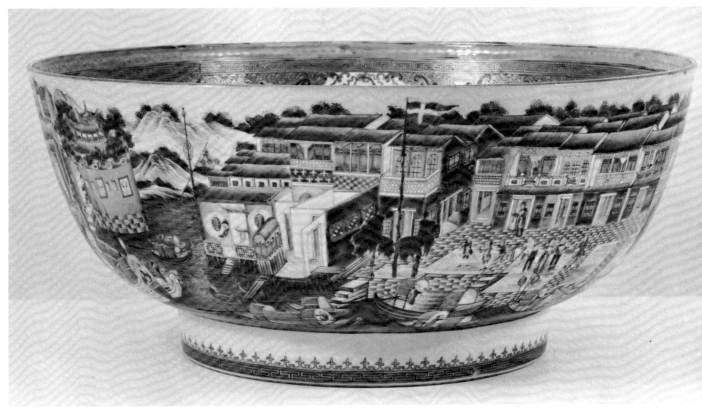

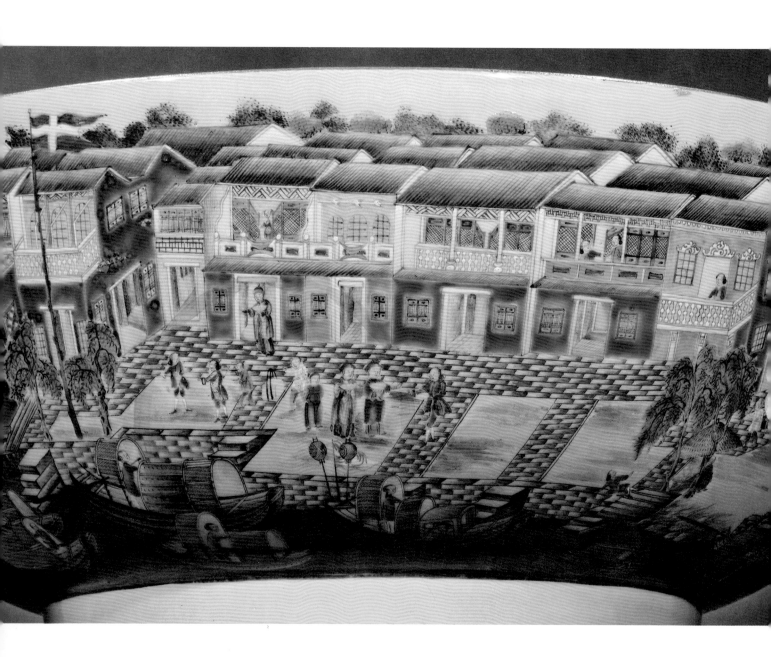

comprised a group of two- or three-story structures connected train-fashion by archways and courtyards, reaching behind the river-fronted buildings to a depth of over 500 feet. Separating the front rank of buildings from the river was Respondentia Walk, a promenade with flights of steps leading to boats that carried chaperoned pleasure parties by appointment. The foreigners enjoyed on Respondentia Walk the only unsupervised outdoor recreation permitted them by their hosts, for the area was strictly isolated from the rest of Canton, and except for necessary dealings with the hoppos the Europeans were allowed no contact with the Chinese.

The factories were generally leased by the month or for the five-month season. The seasonal rent in 1787, for example, ranged from seven hundred to twelve hundred dollars.[1] "On arriving at Canton," wrote John Barry in 1787, "one of the first things to be attended to is procuring a factory,"[2] but in fact by that date most had been so regularly contracted for year after year that they had come to be identified by the nationalities of their habitual tenants. The Danish factory was at the west end of the line, followed by the Spanish, French, American, Imperial (Austrian), Swedish, English, and Dutch. Interspersed were factories for general lease called by such names as "Justice and Peace" and "The Great and Affluent Factory."[3] Originally simple boxlike buildings, the factories became architecturally more elaborate and Westernized in the course of the eighteenth century. A fire in 1743 burned over 150 houses in the area, and it was probably after that conflagration that the rebuilt structures acquired the appearance seen on China trade punch bowls.

The flags shown in representations of the hongs varied from time to time according to the nationalities of the ships in the harbor. 49 and six other bowls differ compositionally only in this respect.[4] Shown on 49 are, from left to right (west to east), the flags of the Danish, Imperial, French, Swedish, British, and Dutch companies. The bowl may therefore be dated before 1784, when the American flag first appeared at Canton following the arrival of the *Empress of China* out of New York. (William Hickey, the erratic diarist who spent the 1769 season in Canton as a guest of the English company, reported that the Americans "have also a flag,"[5] but this is unsupported by any other evidence.) The presence of the Austrian Imperial flag does not denote a revival of the old Ostend Company, whose charter had been revoked in 1731 (p. 3); the flag reappeared at Canton in 1779 as a front for a Hungarian-licensed French ship "it is pretended ... belongs to a set of Merchants called the Triest Company."[6] The Imperialists, whoever they really were, were at Canton for only two seasons, although they are recorded at Macao as late as 1787.[7]

The Canton factories no longer exist. All except the Danish and Dutch buildings were ruined by fire in November 1822. Rebuilt, they were finally destroyed, burned by the Chinese, on 13 December 1856.

NOTES

1 Mudge, p. 30 (quoting from the ms. journal of John Barry).

2 Ibid., loc. cit.

3 *Description of the City of Canton*, 2nd ed., Canton, 1839, p. 116.

4 Museum of the Rhode Island School of Design; H. F. Du Pont Winterthur Museum; collection of Mrs. H. E. Dreier, Mrs. G. B. B. Lamb, and Mrs. Thomas Lowden Drier, lent to the Metropolitan Museum; Sotheby & Co., 7 February 1967 and 28 May 1968; and one on the art market. The Winterthur and Rhode Island bowls, which show the American flag, have rim and foot borders identical to those on 49. The American flag is absent from the other examples. Three other hong bowls, one in the British Museum, another at Temple Newsam, and the third formerly in the Jay Dorf collection, are quite different in composition and style from this group, with conspicuous variations in architectural details. As one at least of these has the American flag it is likely that they are much later in date, possibly made after the expansion and rebuilding of the British factory in 1811 or even after the fire of 1822.

5 William Hickey, *Memoirs*, London, 1919, I, p. 202.

6 Morse, II, p. 39. Again unreliably, Hickey declared that "for years there has been an Imperial flag flying before the factory occupied by the Germans."

7 Ibid., p. 136.

50 Plate

American market, about 1802
D. 9¾ in.
Accession 55.110

Decoration in enamel colors of dark brown and sepia, and
gilt. In the center, a funerary monument surmounted by
an eagle, a weeping willow behind; in an oval reserve on

the pedestal, the name WASHINGTON. The well is edged with a double line originally filled in with a gilt pattern. Around the octagonal rim, a band of S-shaped leaves forming a guilloche between rows of gilt stars; from this band intertwined drapery and floral swags depend, interrupted at the top by an oval reserve enclosing the script monogram PAS.

Two dinner services of this pattern are recorded. At present, this is the only known piece from the PAS service; pieces from the other service bear the monogram JRL.[1] The two were undoubtedly ordered at the earliest opportunity after the death of Washington on 14 December 1799, and from the coherence of their design and coloring it is evident that they were commissioned in their entirety, rather than purchased from a stock of half-painted ware. Neither the central motif nor the border pattern is, of course, unique. The device of the willow and an urn on a pedestal had become the standard representation of mourning by the turn of the eighteenth century, and its use proliferated in the decorative arts after Washington's death (Figure 62). The combined border decoration of festoons and leaf band occurs on a few porcelains made for the American market in the early nineteenth century. Its appearance, with different coloring, on a punch bowl presented to the Pennsylvania Hospital in 1802[2] is of interest in confirming the currency of the pattern at the time this plate—on grounds of topicality alone—may be presumed to have been made.

It has been said that two dinner services were ordered for Philadelphia families,[3] and the name of John R. Latimer, a Philadelphia merchant active in the China trade from about 1815 to 1833 has been traditionally associated with the JRL service. However, no evidence has been discovered to support either of these suggestions.

50, unlike the pieces from the JRL service, shows an unusual amount of wear.

FIGURE 62 Embroidery commemorating the death of George Washington. American, about 1802. The Metropolitan Museum of Art, Bolles Collection, Gift of Mrs. Russell Sage, 10.125.416

NOTES

1 Two octagonal plates, an oval platter, a custard cup, and a glacier are in the Winterthur Museum (63.966.1–6), three illustrated in Mudge, fig. 110. A platter is in the American Wing of the Metropolitan Museum (54.87.31).

2 Mudge, fig. 120.

3 J. A. Lloyd Hyde, *Oriental Lowestoft*, Newport, England, 1954, p. 130.

51 Two dishes

English market, about 1805

Ls. 10⅛, 10¼ in.

Accession 58.155.3, 4

Arms: Argent a cross gules in dexter chief quarter an escutcheon
 with the arms of Great Britain (1 & 4. England, 2. Scotland,
 3. Ireland), the shield ornamented and regally crowned or.
 Crest: on a wreath argent and gules a lion rampant gardant
 or holding between the forefeet a royal crown proper.
 Supporters: two lions rampant gardant or each supporting
 a banner erect argent charged with a cross gules. Motto:
 Auspicio Regis et Senatus Angliae[1]

In the center, the arms of the English East India Company.
A band of pierced latticework on the rim is bordered in-
side with a single line—mauve on one dish, dark purple
on the other—outside with a geometric leaf-and-tongue
border drawn in white and purple on a salmon ground.

These dishes are part of a dessert service traditionally
said to have been made for the East India Company's
president at Madras (Fort St. George). A number of pieces
from the service, including an oblong covered dish with
cabbage-head finial, were once owned by Tudor-Craig;[2]
a square dish from the service, lacking the pierced border,
is in the Metropolitan Museum (48.172.8); a dish and
fruit basket are in the Victoria and Albert Museum.[3] Var-
iations in the rendering on these porcelains imply a large
order worked on by many painters.

The design of these dishes and their unusual coloring
may be traced to the patterns for creamware of Josiah
Wedgwood. A version of the leaf border appears in his
first pattern book of 1770; variant renditions occur on
pieces dating at least to 1790. This service must date after
1801, since the arms of Great Britain are those adopted in
that year, and it is probably earlier than 1810, when this
type of pierced decoration went out of fashion.

NOTES

1 The arms of Great Britain are incomplete, lacking the inescutcheon of Hanover. In the supporters, the lion of Scotland has been tinctured azure instead of gules on one dish, and the mantling on both is incorrectly shown as azure and or rather than gules and argent.

2 Documented by a photograph in the Tudor-Craig Archives, Western European Arts Department, The Metropolitan Museum of Art.

3 W. B. Honey, *Guide to the Later Chinese Porcelain*, London, 1927, p. 70.

52 Platter

Probably American market, 1830–40
L. 22⅞ in.
Accession 1970.278

Decoration in polychrome enamel colors and gilt. A pro-
fusion of butterflies, fruits, and flowers including peonies,
lilies, magnolias, peaches, and roses. Exterior covered
with turquoise enamel. Rim gilded.

The dense and colorful pattern is characteristic of a
group of nineteenth-century export porcelains, that,
because of their customary pale sea green ground, is
sometimes referred to as Celadon. The white ground of
52 is rare. The type of decoration is contemporaneous
with the Rose Medallion and Mandarin patterns, which
were made from the early nineteenth century to about
1850, exclusively for export, largely to the Americans,
who were the only Westerners actively engaged in a
porcelain trade with China at the time. Because of the
long and widespread popularity of the three patterns, it is
difficult to establish more than a general evolution of
the style. However, the decoration of this platter can be
compared with the fluency and refinement of the painted
panels on a Rose Medallion dinner service imported for
the wedding of Mr. and Mrs. Frederick Hall Bradlee of
Beverly, Massachusetts, in 1831;[1] and on a Mandarin
punch bowl presented to Dwight Boyden, manager of
Tremont House in Boston, in 1832.[2] A similar, sparsely
decorated Celadon dish, also with a white ground, has
been dated about 1815–30.[3]

NOTES

1 C. L. Crossman, "The Rose Medallion and Mandarin Pat-
terns in China Trade Porcelain," *Antiques*, October 1967, p.
533, fig. 7.

2 Ibid., p. 535, fig. 11.

3 C. L. Crossman, *A Design Catalogue of Chinese Export
Porcelain for the American Market*, Salem, Massachusetts, 1964,
no. 227.

Works Cited in Abbreviated Form

Beurdeley
 Michel Beurdeley. *Chinese Trade Porcelain*. Translated by Diana Imber. Rutland, Vermont, 1962.

Jenyns, *Japanese Porcelain*
 Soame Jenyns. *Japanese Porcelain*. New York, 1965.

Morse
 Hosea Ballou Morse. *The Chronicles of the East India Company Trading to China: 1635–1834*. 5 vols. Cambridge, Massachusetts, 1926–29.

Mudge
 Jean McClure Mudge. *Chinese Export Porcelain for the American Trade: 1785–1835*. Newark, Delaware, 1962.

Phillips
 John Goldsmith Phillips. *China-Trade Porcelain: An Account of its Historical Background, Manufacture, and Decoration, and a Study of the Helena Woolworth McCann Collection*. Cambridge, Massachusetts, 1956.

Scheurleer, *Chine de Commande*
 D. F. Lunsingh Scheurleer. *Chine de Commande*. Hilversum, 1966.

Volker, *Japanese Porcelain Trade*
 T. Volker. *The Japanese Porcelain Trade of the Dutch East India Company after 1683*. Leiden, 1959.

Volker, *Porcelain*
 T. Volker. *Porcelain and the Dutch East India Company, as Recorded in the Dagh-Registers of Batavia Castle, those of Hirado and Deshima, and other Contemporary Papers: 1602–1682*. Leiden, 1954.

INDEX

Figures in boldface type refer to entire catalogue entries, not page numbers.

133

134